CULTURAL EXCHANGE

Jews, Christians, and Muslims from the Ancient to the Modern World

William Jordan, Michael Cook, and Peter Schäfer, series editors
Edited by Michael Cook, William Chester Jordan, and Peter Schäfer

A list of titles in this series appears at the back of the book.

CULTURAL EXCHANGE

Jews, Christians, and Art in the Medieval Marketplace

Joseph Shatzmiller

PRINCETON UNIVERSITY PRESS

Princeton and Oxford

Published by Princeton University Press, 41 William Street, Princeton, New Jersey 08540
In the United Kingdom: Princeton University Press, 6 Oxford Street, Woodstock, Oxfordshire OX20
 1TW

press.princeton.edu

Jacket Art: "Initial E: A Man Receiving a Purse from a Jew in Exchange for a Goblet"
 (83.MQ.165.114). Artist: Unknown, Possible Michael Lupi de Candiu, about 1290–1310.
 Courtesy of the Getty Museum.

Library of Congress Cataloging-in-Publication Data

Shatzmiller, Joseph, author.
Cultural exchange : Jews, Christians, and Art in the medieval marketplace / Joseph Shatzmiller.
 pages cm. — (Jews, Christians, and Muslims from the ancient to the modern world)

Includes bibliographical references and index.
ISBN 978-0-691-15699-6 (hardcover : alk. paper) 1. Jews—Europe, Western—
 Civilization. 2. Jews—Europe, Western—Social life and customs—To 1500. 3. Christians—
 Europe, Western—Civilization. 4. Christians—Europe, Western—Social life and customs—To
 1500. 5. Europe, Western—Civilization—To 1500. 6. Europe, Western—Civilization—Jewish
 influences. 7. Europe, Western—Ethnic relations. I. Title.
DS135.E81S53 2013
381'.108992404—dc23 2012046441

British Library Cataloging-in-Publication Data is available

Publication of this book has been aided by a grant from Duke University's History Department; the
 incorporation of the illustrations has been supported by a grant from The Lucius N. Littauer
 Foundation

This book has been composed in Sabon
Printed on acid-free paper. ∞
Printed in the United States of America

10 9 8 7 6 5 4 3 2 1

Contents

List of Illustrations

———————————

Preface

———

In writing this book I have tried to simplify the narrative as much as possible in order to facilitate the reading of its seven chapters. For this reason I have tried to reduce the volume of scholarly apparatus, perhaps less successfully than anticipated. Footnotes have been shortened to the most essential elements, but will send the curious reader to a more detailed bibliography.

For the sake of simplification, almost all quotations and references are given in English, not Hebrew or Latin. In the majority of cases I have had access to reliable translations. When an alternative interpretation of a term or a sentence is possible, I have included that in brackets.

In an effort to avoid the readers having to struggle with an avalanche of references, I have, when presenting a continuous set of data drawn from the same source, provided the reference within the text itself, not in the footnotes. The item number or the page number is given in parentheses. References to call numbers ("signatures") of codices and folios of manuscripts are also included parenthetically in the text rather than in the footnotes. In several instances, when the title of a printed book made part of the discourse of a paragraph, I quoted its title in full in the text and provided also the bibliographical reference instead of relegating it to a note.

This book has been generously supported by the Department of History, Duke University, and by the Lucius N. Littauer Foundation, New York. I wish also to express thanks to the libraries that provided permission to publish illustrations from their collections and especially to those who generously waived the fee or provided an educational discount. All credits are mentioned in the captions that accompany each of the illustrations.

Larissa Klein, editorial assistant at Princeton University Press, worked with me for almost a year providing advice and helping with the onerous task of collecting permissions to publish illustrations from many different sources. We had close to daily contact struggling to achieve the permis-

sions. Her efforts and successes can serve as an example of patience, perseverance, and efficiency. Dr. Brigitta van Rheinberg, editor-in-chief and executive editor of Princeton University Press, including its Judaica series, took an avid interest in my manuscript from the first minute and navigated its course within the different committees with much sympathy and understanding. Her wise suggestions helped shape the story and make it more effective. To both I send my heartiest thanks. Special thanks to Debbie Tegarden who worked with grace and efficiency on the final version of this book. Many other friends and colleagues have helped me during the many years that I worked on this project. They will find their names and my thanks in the notes.

This book took a long time to write. Still, without the help, so generously given by these friends, it would have taken even longer. Let me extend my thanks to my wife Gayle Murray, who in many hours of hard work tried to make sense of my English and saw to it that I followed the rules of logic. The least I can do is dedicate this book to her.

CULTURAL EXCHANGE

INTRODUCTION

This book is about the cultural exchange between Jews and Christians in the High and Late Middle Ages (c. 1230–1450 CE). Members of each group contributed to the other's culture, even to their religious practices. The Christian protagonists appear more frequently in most chapters, but Jews, too, are handsomely represented. My interest in these people and their endeavors was raised while I was working on the history of the West European marketplace and its financial services. Moneylenders, Jews and non-Jews, could not always count on notarized contracts to secure the loans they were extending, and required tangible objects as collateral. They became, in fact, pawnbrokers. This fact led me to undertake the present project.

Jews would often have in their possession artistic objects from the surrounding society. Even if held for a limited time, these objects were most likely influential in shaping the possessors' own art. The idea of looking at the Christian environment when studying Jewish ritual objects was raised in 1960 by Mordechai Narkiss, then the director of the Bezalel Art Museum in Jerusalem. He was studying the shape of a Jewish ritual object—the spice box—known in Hebrew as a *besamim* box or *hadass* (myrtle). This small elegant object (see fig. 24) frequently shaped like a tower, is used in the concluding moments of the Sabbath and of holidays when the fragrance spread from the box announces the beginning of a new week. Narkiss noticed that originally these *besamim* (perfume) boxes were similar in shape to Christian reliquaries labeled in German as *Monstranz*. Jewish moneylenders, Narkiss suggested, must have kept such reliquaries as pawns to guarantee the loans they provided. To support this hypothesis he provided a dozen references showing how medieval Jews accepted Christian liturgical articles as securities. As if in support of this suggestion, Parisian art historian Victor Klagsbald noticed that in the sixteenth century, goldsmiths in Frankfurt called the *besamim-hadass* box a *Judenmonstranz*. Meyer Shapiro, the nestor of the discipline, would agree with Narkiss. He had no hesitation writing about "the intimate

bond between Christian and Jewish culture in the middle ages in spite of the separateness of the communities."[1]

Materials for this enterprise came from all corners of the Latin West. Fourteen years of searching did not provide me with enough data to concentrate the study in one region, or to limit its chronology to a span of time shorter than three centuries. The field of observation had to be extended in order to cover all aspect of the story I wished to tell. Even so, it is more than probable that I have not discovered all the information that could be of relevance. Thus, precious evidence has come to my attention since I first submitted the manuscript to the publisher and other relevant materials are sure to surface following the publication.

The first part of this book, chapters 1 to 3, is devoted to a study of the exchange of cultural values in the medieval money market and to the venues of their transmission. Here we can observe the cross cultural exchange of material objects. We enter now the world of pawnbroking. In chapter 1, we meet mostly peasants and humble citizens. As can be surmised, not much in terms of beauty can be expected to be discerned from the objects that these simple people brought to the market. Their relationships with the pawnbrokers are studied through the exploration of the tribunal registers of Manosque (in Upper Provence), which indicate the rules that governed the practice of exchange and exhibit the complications and disagreements that may have arisen between the business partners. Chapter 2 exposes members of the clergy in need of credit for their monasteries and churches. They were prepared to give as securities objects that were considered sacred. By relinquishing such objects they ignored papal and ecclesiastical councils' prohibitions. Chapter 3 deals with moderate to high financial assistance that was required at times by well-to-do urban inhabitants and by members of the princely class. There were situations in which even members of royalty borrowed from Jewish moneylenders. Much more aesthetic value (at least to the modern eye) was present in the objects brought to the pawnbrokers' premises by this

[1] Mordechai Narkiss, "The Origin of the Spice Box," *Journal of Jewish Art* 8 (1981): 28–41. A previous version of this study was published in Hebrew in *Eretz-Israel: Archeological, Historical and Geographical Studies* 6 (1960): 189–98. See also Victor Klagsbald, "Myrte, parfum du jardin d'Eden," in *A l'ombre de Dieu: dix essais sur la symbolique dans l'art juif* (Leuven, Belgium, 1997), 109–18 and the illustrations there. For the quote from Meyer Shapiro, see his "Introduction," in Moshe Spitzer and Max Jaffé (eds.), *The Bird's Head Haggada of the Bezalel National Art Museum in Jerusalem* (Jerusalem, 1967), 16; see also his statement on 15: "We cannot imagine the Haggadah with this ornate and lively illustration before the Middle Ages, when Christian art had created the Psalters and liturgical books with pictures."

class of borrowers. It is not hard to imagine how Jews could have been enchanted by pledges offered by the very upper class of society. Indeed, on rare occasions they expressed their admiration for the refined taste of such securities.

Part Two, anchored in Germanic lands, begins with chapter 4, which offers a most astounding testimonial to the influence that success had on the development of the aesthetic taste of Jewish financiers. It describes the decorations in an apartment discovered in the mid-1990s in the city of Zurich. In this apartment, between the years 1320 and 1330, lived the family of the exceedingly rich Rabbi Moses ben Menahem, the spiritual leader of the city's small community who is well known today to rabbinic scholars. Visiting the premises in the summer of 2003, I was surprised by the remains of the wall paintings that once surrounded the living room. Although in all likelihood they were painted by non-Jews, I expected nevertheless to see scenes of great moments of the biblical narrative, or, alternatively, images of impossible hybrids, of waterfowl, of unicorns or of dragons swallowing serpents, the way they appear in the decorated medieval manuscripts. Instead, the message these frescoes send is bereft of any of the fantastic and is instead one of strict realism. Moreover, neither of the two frescoes has anything do with Jews or Judaism. One of the two shows a group of men and women dancing; the other shows a man and a woman riding in what seems to be a romantic promenade. In order to better understand the cultural profile of the rabbi and (mostly) to evaluate the contribution of these wall paintings as indications of the artistic horizons of German Jews of the fourteen century, I decided (for chapter 5) to briefly review their art history in the centuries that preceded and followed these frescoes (1230–1450 CE).

Part Three (chapters 6 and 7) will underline again the fact that the marketplace brought Jews in touch with Christian artists and craftsmen, where they learned to value their skill and expertise. That this helped to shape their sensitivity to what was considered then as beautiful is shown plainly by their preparedness to hire Christian artists and craftsmen to decorate Hebrew prayer books and to create for them objects with which Jews performed their liturgical obligations (chapter 6). These Christian professionals were not necessarily familiar with the intricacies of the Jewish religion, and when not consulting a Jew, at times committed mistakes. The late Ruth Mellinkoff went a step further and claimed that the deformed way Jews are presented in these Hebrew manuscripts was due to the hostility of these Christian painters toward the rival religion. In this

chapter I cannot subscribe to this suggestion. These deformations, I shall try to prove, followed a Jewish initiative and not a Christian one. More than that, in most manuscripts and objects that I observed I did not sense any hostility. As far as I can tell, in most cases these non-Jews wished to present an honest product to the satisfaction of the patron. This lack of rivalry or animosity brings our book to chapter 7, the last—and for me the most intriguing—chapter. It shows Jewish artists and craftsmen working together for the church and its institutions. This is unexpected, because even current historiography is still centered on instances of tension and dispute and has the story of hostility as its central preoccupation. To be sure, historians are not pointing readers in the wrong direction since much of the relations in the past were unfortunately marked by persecutions and massive bloodshed. But a study like the present volume should prepare all of us to encounter instances of tolerance, of humanity, and of collaboration that existed then, as surely as they exist now.

The term *cultural exchange* when discussed from the point of view of the Jews means external input into their civilization. In the preceding pages we limited the discussion to art and craftsmanship and to the medieval marketplace. But other aspects of life, be it ceremonials, customs, or even communal institutions, can be subjects of examination as well. And indeed they were in the past and still are at present. In the appendix to this book I present such studies as conducted by distinguished scholars, and the reaction—some of it negative—their scholarship attracted. The towering figure of Historian Fritz (Yitzhak) Baer gets, of course, special attention. In a short addition to these pages I raise the issue of whether we can go beyond identifying influences and pointing to similarities and try to follow the channels through which these "external inputs" flowed.

Finally, a note about the monetary terminology used in the following pages. Although several coins were in use in the medieval marketplace, the most prevalent was the *denarius*. A pound (*libra*) of silver—or most often a mixture of silver and other metals—was divided into 240 *denarii*. Twelve denarii made for a *solidus* (shilling), and twenty shillings made a pound. These last two denominations did not exist as coins and were just units of monetary calculation.

The present study does not use the Roman terminology but will quote salaries in pounds and shillings in order to simplify matters. A day's salary for an unskilled laborer would rarely exceed eight denarii. He might rightly claim that this sum was equal to two-thirds of a shilling.

PART ONE

Pawnbrokers

Agents of Cultural Transmission

Chapter One

FINANCIAL ACTIVITIES IN THE MEDIEVAL MARKETPLACE

The museologist Mordechai Narkiss has rightly pointed out that the business of pawnbroking constituted one of the most important avenues through which Christian artistic achievements found their way into the Jewish society. Yet he said nothing about the marketplace itself and its dynamics. Therefore, before getting into a detailed discussion of his thesis it is necessary to survey, in broad strokes, a picture of the social and economic conditions that prevailed in the medieval West in the High and Late Middle Ages. We must start by mentioning that during the last centuries of classical antiquity and those of the Early Middle Ages that lead to the year 1000 CE, Europe reached one of the lowest points in its history. To quote the French historian Georges Duby, "As of the end of the sixth century, Europe was a profoundly uncivilized place."[1] The short Carolingian Renaissance of the ninth century notwithstanding, this state of stagnation went on until the end of the tenth century and even later. During these centuries of European decline, civilization flourished in the Islamic empires that stretched their authority from mid-Asia to the Atlantic Ocean and included the Middle East, North Africa, and most of Spain. It is only around the year 1000 CE that we are allowed to talk about an unmistaken awakening of the medieval West.[2]

The causes of this invigoration were multiple and are connected each to the other. Historians observed a discernible agricultural growth that in

[1] Georges Duby, *The Early Growth of European Economy*, trans. Howard B. Clarke (Ithaca, NY 1974), 3.

[2] Scholarship regarding the social and economic history of the medieval West is of immense dimension. The small survey in Robert-Henri Bautier, *The Economic Development of Medieval Europe* (London, 1971), which I admire very much, has in its bibliography hundreds of entries. To present a list of works that has appeared since 1971 would require in all probability an entire book or even several of them.

an increasing number of places even produced a surplus. This was due to technological innovations, to changes in social relationships, and mostly (I follow here the studies of Emmanuel Le Roy Ladurie) to a climatic shift for the better.[3] In the markets, which were at the beginnings of an urban revival, the people that visited them, eager to exchange goods and services, abandoned the system of barter and welcomed the introduction of money (never in sufficient quantities) that facilitated mercantile activities. Optimism about the functioning of the economic system enticed creditors to offer loans that would today be consider short-term. By the mid-thirteenth century, as Richard W. Emery discovered in his *Jews of Perpignan in the Thirteenth Century* (New York, 1959), practically all members of the society, from whatever class they stemmed, were permanently indebted. Other studies confirmed his conclusion. This revived "money economy" required a concomitant agile and swift legal system in order to regulate and to defend the activities of the marketplace. In most cases the old, customary (oral) law did not fit the new dynamics of the social and economic relationships. Authorities therefore found it necessary to introduce legal procedures that corresponded to the pace of the activities in the markets. Most of all the dormant Roman law reappeared with much vigor and was applied even in modest localities like the city of Manosque, a regional center in Upper Provence. Judges, lawyers, heralds, messengers, and even prison guards were kept busy by the hectic marketplace of the city. The public notaries, whose deeds had the power of proof in cases of disagreement, reappeared in great numbers on the social scene, as evidenced by the great quantity of their registers that are kept in the archives of Manosque, Digne, and Marseille.

In the first stages of the European revival, Jews (most of whom still lived under Islamic rule) were more than welcomed into the revitalized Latin West. Indeed, documents show that they were invited to join. While the church condemned credit operations as "usurious," society and its political leaders on the other hand appreciated credit as an energizer of economic growth. Jews, therefore, who were not under the church's jurisdiction, were ideally suited to serve in the money economy. To be sure, neither were they the only ones to be active in this branch of activity nor did they dominate it, so that with the halt of growth around the year 1300 they were no longer as prosperous as six generations beforehand, and authorities lost interest in their diminishing contribution. As a result,

[3] See, for example, the very detailed study in Guy Bois, *The Transformation of the Year One Thousand: The Village of Lournand from Antiquity to Feudalism* (Manchester, England, 1992). For the environmental change and its consequences I count on the two volumes of Emmanuel Le Roy Ladurie, *Histoire du climat depuis l'an mil* (Paris, 1983).

many cities, counties, and states were eager to adopt the church's attitude
and expel them.

———————

Let us return our attention to pawnbroking. Jews to be sure were devoted
clients of the notaries. In the registers of these jurists, deeds concerning
Jews represented at times 50 percent of the total and even more. We
know of notaries that worked mainly or only for Jews. Still, not all opera-
tions of the Jews and of other creditors were insured by notaries' deeds.
Sometimes the sums involved were too high and the creditors looked for
safety by asking for precious objects as collateral. In other instances the
loan was, on the contrary, too small and did not justify the expense of a
notary's registration. Here, too, a pawn—a modest one of course—would
serve as insurance against nonpayment. And since in the thirteenth and
fourteenth centuries Jews were dealing largely with members of the lower
classes of society these small pledges were of much concern to them. This
fact is openly documented in the records of three Italian municipalities.
In the early 1390s the Venetian commune made the admission of Jews to
the city conditional upon their being able to lend money to "support in
particular the poor people (*specialtier pro subventione pauperium per-
sonarum*)."[4] About one hundred years later, on August 14, 1482, the
councillors of the city of Pavia in the Duchy of Milan alerted the duke to
a crisis caused by the Jewish moneylenders of the city. They were refusing
to extend loans to anybody as they claimed to already possess too many
pawned items. "This will hurt most of all the poor people who have no
way to buy their bread," the councillors warned. Since social unrest was
on the horizon and riots appeared imminent, the Duke was asked for
help.[5] In 1633, more than a generation after William Shakespeare's *Mer-
chant of Venice* appeared on the stages of London (worth mentioning
even if beyond the chronological limits of our study), the city council of
Padua pressured the local Jewish community to establish a popular bank
because "the hue and the cry of the poor for credit reached heaven."[6] For
their part Jews were aware for hundreds of years beforehand of what was

———————

[4] See Reinhold C. Mueller, "Les prêteurs Juifs de Venise au Moyen Âge," *Annales, E.S.C.*
30 (1975): 1277–1302; and Reinhold C. Mueller, "Jewish Moneylenders of Late Trecento
Venice: A Revisitation," *Mediterranean Historical Review* 10 (1995): 202–17.

[5] See Shlomo Simonsohn, *The Jews in the Duchy of Milan*, vol. 2, 1477–1566 (Jerusa-
lem, 1982), 868, doc. no. 2089.

[6] I am indebted for this information about "the hue and cry" to the study of Abraham
N. Z. Roth, "The Book of Regulation between Lender and Borrower Attributed Wrongly to
Zacharias Publiesi," *Hebrew Union College Annual* 26 (1955), Hebrew section, 41–43.
Daniel Carpi, *Minutes of the Council of the Jewish Community of Padua*, 2 vols. (Jerusalem,
1973–79) reaches only the year 1630. On the relations between the public authorities of
Padua and the Jewish moneylenders, see Philippe Braunstein, "Le prêt sur gages à Padoue et

expected of them. Meir ben Shimon of Narbonne, a leader of southern
French Jewry around the mid-thirteenth century, was proud of the contri-
bution his brethren made as moneylenders to the humble and the needy
in society. "Who else," he asked, "would lend to the poor and to the less
fortunate, if not the Jews?"[7]

Scholars of pawnbroking must work hard to acquire some idea of the
kind of objects that circulated in the marketplace. The difficulty results
from the fact that many (perhaps most) transactions relied on oral agree-
ments and (as mentioned above) were not backed up by written docu-
ments. Even though the parties involved could have approached any one
of the dozens of notaries, particularly in the Mediterranean regions, this
happened only rarely and when little money was asked for, since these
legal practitioners would often charge a fee that could exceeded the value
of the transaction.[8]

There are nevertheless ways of opening windows in the otherwise
shuttered marketplace of popular pawnbroking. Local legislation was en-
acted to regulate business, and in particular to establish a minimum
length of time for which the creditor was required to keep pawned items
in his possession before he could put them up for sale. A twelve-month
period seems to have been the most common time frame, though this
could be extended to fourteen months, as happened in Volterra, Tuscany,
in 1462 and 1474, or to one year and six weeks, as happened in Biel, in
the Swiss Confederation.[9] As well, the law decreed that borrowers must
be reminded to redeem their pawned items, and it was the task of the
herald (*preco*) of the city to alert them. The archives of Manosque, Upper
Provence, which are today housed in the Archives Départementales des
Bouches-du-Rhône in Marseille (series 56H), contain a register of the
public announcements that were proclaimed in that medium sized city
between 1334 and 1341.[10] Its call number is 56H980. There we discover,

dans le Padouan au milieu du XVe siècle," in *Gli Ebrei a Venezia: secoli XIV–XVIII* (Milan,
1987), 651–69.

[7] For Meir ben Shimon, see Joseph Shatzmiller, *Shylock Reconsidered: Jews, Moneylend-
ing and Medieval Society* (Berkeley, 1990), 80–81.

[8] For Mediterranean notaries, see the contributions in Paulo Brezzi and Egmont Lee
(eds.), *Sources of Social History: Private Acts of the Late Middle Ages* (Toronto, 1984).

[9] Alessandra Veronese, *Una familia di banchieri ebrei tra XIV e XVI secolo: I da Vol-
terra. Reti di credito nell'Italia del Rinascimento* (Pisa, Italy, 1998), 105; Augusta Steinberg,
Studien zur Geschichte der Juden in der Schweiz während des Mittelalters (Zurich, 1902),
79–80.

[10] For a list of the registers of Manosque kept today in the Archives Départementales des
Bouches-du-Rhône in Marseille, see Édouard Baratier and Madeleine Villard, *Répertoire de
la série H.56H: Grand prieuré de Saint-Gilles des Hospitaliers de Saint-Jean de Jérusalem*

IN THE MEDIEVAL MARKETPLACE

for example, that on January 14, 1339 (fol. 54bis-v), the *preco publicus* Matheus Rostagni proclaimed the following message in the streets: "All persons who have had pledges for more than a year [in possession of] Bellandus Salamonis, Jew, should redeem them within ten days. Once that time has elapsed, the court will have no further dealings with them (*ulterius non audiretur*)." Four years earlier the local herald had called all those who had lodged objects as collateral in the premises of Bonetus Bonafos to claim them within ten days since this Jew intended to leave the city (*domicilium alibi mutare*; fol. 7v). As it happens, Bonetus was in no great haste to abandon Manosque: in October 1336 he asked the court to issue a similar pronouncement. This time the scribe of the tribunal reported that the herald Matheus went out to the city and after a while returned and declared under oath that he had accomplished the mission. When the Jews possessed pawns belonging to their coreligionists, the messenger would enter the synagogue on a Sabbath day "when the Jews are in the said scola" and remind them about the customary ten-day delay. Such an intervention occurred at the instigation of Master Leo, a doctor, on August 25, 1285 (56H906, 90r).

Urban legislation also regulated the sale of the unredeemed objects. They had to be publicly auctioned, not sold in private, and the event had to take place within the walls of the city. "Anybody, Jew or Christian who has pledges for auctioning should sell them, or cause them to be sold in public, in auction in the city of Manosque and not elsewhere. A fine of one hundred solidi [will be imposed] for each [transgression] and the pledges themselves will be confiscated." This decree was made public on the last day of February 1339 (fol. 53v). It was repeated three months later,[11] referring this time to "pawns and clothing" (*pignora et raube*).

The registers of the series 56H offer even more information about the business of pawnbroking. While the notaries' registers of Manosque are not much help in the history of small credit, the records of the city tribunal introduce us to individuals whose names are spelled out and to events that can be dated. An inventory of objects that served as collateral can be established without much difficulty, while the sentences pronounced by the judges show how insistent the authorities were when it came to enforcing the law. A systematic survey of these court records is still needed. The following examples may indicate what future researchers may expect to find in the course of a comprehensive scrutiny of these archives.

(Marseille, 1966). It is mostly from the 56H series in these archives that references will be given in the following pages. The court registers of the German city of Frankfurt am Main provide similar information to that of Manosque. See Isidor Kracauer, *Geschichte der Juden in Frankfurt a.M. (1150–1824)*, vol. 1 (Frankfurt am Main, 1925), 84–106.

[11] See Camille Arnaud, *Histoire de la viiguerie de Forcalquier*, vol. 2 (Marseille, 1875), 134.

Pawnbrokers were often accused of selling off pledged items before they were supposed to do so. The original owners would complain in court about such precipitate sell-offs. One of the first procedures found in the Manosque records describes a group of thirty-five Jews, nineteen of them women, accused of this illegal practice (56H952, 45r; 27.5.1286). Although they may have been acquitted on this occasion (no information about the verdict is available), many of their fellow Jews had to endure similar purgatorial situations in the ensuing years. Thus, in March 1292, a certain Guillelmus Garcinus claimed that the Jew Vinellas did not wait more than five days before selling a dresser (*gardacorcium*) that he had pledged with him. (56H954, 25r, 29r, 31r–v; 13.3.1292). Moses of Grassa, another Manosque Jew, sold a rug (*baratanum*) to a fellow coreligionist just eight days after getting it. He, however, insisted that the deal was entirely legal, claiming that it had been a precondition of the transaction from the very beginning (56H954, 56r; 1291). Moses Anglicus, in a dispute with one Petrus Stephani that went on for several months, gave conflicting information to the court: at first he claimed that three and a half years had elapsed since the item had been pawned to him. Then he reduced the time span to a year and a half. Finally, he presented the judge with a written permission, dated November 16 of that year (1295), allowing him to sell the item less than a month before he faced justice. Still he won the case, and asked for an official document to exonerate him (56H957, 12v–23r; 12.12.1295).

The Manosque judges would do whatever was needed to discover the truth and penalize the perpetrators. In 1308 a Jewess named Falcona, the wife of Bonus Nomen, was warned not to put on sale three vases, two of them full of wine (56H885, 23r; 17.5.1308). Three months later a similar message was sent to Abraham of Castelanna. He was threatened with a huge fine of fifty pounds (56H885, 25v; 9.8.1308). In yet another instance a Jewish tailor named Aymmus of Sisteron was charged together with a Manosque lady named Resplanda, with being the perpetrator of multiple fraudulent transactions. He was found guilty, and had to choose between a fine of thirty shillings and a sentence exiling him from the city (56H952, 21v; 6.10.1285). The tension accompanying some of these litigations is exemplified in the case involving Jacob Anglicus, the son of the above-mentioned Moses. In the summer of 1306 his wife refused to let in a court messenger who came to fetch a pawned item, while he, Jacob, allegedly even insulted him (56H960, 84r;15–16.9.1306).

Most pawns mentioned in these records were of little value. The dresser (*gardacorcin*) that was the disputed object of the 1292 lawsuit just mentioned served as surety for a loan of no more than three shillings. A cooking pot (*cacobus*) was taken to assure a loan of one solidus (56H960, 60r; 5.8.1306). Textile products, dresses, or covers are men-

tioned frequently: a vest (*fayssada*) (56H962, 33r; 21.11.1310), a coat (*epitogium*; 56H961, 32r; 3.6.1309); or a cover (*coopertum*) (56H961, 81r; 21.1.1309) are some of the items that surface in these documents. A simple sack held by Samuel de Grassa became the subject of litigation in November 1309. The Jew, it was claimed, filled it up with flour, which he was not expected to do. Samuel admitted the misdemeanor and claimed that he simply forgot that the sack did not belong to him (56H961, 97r; 27.11.1309). Confusion, misunderstanding, and forgetfulness might have had severe consequences for another Jewish pawnbroker, Mossonus. Two messengers of the court accused him on January 12, 1330, of no less than the theft of pawned items. The Jew denied ever having received any objects, and to make his point took the severe oath "More Judaico" in the synagogue (*in schola . . . maledictionem que apud judeos pro excommunicatione habetur pluries ascultavit*). Still, the objects were found on his premises. In his defense Mossonus claimed that it was his son-in-law who had received the objects. It was the young man who had written the (probably Hebrew) notes that were attached to the objects in order to identify their owners, and these were exhibited in court as proof of Mossonus's culpability. This explanation made sense to the judge, who imposed a moderate fine of five solidi on the accused (56H981, 16r; 12.1.1330).

More than any other region in the medieval West the island of Sicily was home for a large number of Jews who were members of the working classes. They were involved in manual production or maintenance work, including agricultural labor. To be sure, there also existed an upper class whose wealth is revealed in their marriage contracts and wills. But all, rich and poor alike, were involved in the credit economy and frequently appeared in the judicial system, just as their fellow Jews in Manosque did. In Palermo, the capital, the civil tribunal was presided over by the pretor of the city; hence, Corte Pretoriana, an institution that continued to function until the nineteenth century. Until they were expelled from the island in 1492 the Jews were also under the authority of this court in matters of civil litigation. Before reaching their conclusion the judges would, of course, lead interrogations, hear witnesses, and examine written documentation, as they did in Provence. The amount of material they left in the archives is immense. Shlomo Simonsohn dedicated practically all of *Corte Pretoriana and Notaries of Palermo* (Leiden, Netherlands, 2006), the ninth volume in his monumental series The Jews in Sicily, just to listing the verdicts issued by the court.

Sentencing policy was not the same in the courts of Palermo as it was in Manosque. Most of the Sicilian verdicts tended not to be final and

definitive: when the litigant was found to be at fault part of his belongings were sequestered, but not confiscated and not immediately handed over to his rival. Rather, he would be encouraged to look for a constructive solution within four days (in most cases) and to come to an agreement with his opponent. Only when he was unable to reach such an agreement would he see his confiscated objects become pawns and put up for auction.

Many of the objects that were most often sequestered were similar to those seen in Manosque, though differences between the two cities did exist. For the most part they were private belongings and household utensils. There were huge quantities of clothing. Tunics, gowns, jackets, shoes, women's shirts and silk napkins formed just fraction of the inventory. Household objects such as beds and mattresses, sheets, and bedcovers were often included as well as hides and carpets, cauldrons, pans and even iron jerry cans. Casks of wine were common, and in one case (Simonsohn, vol. 9, p. 5390) the court took away twelve casks of kosher wine. In Palermo even more than in other courts a great numbers of horses, mules, and beasts of burden were sequestered. Slaves, black and white, male or female, could also end up as pawns.

In Sicily as in Provence, there was a tiny minority of cases where jewelry and precious metals changed hands. Thus a silver cup with Hebrew inscription on it was taken away from its owner (Simonsohn, vol. 9, 5222–23). Another cup, this time with the inscription "*in te domine sperans*" followed the same path (p. 5623). We have a reference to jewels (p. 5338) and to a filigree gold box (p. 5846). Longer lists of precious objects can also be found in Simonsohn's ninth volume (pp. 5970, 5972–73). Similar lists exist, although less frequently, in the other eighteen volumes of this monumental publication.[12]

All that is known about the financial marketplace in Manosque comes from Latin documents. The Jews of the city must have kept in their shops registers written in Hebrew where operations were recorded as well as the identifying notes that were attached to pawns, but none of them have survived. Similar losses occurred in all other regions of the medieval West. There are however several exceptions. Here and there, mostly in Catalonia and in Germany, isolated pages in Hebrew surface that must have been part of entire registers.[13] There are also a few instances, some half

[12] On the increased access to luxury among Sicilian Jews, as shown, for example, in the jewelry they carried or the habits they wore, see Henri Bresc, *Arabes de langue, Juifs de religion: l'évolution du judaïsme sicilien dans l'environnement latin, XIIe–XVe siècles* (Paris, 2001), 200–202.

[13] See Annegret Holtmann, *Juden in der Grafschaft Burgund im Mittelalter* (Hannover,

dozen by my count, where we can hold in our hands the complete registers that belonged to medieval pawnbrokers. These are all still in manuscript form. The earliest in the group are two registers dating from the first quarter of the fourteenth century from the Burgundian city of Vesoul.[14] The latest, chronologically, is a hefty register (actually two, bound together) of more than three hundred folios that is kept in a monastery in Cava de Tirreni, south of Naples. It dates from the very end of the following century (1492–95) and I estimate that it contains more than eight thousand entries relating to loans given out in the Salerno region.[15] Then there are two well-known registers from Florence, the financial metropolis of the Late Middle Ages, one kept in the city's archives (Archivio di Stato di Firenze, Miscellanea Repubblicana 130), the other in the Vatican Library (Vaticanum, Heb. 425); they date from 1473–75 and from 1477, respectively. Also in Italy we have twenty-nine folios, which are the remains of a register from Montepulciano from 1409–10 and thirty-two folios from Bologna from the years 1426–30.[16] As early as 1343, the elders of the Florence commune enacted legislation obliging pawnbrokers, whoever they were, to keep such registers.[17] The municipality of Vigevano

Germany, 2003), 162–63, where a list of such findings is given. For Italy, see Chiara Marucchi, "I regesti di prestatore enrei come fonte storica," *Materia guidaica* 9 (2004): 65–72. For Catalonia, see also Manucci, 65n1. Judith Olszowy-Schlanger has informed me about a recent discovery of parts of a pawnbroker's register from the Rhone Valley or Burgundy of the 1320s.

[14] See Holtmann, *Juden in der Grafschaft Burgund im Mittelalter*, 164–182 and passim, as well as Annegret Holtmann, "Medieval 'Pigeonholes': The Jewish Account Books from Vesoul and Medieval Bookkeeping Practices," in Michael Toch (ed.), *Wirtschaftsgeschichte der mittelalterlichen Juden* (Munich, 2008), 103–20. Still of much value is Isidore Loeb, "Deux livres de commerce du XIVe siècle," *Revue des études juives* 8 (1884): 161–96; and 9 (1884): 21–50, 187–213.

[15] For the document kept in Cava dei Tirreni, see Salomone de' Benedetti, "Un manoscritto cavense in caratteri Rabbinici," *Archivio storico per le province napoletane* 8 (1883): 766–74; see also Pascuale Natella, "Salerno Ebraica: Fortuna e oblio d'un insediamento urbano," *Il Picentino* 41 (2005): 37–52. With the help of Alfonso Leone of Naples and Mario Infante of Salerno I was able to examine only briefly the register in December 2006. The difficult writing and the Italian terminology (in Hebrew letters) will present future scholars with an enormous challenge.

[16] See Umberto Cassuto, *Gli ebrei a Firenze nell'età del Rinascimento* (Florence, Italy, 1918; reprinted 1965), 160–67; and Umberto Cassuto, "Un registro ebraico di pegni del secolo XV," *Zeitschrift für hebräische Bibliographie* 15 (1911): 182–85; and 16 (1913): 127–42. See also Flavia Careri, "Il 'Presto ai Quattro Pavoni': dal libro-giornale di Isacco da San Miniato (1473–75)," *Archivio Storico Italiano* 159 (2001): 395–421. For the registers of Montepulciano and Bologna, see Chiara Marucchi, "I registri di prestatori ebrei come fonte storica, *Materia Judaica* (9) 2004: 65–72; and Daniel Carpi, "The Account Book of a Jewish Moneylender in Montepulciano (1409–1410)," *Journal of European Economic History* 14 (1985): 501–13.

[17] Marvin B. Becker, "Gualtieri di Brienne e la regolamentazione dell'usura a Firenze," *Archivio storico Italiano* 114 (1956): 734–40, esp. 738.

in the Duchy of Milan targeted Jewish practitioners in particular and on May 15, 1435, decreed that their registers, whether written in Hebrew or in Latin, should be given full credence. On October 17, 1477, Novara, another city in the Duchy, followed the same rule.[18] Other Italian towns and cities probably enacted similar regulations.

As was mentioned earlier, none of these registers has yet been published and no complete study of any of their contents has ever been undertaken. The Florentine registers benefited, however, from more attention than the others while the Salernitan one is mentioned in the literature, but only rarely. In 1492 a Florence University student, Flavia Careri, explored two months' entries in the register kept in the city's archives as part of her doctoral dissertation.[19] Decades earlier, in 1918, Umberto Cassuto had examined briefly not only the register in Florence but also the one kept in the Vatican.[20]

The first Florentine register, of 269 folios, belonged to a local financial institution known at the time as the Bank of the Four Peacocks (Ai Quattro Pavoni), which was owned by a certain Isaac of San Miniato. In it are registered transactions that took place between October 1473 and February 1475. The draftsmanship of the register's folios greatly facilitated the handling of the information contained there. Each page is divided into three vertical columns and thirty-five numbered horizontal rows. Each operation is described in the three boxes thus created. The first box gives the name of the borrower and other personal details which facilitate his identification. The second box records the sum of money given out, while the third one, of crucial importance for the present discussion, describes the pawns that served as security. This last box (though not the other two) is written in Hebrew script but frequently uses the local vernacular. Cassuto, who limited his investigation to the first three months of the bank's activities, found that an average of fifty transactions were carried out every week.

The second Florentine register belonged to another banking house known as The Cow (*Vacca*), owned by Manuele di Bonaiuto di Camerino. Unlike that of the Quattro Pavoni, it is not a daybook and its aim is quite different: it is the objects that were found in the shop in the month of March 1477 that are registered here. The rooms, halls, and furniture of the premises are described first, followed by an inventory of the pledges kept in each and every room. Objects of the same kind have their own paragraphs. In the margin for each line there are numbers that

[18] Shlomo Simonsohn, *The Jews in the Duchy of Milan*, vol. 1, *1387–1477* (Jerusalem, 1982), 10, 40.

[19] See Careri, "Il 'Presto ai Quattro Pavoni.'"

[20] See Cassuto, *Gli ebrei a Firenze*.

probably refer to the page and line of a daybook like that of the Quattro Pavoni. Then, for each item there follows the name of the debtor, the amount of money involved, and the date on which the transaction took place. Cassuto was surely right to suggest that such registers complimented each other and were used simultaneously. Each bank must have kept both types.

The two registers of Vesoul are also daybooks in their way; one of the two holds forty-eight folios while the other contains sixty (Archives de la Côte-d'Or, B10410-B10411).[21] Much less structured than their Florentine counterparts, and hence lacking much of the latter's clarity, they record first the sum of money handed out and then the other necessary details—notably, the names of the debtors and that of their guarantors. They were in use between 1300 and 1318, and record the activities of a financial consortium headed by a Jew named Heliot. One reason for the lack of orderliness and regularity in registration has to do with the fact that the partners and their agents entered their notes into the daybooks at the same time. Unlike the Florentines, the scribes of Vesoul dedicated special spaces to loans extended in a given locality or even to a particular client. In some cases these particular relationships with individuals or localities cover a number of folios.

When finally published (Annegret Holtmann of Trier and Yacov Guggenheim of Jerusalem are preparing a critical edition of these precious documents) these Vesoul registers promise to be of great value for the history of the Burgundian society and the functioning of its financial institutions. Even in their present state their contribution to the history of pawnbroking is of great value, despite their previous impressionistic treatment by scholars. Thus, several luxurious items are registered alongside cheap clothing or kitchen utensils; a set of knightly armor is also recorded. As in Sicily, here, too, animals served as sureties. However, it is not possible to offer any quantitative assessments or to express numerically the relative importance of any of these objects to the sum total of the consortium's activities.

Fortunately, however, students are not dependent on these two Hebrew registers when they are trying to engage in quantification and to work out more precisely the ways in which business was carried on in late medieval Burgundy. To begin with, the archives of the region kept the inventories of moneylenders who had passed away during the Black Death epidemic, or who were expelled from the county as a result of this catastrophe.[22] However, a most exciting discovery in the Franche-Comté archives in Dijon consists of an inventory of the contents of a premise

[21] On the account books of Vesoul, see n. 14, above.

[22] See Holtmann, *Juden in der Grafschaft Burgund*, 192, 235, 280.

belonging to a Jew named Joseph of Saint-Mihiel. He was one of those
who were expelled from France in 1394, in what today is labeled there
the "Final Expulsion."[23] The document (Archives de la Côte-d'Or BII-
356/1), a register of ten folios, enumerates 813 items. They include, first,
luxurious and semiluxurious objects: 14 gold rings and sticks, 16 silver
spoons, 31 silver belts, 14 silver purses, 4 silver plates, and 7 knives and
pins. These were all kept in a room where 10 Christian devotional items
("objects of piety") were also stored. These "sumptuous" pledges repre-
sent almost 12 percent of the holdings. The other 727 pledges—the vast
majority—consisted of more simple objects: 120 sheets, 258 drapes and
clothing, 339 everyday home dishes. These numbers are almost in exact
agreement with the ones obtained by Annegert Holtmann from the analy-
sis of the above mentioned post1348 Burgundian inventories, where lux-
ury items had an even smaller place. Forty-eight percent of the inventory
consists of all sorts of kitchenware, and 34 percent textile items in the
form of linen, maps, and towels. Clothing represents 10 percent of the
items, while working tools represent 4 percent. Less than 5 percent is left
for anything that could be considered luxurious.[24] The Burgundian evi-
dence shows that even humble, unassuming moneylenders may have oc-
casionally, but rarely, had access to the magnificence of precious objects.

The scarcity of the sumptuous and the predominance of the ordinary
and inexpensive should not come as a surprise. The present chapter
started with the assumption that most Jews of the High and Late Middle
Ages dealt principally with people of modest means who could bring only
pledges that reflected their place in society. Textiles in all forms and
shapes (worth more than they would be today) often changed hands,
even if neither party was excited about this. In Florence such items repre-
sented over 75 percent of the pawns accepted by the bank Ai Quattro
Pavoni. This predominance is also demonstrated in a Navarrais docu-
ment dated December 2, 1406, and published by the historian Béatrice
Leroy.[25] The property of a deceased Jewish lady named Duena, an inhab-
itant of Estella, is inventoried there in great detail. The royal officers who

[23] Roger Kohn, *Les Juifs de la France du Nord dans la seconde moitié du XIVe siècle*
(Louvain, Belgium, 1988), 137–39, 149; and Roger Kohn, "Fortunes et genres de vie des
Juifs de Dijon à la fin du XIVe siècle," *Annales de Bourgogne* 54 (1982): 177–80.

[24] Holtmann, *Juden in Grafschaft Burgund*, 234–35.

[25] See Béatrice Leroy, "Recherches sur les Juifs de Navarre à la fin du Moyen Âge,"
Revue des études juives 140 (1981): 319–432, esp. 417–21. Leroy discovered the document
in the archives of the kingdom of Navarra, which are as copious with information about the
Jews as are those of Sicily. A multivolume series, Navarra Judaica (ten volumes to date), is
being published by Juan Carrasco Perez and his disciples. Thousands of objects held by Jews
(or robbed from them) are mentioned in these documents. See for example, vol. 1, *Los
Judíos del Reino de Navarra* (Pamplona, Spain, 1994), 435–36, for precious stones and met-
als, and 446–65 for textiles and dresses.

prepared the list claimed not to have found any metallic objects—either expensive or of little value—among her possessions. The rabbinic library she left behind must have been a family asset. While a quantity of sheets, towels, napkins, and cushions is recorded without any specification, clothing is described in minute detail. Information about the color, state of preservation, and place of fabrication of each item is provided. The inventory starts with a *jacqueta*, a long coat of somber coloring, then continues with a *cudela*, a textile twill, and then with a habit with an Arabic-sounding name—*ayuba* or *aljuba*. The distinction is also made between clothing for men (e.g., *una jaqueta para hombre, una ropa para hombre*) and thirty-one out of a total of ninety habits for women (e.g., *gardacos para mujer, una manto bermeillo para mujer*). The fact that these were all pledges and not items constituting part of Duena's private wardrobe can be confirmed, if necessary, by the fact that ninety-nine headscarves for women were also found in her premises. The inventory also mentions the habits of "friars," one black tunic and one white (*un abito nero de freyre, una sia blanqueta para freyre*). This Navarrais inventory from 1406 also provides details about the origins of some of the textiles. Some were produced in Ypres in the Low Countries, others in Cuenca, Eastern Castile, and in Orange and (perhaps) in Fanjaux, both in the South of France. Some of the dresses are qualified as "Jewish." It is difficult to decide whether this is a reference to the biblical interdiction against mixing wool and flax or to the habits that Jews had been obliged to carry since the Fourth Lateran Council in 1215. These "Jewish" garments may have been given as collaterals by Jews who were borrowing money. Not having been redeemed, they may have entered the circuit of pawns and pledges and ended up in the premises of the lady of Estella.

The obligation to keep an eye on so many hundreds of items must have been quite confusing. Credence must be given to the claims mentioned earlier—of Samuel of Grasse and of Mossonus, both Jews of Manosque—that they simply forgot or did not have any clear idea about the provenance of objects in their premises. The layout of the aforementioned Joseph of Saint-Mihiel's dwelling testifies to his constant struggle to keep the arrangement of his pawns in order. His accommodation consisted of three halls, lower and upper rooms, a storeroom, and living quarters. The first hall contained the most valuable objects, while the other two stored the heavier and more voluminous ones. The textiles were laid out in the lower room, while the upper one contained kitchenware, plates, and dishes. The storeroom contained wine for private consumption while another room, which faced the street, served as the family's living quarters. Still, living amid these piles of objects must have been awkward if not

bewildering. Roger Kohn, who published Joseph's inventory, described the disarray that must have governed the pawnbroker's premises as "chaotic" (*capharnaum* in French).[26]

Generations of Jews must have found ways to cope with such bewildering numbers of objects. Yet an anonymous Italian coreligionist of the Late Middle Ages (or early modernity) found it worth his while to compose a Hebrew treatise that may be labeled "The Guide for the Pawnbroker." Of the five manuscripts in existence, the earliest (Jerusalem, Rabbi Kouk Institute, Ms. 513) has attached to it the seal of the Christian censor in the year 1611. Benjamin Richler, who listed these texts, has shown that one of the manuscripts of the anonymous tract was copied by Rabbi Elisah Elhanan Pontremoli (1778–1851) to his relative, a certain Zacharias Puglese.[27] The anonymous author, who indulged in a burlesque in the concluding pages of his treatise, is quite serious when describing the tasks a "shop owner" had to accomplish when running his enterprise. The economics of the business are dealt with first, while instructions concerning the storage of the objects follow. Identifying labels, for example, should be attached to each and every pawned item. As it is taken for granted that certain items risk deterioration, instructions for proper maintenance are provided. The shop, to quote another piece of practical advice, will surely attract mice. The author recommends therefore the presence of a cat on the premises.

———————

Most of the moneylenders mentioned in this section did not belong to the higher echelons of Jewish financiers. And yet, luxury objects of some quality—many of which we are to see in the next two chapters—were not absolutely beyond their reach. Even in Manosque, where we started our itinerary, there is evidence to this effect. To quote a rare example, in December 1295 Moses Anglicus and his wife appeared in court to defend a collection of items in their possession worth ten pounds. As might be expected, it consisted of some damaged textiles and a pair of boots, but a silk girdle embroidered with gold leaf was included as well. What drove the value of the property even higher was a gold ring with a sapphire

[26] Roger Kohn, "Fortunes et genres de vie," 180. An example of a pawnbroker who did keep an orderly book in which all his operations were recorded is that of a certain Jacob Levita, who listed 161 pawns that passed through his shop between November 16, 1552 and July 1555. See Shlomo Simonsohn, *The Jews in the Duchy of Milan*, vol. 2, *1477–1566* (Jerusalem, 1982), 1280, doc. no. 293.

[27] Roth, "The Book of Regulation." See also Benjamin Richler, "Regulation between a Lender and Borrower Attributed to Zacharias Puglese," in Abraham David (ed.), *From the Collections of the Institute of Microfilmed Hebrew Manuscripts* (Jerusalem, 1995), 102 (in Hebrew).

stone (56H959, 98v; 21.2.1305). Five years later the same couple found themselves in a similar quandary. On this occasion, objects estimated at a value of fourteen pounds included a silver crown as well as clothing embroidered with silver (56H957, 59r–61r; 9.11.1300). Members of another family, whose head was called Caracausa, also held a silver crown as collateral. In this case it served as a security for a loan of ten pounds (56H959, 98v; 21.1.1305). Further research in these archives will reveal more such items, but the net will have to be thrown far and wide.

Chapter Two

SECURITY FOR LOANS

Church Liturgical Objects

The emerging credit economy in the High Middle Ages required solid as-surance and at times collaterals of great value. Church property comes immediately to mind, since most artistic creativity was commissioned by ecclesiastics and religious institutions, right up to the High Renaissance period and even beyond. In many cases Jewish and Christian financiers about to strike a deal would look at sacred objects and assess their value before reaching an agreement. Needless to say, ire and unhappiness occurred in both camps, but the necessities of life had the upper hand, and protesting voices were calmed.

Books in manuscript form often served as collateral for loans. Many of them were expensive, and moneylenders were quite prepared to accept them as surety for loans. Notarized agreements sealed in the south of France even reveal the titles of manuscripts that changed hands as part of financial transactions. In the archives of Manosque, for instance, there is a contract from around mid-September 1291(56H954, 62v.o; 13.9.1291) in which Johannes Boneti, a jurist, handed over a small collection of legal

Parts of this chapter were included in a paper I presented at the Historisches Kolleg of Munich in June 2005. See Michael Toch (ed.), *Wirtschaftsgeschichte der mittelalterlichen Juden* (Munich, 2008), 93–102. I thank Oldenbourg Verlag, Munich, for permission to use these materials.

manuscripts to a Florentine moneylender as security for a loan of six pounds.[1] The list included classics of the *Corpus juris civilis*—namely, the "old" and "new" digests (but not, it would seem, the *Infortiatum*), as well as the two codices of Theodosius and Justinianus. The *Institutes* of Justinian also formed part of the deal. In addition, the jurist handed over two tracts concerning feudal jurisprudence, one a summa authored by Jean Blanost in 1256 known as the *Summa super feudis et homagiis* and the other a treatise referred to as *Usus feodorum*, which was probably the *Summa super usibus feodorum* written by the Marseille *advocatus* Jean Blanc around 1259. (In the 1260s, incidentally, Jean Blanc spent some years in Manosque as a political refugee.)

Some thirty years later a notary of Marseille helped to conclude a similar transaction. This time a book known then as the *Volumen* (*quondam librum legalem vocatum volumen*) was redeemed by its owner, who paid his creditor the sum of close to 115 shillings (six pounds). In medieval jurisprudence the *Volumen* referred to a codex in which a series of ninety-six new laws (*Novellae*) of Justinian's legislation, the last three books of his *Code*, and the above-mentioned *Institutes* were all bound together.[2]

Of course, Jews saw no harm in accepting books of the technical *Corpus juris civilis*. They went even a step further and were ready to extend loans that were secured by codes of church legislation. Examples of this may be found in the archives of Marseille and Montpellier. For instance, in April 1394, Senhoret of Lunel had in his possession in Marseille a copy of the *Decretales*, the well-known collection of papal letters and instructions assembled and issued in the year 1234 by Pope Gregory IX. Senhoret also held a copy of the statutes of the city. The value of the *Decretales* was then assessed as worth no less than twenty-five florins. One hundred years earlier a copy of the *Decretales* had also been in the hands of Jewish moneylenders in the university city of Montpellier. Two brothers, Jacob and Vives, who carried the name of the neighboring locality Nosserian, had in their possession a copy that belonged to the judge Pontius de Sancto Romano, and a second copy that belonged to a student

[1] For the identifications of these books and treatises, see Gérard Giordanengo, *Le droit féodal dans les pays de droit écrit: l'exemple de la Provence et du Dauphiné, XIIe–début XIVe siècle* (Rome, 1988), 141, 146; and Gérard Giordanengo, "Les feudistes (XIIe–XIVes)," in Aquilino Iglesia Ferreriós (ed.), *El dret comu: Catalunya, Actes del IIon simposi internacional, Barcelona 31 Maig–1 Juny del 1991* (Barcelona, 1991), 67–139, esp. 109, 112–13. About the "Digest," see Lynn Thorndike, *University Records and Life in the Middle Ages* (New York, 1994), 66n1.

[2] See the Archives Départementales des Bouches-du-Rhône, Marseille, 381E23, fols. 67v–68r. For the identification of the "Volumen," see James A. Brundage, *Medieval Canon Law* (London, 1995), 202, 204.

named Guillelmus Arnaudi. While Pontius recovered his pledge when the redemption date arrived, the young student appears to have been unable to do so.[3]

The archives of several municipalities in Umbria reveal exciting information relating to the movement of books, which can be found in Ariel Toaff's three-volume collection *The Jews in Umbria* (Leiden, Netherlands, 1993–94).[4] Document number 1117, for example, shows a student of the University of Perugia selling "a book" to a Jew by the name of Abramo, son of Ventura, in May 1449, while twenty years later (doc. no. 1360) a student at the same university had to hand over two books as collateral in order to get a loan of six golden ducates from Musetto, son of Moses of Bevagna. Document number 1144, of June 1450, deals with a treatise by the famous mid-fourteenth-century jurisconsult Bartolo de Sassoferato, adding that the book was richly illuminated. In June 1446 (doc. no. 1081) Bartolo's commentary on the *Old Digesta* was redeemed by the Bishop of Frigento in the district of Avelino. A similar act of retrieval took place in Umbria nineteen years earlier (doc. no. 1003).

The holding of a book occasionally created unpleasant complications. Document number 124 of Toaff's Umbrian collection reports that a Jewish pawnbroker of Assisi by the name of Vitale, son of Mele, was charged in 1334 with illegally holding a legal codex. The same Jew (doc. no. 119) was held responsible in the same year for the fact that the condition of a codex of the *Decretales* deteriorated while the manuscript was in his possession. Document number 69 describes the concerns of Abramo, son of Vitale, who obtained a Bible from an Umbrian ecclesiastical institution in October of 1308. He asked for assurances that if a church court annulled the transaction he would get his money back. This may have been a case where exceptional precautions were taken, as other Jews did not shy away from receiving sacred objects as pledges (as we shall see), and certainly not "Christian books." Indeed, sacred Christian books held by English Jews of the thirteenth century are mentioned in inventories from the south of the island, as will be discussed in chapter 3. Salomon of Hammerstein and Salum of Chippenham each kept no less than fifty-four

[3] I learned about the Marseille "Decretales" in Juliette Sibon, "Les Juifs de Marseille au XIVe siècle," vol. 2 (PhD diss., Université Paris X Nanterre, 2006), 862. Sibon recently published a book by the same title (Paris, 2011), reworking volume 1 of her dissertation; in the present study I rely on volume 2 of the unpublished dissertation, and as such, references are to that version rather than Sibon's new (and remarkable) book. The Marseille document is to be found in the departmental archives in register 3B122 fol. 204r; the Montpellier records are in that city's municipal archives, register BB1, fols. 35v, 89r. For the brothers Jaco and Vivas of Nosserian, see Salomon Kahn, "Documents inédits sur les Juifs de Montpellier au Moyen Âge," *Revue des études juives* 22 (1891): 264–79, esp. 277–78.

[4] Toaff calendared many of his documents and gave numbers to all of them. In the following pages I shall refer to these numbers in parentheses.

Latin books as pawns. While none of these 108 is actually named, this is not the case with Salum of Wilton; he kept three volumes of the *Decretales*, three Psalters, two Books of Hours, and one Bible, all "Christian."

———

We may safely assume that most Jews did not read Latin at that time. In order to identify these books and avoid confusion they would in many instances write a short note on one of the pages of the book in Hebrew, identifying it and adding information about its owner and about the conditions under which the transaction took place. Recent research has led to an amazing discovery of this practice: dozens of the books that were placed in Jewish hands as pledges, among them "sacred" ones, still exist in some European libraries. Cambridge University, for example, has a Gospel of Matthew and Mark that may originally have been the property of the Augustinian friars of Canterbury. It has a short, three-line Hebrew inscription in it, no doubt written by the moneylender himself. The complicated script suggests that it served as a pawn, was redeemed, and then given as a pledge once more. Line number 1, deciphered by Cecil Roth, reads in translation, "Four shillings on this [add, probably, 'as well as'] on two rings and a [holy?] (one word is not decipherable) to Adam de Sangis of Monigham. On line number 2 we have, "[Hugh?] of Canterbury on this and on [Markus?]." Line number 3 states, "Half a mark on this and on other epistles [probably, 'Gospels'] on Mark, on the warranty of Adam of Sangis." I have added the word "warranty" (Hebrew: *be-aharaiut*) to Roth's deciphering but was unable to do better with the rest of the inscription.

Another manuscript, which can be seen today in the Austrian National Library in Vienna (Cod. Ser. Nov. 2701) is a "giant Bible" that is known in Austria as the Admonter Bible and in Hungary as the Gutkeled Bible. It was copied and illuminated in Salzburg for the Csatar monastery in Veszprem, Hungary. Sometime before the year 1263 it was handed over to a Jew of Burgenland named Farkas (Farcasius) as a pledge. A Latin inscription on the manuscript itself specifies the arrangements for the redemption of the book by its owners that both sides agreed to follow.[5]

A much greater number of Latin books with similar short Hebrew inscriptions can be seen in the Libraries of France. Colette Sirat, who discovered these treasures, published just a mere fraction (ninety-eight items) of her findings. As in the case of the Cambridge Gospel of Mat-

[5] Cecil Roth, "Pledging a Book in Medieval England," in *Studies in Books and Booklore* (London, 1972), 36–41. For the Admonter Riesenbibel, see Eveline Brugger and Birgit Wiedl, *Regesten zur Geschichte der Juden in Österreich im Mittelalter*, vol. 1 (Innsbruck, Austria, 2005), 55–58; and Hans Wagner, *Urkundenbuch des Burgenlandes*, vol. 1 (Graz, Austria, 1955), 282.

thew, the short Hebrew notes are often difficult to understand, but, on the other hand, most of the Latin books are readily identifiable. Sirat's discoveries are breathtaking. An early-thirteenth-century copy of the *Historia Scholastica* by Petrus Comestor has a Latin (not Hebrew!) note that reads, "I Radulfus owe Vivant the Jew eight pounds less four shillings. . . . That is for principal and interest." Folio 162 of this manuscript has a Hebrew note, almost certainly written by Vivant. Another manuscript marked with a note in Hebrew and including the texts of the Acts of the Apostles, the Apocalypse, and parts of the Bible is presently in the Bibliothèque Mazarine, also in Paris. Even more exciting, if possible, is a manuscript of 142 folios containing the prophecies of Hildegard von Bingen that was copied no later than the year 1323. Plutarch's *De viris illustris* has on folio 168 an inscription in a typical Provençal Hebrew cursive script that reads, "Six of Plutarch's illustrious men."

Although the Parisian project is not yet completed, Sirat has already drawn some conclusions that are pertinent to the present discussion about external influences on the books created by medieval Jews and why they have so much in common with the works of non-Jewish artisans. The fact that Jews had access to Latin books, even if temporarily, may explain the ways in which their fabrication techniques evolved. This explains the architecture of the pages, the density of the black letters, and the choice of what is known as the Gothic style of writing. The Latin books left a most enduring impression on the Jewish books of the period. In the words of Sirat, "The traditional Hebrew text acquired the mantle of the Latin book."[6]

Some of the leading rabbinic authorities of the time, like their Christian counterparts, were unhappy about this state of affairs. R. Jacob Tam

[6] See Colette Sirat, "Notes sur la circulation de livres entre Juifs et Chrétiens au Moyen Âge," in Donatella Nebbiai-Dalla Guarda and Jean-François Genest (eds.), *Du copiste au collectionneur: Mélanges d'histoire des textes et des bibliothèques en l'honneur d'André Vernet*, Bibliologia 18 (Turnhout, Belgium, 1999), 383–403. See also Colette Sirat, "En vision globale: les Juifs médiévaux et les livres latins," in Pierre Lardet (ed.), *La tradition vive: Mélanges d'histoire des textes en l'honneur de Louis Holtz*, Bibliologia 20 (Turnhout, Belgium, 2003), 19–23; and Colette Sirat, "Le livre hébreu: rencontre de la tradition juive et de l'esthétique française," in Gilbert Dahan, Gerard Nahan, and Elie Nicholas (eds.), *Rashi et la culture juive en France du Nord au Moyen Âge* (Paris, 1997), 243–59, and esp. 248 for the quotation "Le texte hébreu traditionnel a pris la robe du livre latin." Four similar inscriptions were discovered by Judith Olszowy-Schlanger in the collegiate church of Saint-Étienne in Troyes (Champagne). See Judith Olszowy-Schlanger, "Juifs et Chrétiens à Troyes au Moyen Âge: la pratique du prêt sur gages à travers les manuscrits de Saint-Étienne," *Rachi de Troyes, La vie en Champagne*, May 2009, 44–49.

(Rabbenu Tam, d. 1171), the leader of the Jews of northern France, issued decrees forbidding dealings ("purchasing" is the term he used) in "Prayer books of the Church,"[7] while the German Pietists (the Hasidim of Ashkenaz) tried to curb the practice by preaching about the right course of action. In Sefer Hasidim, a collection of more than two thousand exempla compiled around the year 1200, a Christian book was labeled a Sefer passul, which may be understood as a "disqualified" book or perhaps as one tainted by idolatry (*pessel* = "statue" = idol).[8] The German Hasidim knew, for example, about a Jew who sinfully accepted "Christian books" as collateral. When his son looked for a way to sell them to a priest, he was punished by Heaven. On another occasion, a person who inherited an unredeemed Sefer passul did not wish to make any profit by selling the book. Rather than do so, "he burned it" (exempla nos. 1350–51). As far as these pietists were concerned, dealing with any articles relating to the Christian religion—not just books—was to be forbidden. Exemplum number 1349 states clearly that "most persons who deal with priests do not stay rich to the end of their days." The reason? "Because they [the Jews] provide them [the priests] with articles for [the practice of their] idolatry." The pious narrator then tells the story of a Jew "who lent money on pawns (like) crosses and other objects of cult." Upon his death another Jew who knew where the objects were hidden refused to disclose their whereabouts to the heirs for fear that they "will go ahead and sell them to priests and monks." This righteous man added that should he disclose the information he would find himself in a state of sin. Another Jew who used to sell to priests ornaments and decorations for their churches was, in the Hasidim's opinion, sinful. Divine retribution did indeed strike him upon his death and he was subjected to a shameful humiliation on the occasion of his burial (exemplum no. 1359).

While these pious exempla did not offer more than moral guidance, the decrees issued by Rabbenu Tam's synods some fifty years earlier were expected to impose binding rules of behavior. The dignitaries who assembled in these synods did not raise any theological reasons for the prohibition, but they did express concerns about safety and harm. They warned Jews "not to accept church vessels as pledges for debt" and "not to buy a chalice or the cross or holy vestments or prayer books of a church or its vessels." More severely they warned "not to buy a stolen chalice or cross or holy vestments . . . because of the peril" and "not to

[7] See Louis Finkelstein, *Jewish Self-Government in the Middle Ages*, 2nd ed. (New York, 1964), 188.

[8] Jehuda Wistinetzki (ed.), *Das Buch der Frommen (Sefer Hasidim)*, 2nd ed. (Frankfurt am Main, 1924; in Hebrew). In the following pages, references will be provided in parentheses for the numbers of the exempla referred to in this publication.

buy stolen things such as images ... or vessels of worship, because of the danger."[9]

───────────

Christian theologians and canon lawyers quite naturally also expressed serious reservations in the face of this turn of events. In all probability they did not mind that the classics of civil jurisprudence changed hands as part of financial transactions. But the use of articles pertaining to Christian cult and liturgy as collaterals raised their ire. They considered having missals, Gospels, Psalters, or the Book of Revelation in Jewish premises unacceptable and even humiliating. Around the year 1140, Peter of Cluny "The Venerable," one of the two major Christian spokesmen of his time, expressed his anger in explosive rhetoric: "The sacred vessels are held captive among them ... as in olden time other sacred vessels were held captive among the Chaldeans, (and) suffer shame even though they are inanimate. Indeed Christ feels the Jewish abuse in the insensate vessels sacred to him." The Abbot of Cluny then shared with his flock some alarming information: "I have often heard from truthful men ... [that the Jews] direct such wickedness against those celestial vessels as is horrifying to think and detestable to say."[10] The listeners had to work out for themselves what this allusion was all about. A slightly more explicit account of such "horrors" is given by the monk Rigord (d. c. 1207), the biographer of Philip Augustus King of France (1165–1223). According to Rigord, the expulsion of the Jews from the royal domain in 1182 was the result of the severe "atrocities" they had committed. As the chronicler related in chapter 12 of his biography, "As the culmination of their [the Jews'] wickedness, certain ecclesiastical vessels, consecrated to God, the chalices and crosses of gold and silver bearing the image of our Lord Jesus Christ crucified—had been pledged to the Jews by way of security. . . . These they used so vilely in their impunity and scorn of the Christian religion that from the cups in which the body and blood of our Lord Jesus Christ was consecrated they gave their children cakes soaked with wine (*infantes eorum offas in vino factas comedebant*)."[11] A much more

───────────

[9] For the three first quotations see Finkelstein, *Jewish Self-Government*, 188–89, 201. Finkelstein's rendering of these paragraphs into English has the character of an interpretation rather than a close translation. The Hebrew original employs coarse language; see Finkelstein, *Jewish Self-Government*, 178, 195, 211.

[10] Quoted as translated in Robert Chazan, *Medieval Stereotypes and Modern Antisemitism* (Berkeley, 1997), 52; see also 38, 53, 60.

[11] See Elisabeth Carpentier, Georges Pon, and Yves Chauvin (eds. and trans.), *Rigord, Histoire de Philippe Auguste* (Paris, 2006), 146–49. The translation offered herein is that of Jacob R. Marcus, *The Jew in the Medieval World: A Source Book, 315–1791* (New York, 1938), 26.

repulsive allegation had been in circulation for centuries. The subject of this story was an unnamed Jew of Constantinople who managed to steal an image of the Virgin Mary, threw it into the privy, and then desecrated it shamefully. Rigord also knew this story, which he describes in chapter 13 of his book. He knew that the defiled objects also included a gold cross adorned with gems, a book of the Gospels (*Liber Evangeliorum*) beautifully decorated with gold and precious stones as well as "silver cups and other vases." The Marian story caught the imagination of King Alfonso "The Wise" of Castile (1221–84), who included it in his *Cantigas* (no. 34). Contemporary illuminators and glass painters used their brushes and colors to spread the allegation further.[12] It is not impossible at all that Peter the Venerable already had this story in mind.

In their synods and councils, the ecclesiastical prelates legislated in the same vein. The assembly convened in Paris by Odo of Sully (fl. 1197–1208) decreed, "No cleric ... shall ... pledge to a Jew in any manner books or ornaments of a church."[13] In 1278, the prelates attending a convention in Trier established that the clergy "shall never let out of their possession any of the church ornaments, nor shall they dare to give up to Jews any religious article without special permission from us."[14] In 1229 the Bishop of Worcester, England, forbade Jews "to receive ecclesiastical books, vestments or other ornaments as pledges or for any other reason," threatening them with "excision from all intercourse with Christians."[15] Other thirteenth-century assemblies repeated these interdictions.[16] The papacy, too, made its voice heard. Pope Innocent III (c. 1160–1216), no friend of the Jews, proclaims that they "perform detestable and unheard-of things against the Catholic faith." In a letter of January 16, 1205, addressed to King Philip Augustus, the pope complained that "they appro-

[12] Alexandre Laborde, *Les miracles de Nostre Dame, compilés par Jehan Mielot* (Paris, 1929), 102 and plate xi. The legend itself has indeed a Byzantine origin and had been known already in the seventh century, as I have learned from Peter Schäfer, *Mirror of His Beauty: Feminine Images of God from the Bible to the Early Kabbalah* (Princeton, NJ, 2002), 191–97. For an English translation of Cantiga number 34, see Kathleen Kulp-Hill, *Songs of Holy Mary of Alfonso the Wise* (Tempe, AZ, 2000), 45. For a painting of the incident, see also Kulp-Hill, *Songs of Holy Mary*, panel no 2. In Aragon of the 1320s a series of laws forbade Jews to deal in Christian books, images, and other symbols. See Yom Tov Assis, *Jewish Economy in the Medieval Crown of Aragon 1213–1327* (Leiden, Netherlands, 1997), 85.

[13] See Solomon Grayzel, *The Church and the Jews in the XIIIth Century*, vol. 1, rev. ed. (New York, 1966), 300–301.

[14] Ibid., 318–19. The dating of this synod is controversial. For the date 1278 I am relying on the judgment of my friend Alfred Haverkamp of Trier University.

[15] Grayzel, *The Church and the Jews in the XIIIth Century*, 320–21.

[16] Salomon Grayzel, *The Church and the Jews in the XIIIth Century*, vol. 2, ed. Kenneth R. Stow (New York, 1989), 278, 280.

priate ecclesiastical goods and Christian possessions."[17] A papal bull
issued by Alexander IV on August 23, 1258, is even more clearly worded.
Writing about his expectation that the clergy would show reverence to
the "vestments of their ministry [and to] the sacred ornaments, the chal-
ices, and the ecclesiastical vessels" he did not hide his disappointment:
"We heard and we speak of it not without bitterness of heart that some
clergy make no distinction between the sacred and the profane and they
dare leave such vestments, ornaments and vessels as loan-pledges with
Jews." Alexander then repeated what had become a commonly held opin-
ion in these circles, that the Jews were desecrating these objects: "And
they, the Jews, like ingrate enemies of the cross and the Christian faith . . .
treat these pledges with irreverence, to the disgrace of the Christian reli-
gion. And [they] act so nefariously towards them as is shameful to speak
and horrible to hear."[18]

The bark of the rhetoric heard in the two camps was more frightening
than its bite. Most Jews seem to have turned a deaf ear to it, even if some
faint voices that emerged from their camp may have been related to R.
Jacob Tam's legislation. For instance, in thirteenth-century England,
Christian church robbers were unable to pledge their booty of two chal-
ices "because no Jew wants to receive them or to lend money against
them."[19] In Zurich in 1272, a thief had to face a similar handicap when
no Jew was ready to receive a chalice worth seventy marks.[20] In both in-
stances, however, the Jews' refusal may have been motivated by particu-
lar or local circumstances that are not accounted for in the sources. This
is not the message found in a third document, written in Hebrew, prob-
ably around this time. It is an *aide-mémoire* written on the back of a
book in which an anonymous Jew records the special conditions he
should put forward to the authorities of a place before agreeing to settle
there. Today the document is kept in the library of the city of Bern in
Switzerland, and it is not impossible that the man intended to establish
himself in this region. Particularly worried about the rules concerning
pledges and collaterals, he reminds himself in this precious and short
memorandum that he should ask the local authorities for permission to
receive whatever pawns may come his way "with the exception of vessels

[17] Grayzel, *The Church and the Jews*, vol. 1, 106–7, 114–15.
[18] Grayzel, *The Church and the Jews*, vol. 2, 62–64. See also Shlomo Simonsohn, *The Apostolic See and the Jews*, vol. 1, *Documents: 492–1404* (Toronto, 1988), 214–15.
[19] See Zefira Entin Rokeah, "Crime and Jews in Late Thirteenth Century England: Some Cases and Comments," *Hebrew Union College Annual* 55 (1984): 95–157, esp. 136n132.
[20] See Gerd Mentgen, *Studien zur Geschichte der Juden im mittelalterlichen Elsaß* (Hannover, Germany, 1995), 441.

of the church, because of the danger." This is probably the only Hebrew retort we have of Rabbenu Tam's synod's decree.[21]

More than that: not all scholars shared Rabbenu Tam's fears. The leader of the Rhine communities, Rabbi Eliezer ben Nathan of Mainz (Ra'avan) (c. 1090–1170), who maintained cordial relations with his great French colleague, did not raise any concerns about "peril" or "danger." He certainly did not share the theological sensibilities of the German Hasidim; in his opinion the Christians of his day were not by any means to be treated as inveterate idolaters. In this he was following the teaching of the great Gershom "Glory of the Diaspora" (c. 960–1028), the founder of German Jewish rabbinic tradition. Ra'avan also maintained that Christians did not make much of their Holy Days and that when they visited the church they did so for enjoyment, not out of devotional commitment. Christians should simply be considered as followers of their own ancestral traditions, he noted. In consequence, Jews could sell clerical vestments and coats (*dosales*) to priests, as these objects possessed no holiness in themselves and were used by the clerics for their personal needs. And, "the same way one [i.e., a Jew] is permitted to sell he is allowed to extend loans against securities of priestly vessels and 'dosales' for the same reason I have mentioned," said the rabbi. He concludes, "As well, one may extend loans against the security of [churches'] vessels as they are there for the priests to drink from while praying." Still, there were limits to Ra'avan's flexibility: like other contemporary authorities he had to make case-by-case decisions. Thus he decided that incense (Hebrew: *levonah*), statues, icons, and censer bearers were in the domain of the forbidden.[22]

Eliezer ben Nathan was perfectly aware of the particular political and social conditions under which Jews had to conduct their economic activities. He realized that at times there existed "a glaring contradiction . . . between [rabbinic] jurisprudence and reality of circumstances" (the language is that of the well-known social historian Jacob Katz).[23] Ra'avan's

[21] This short and precious document was published in Ben-Zion Dinur, *Israel in the Diaspora*, vol. B.1 (Tel Aviv, 1964), 278–79 (in Hebrew). The manuscript is kept in the Burgenbibliothek in the city of Bern, Switzerland; call number Ms 200, fol. 2586.

[22] See Eliezer bar Nathan, *Sefer Ra'avan, That Is the Book of Evan ha-Ezer* (Jerusalem, 1984) responsa nos. 288–89 (in Hebrew). See also Shlomo Eidelberg (ed.), *The Responsa of Rabbenu Gershom Meor Hagolah* (New York, 1955), no. 21 (in Hebrew).

[23] Jacob Katz, *Exclusiveness and Tolerance: Studies in Jewish Christian Relations in Medieval and Modern Times* (New York, 1969), 24–36; Ephraim E. Urbach, "Rabbi Menahem Ha Meiri's Theory of Tolerance: Its Origins and Limits" in Immanuel Etkes and Yosef Salmon (eds.), *Studies in the History of the Jewish Society in the Middle Ages and in the Modern Period Presented to Professor Jacob Katz on His Seventy-fifth Birthday* (Jerusalem, 1980), 34–44 (in Hebrew). See also Israel Ta-Shma, "Judeo-Christian Commerce on Sundays in Medieval Germany and Provence," *Tarbiz* 47 (1978): 197-215 (in Hebrew).

responsibility was to find a way that would enable Jews to gain a liveli-
hood in the Christian environment. He had to find ways to temper the
tone of the (Jewish) critics and to provide a less offensive image of Chris-
tianity. In this he was followed by his grandson Rabbi Eliezer ben Joel
ha-Levi, known by the name Ra'avyah (c. 1140–1225), who in his turn
also became a master of Halakha (Jewish law). Ra'avyah did not develop
any systematic teaching in this respect, but his short statements are clear
and unequivocal. Like his famous grandfather, whom he quoted fre-
quently, his views were rooted in an old Talmudic statement (Hulin 13b),
according to which, "Gentiles of our times are not to be considered idol
worshippers."[24] He shared with his grandfather the observation that
Christians were not exceedingly devoted to the practices of their religion.
For these reasons, to give one example, Jews could mention without hesi-
tation the names of Christian saints. In former times, he reasoned, idola-
try attained the status of divinity, while in his time Christian saints had
common human names. There was therefore nothing wrong in pronounc-
ing them.[25] Even the crosses that gentiles wore around their necks were
no more than ornaments. Indeed, none of the Christian figures engraved
on gold and silver were to be considered as sacred; they were there only
for their beauty. Like his grandfather, Ra'avyah also regarded the clergy's
robes as bereft of any sanctity; the priests wore them for the sake of ele-
gance when meeting princes and kings. Indeed, he maintained, secular
rulers considered these costumes as decorations and hung them on the
walls of their castles.[26]

Even Rabbenu Tam's nephew, Isaac of Dampierre (known as Ri;
c. 1120–85) distanced himself from his uncle's rulings. He did not follow
the teaching of the German Hasidim in this matter either, although he
was sympathetic to their other doctrines. Ri distinguished between things

[24] See David Deblitzki (ed.), *Sefer Ra'avyah: Hu Avi ha-Ezri le-Masechet Avodah Zara*
(Bnei Brak, Israel, 1976), 22–27 (in Hebrew). See also Katz, *Exclusiveness and Tolerance*,
33; and David Berger, "Religion, Nationalism and Historiography: Yehezkel Kaufman's Ac-
count of Early Christianity," in Leo Landman (ed.), *Scholars and Scholarship: The Interac-
tion between Judaism and Other Cultures* (New York, 1990), 149–68, esp. 152.
[25] I refer here to the Halakhic compendium by Mordechai ben Hillel (d. 1298). See his
commentary on the chapter "Lifnei Eidenhem" (Before their Festivities) in the tract Avodah
Zarah (Idolatry). The manuscript of *Sefer ha-Mordechai* I have consulted is kept today in
the Thomas Fisher Rare Books Library, University of Toronto (MSS.5-011), and was previ-
ously part of the David Salomon Sassoon collection, Ms. no. 534. See *"Ohel David": De-
scriptive Catalogue of the Hebrew and Samaritan Manuscripts in the Sassoon Library, Lon-
don,* 2 vols. (Oxford, 1932). In this manuscript the reference to the *Ra'avyah* is on 231, col.
B. In the "Mordechai" that accompanies the Vilnius "Rom" edition of the Babylonian Tal-
mud, the text can be found in section no. 809.
[26] See Eliezer bar Nathan, *Sefer Ra'avan.*

that belonged to the heart of Christianity and items that were no more than paraphernalia. Thus, for example, the stubs of wax candles put away by a priest became a legitimate object of commerce for a Jew. The same was true, he said, for loaves of bread: people brought them for personal consumption by the clergy and no Christian would consider them as a sacrifice to God. Priestly vestments carried no holiness and were no more than ornaments (Hebrew: *noy*). Jews could buy and sell them and use them as collateral without hesitation. Ri even went a step further: Jews might handle chalices, since to his knowledge these did not form a part of Christian rituals. However, like Eliezer ben Nathan, Ri thought that censer bearers should be excluded, as they were genuine articles of Christian worship.[27]

Ecclesiastics of all levels were handing over sacred articles to moneylenders. Abundant evidence of this can be found in documents from almost all regions of the medieval West. The data assembled from English sources is of a relatively early age. Thus, one of the pipe rolls from the reign of King Henry II (fl. 1152–89) reveals that Santo, a Jew of Edmundsburry, held "vessels appointed for the service of the altar," while in 1170, Benedict, a Jew of Norwich, held similar articles in his possession left as collateral by Nigel, Bishop of Ely.[28] Bishop Chesney of Lincoln (fl. 1143–66) pledged church ornaments with the magnate Aaron of Lincoln, the wealthiest Jew of the twelfth century, who conducted many transactions with ecclesiastic institutions of his time.[29] Some exciting information is available about the pledges given by William Waterville, the Abbot of Peterborough (c. 1155–75). The abbot pledged the relics of St. Oswald while his Bishop handed over "to a certain Jew of Cambridge" the gold crucifix of King Edgar (r. 959–75). The hagiography, which is the source of this piece of

[27] See Isaac's commentary to the tract Avodah Zarah (Idolatry) of the Babylonian Talmud in the printed edition, in particular fol. 50b. On Isaac, see Ephraim E. Urbach, *The Tosaphists: Their History, Writings and Methods*, vol. 1 (Jerusalem, 1980), 226–60 (in Hebrew); and José Faur, "The Legal Thinking of the Tossafot, an Historical Approach," *Dine Israel* 6 (1975), English section, xliii–lxxii, esp. lxviii. On the sympathetic attitude of other French Tosaphists to doctrines and practices held and performed by the pietists of Ashkenaz, see Ephraim Kanarfogel, *"Peering through the Lattices": Mystical, Magical and Pietistic Dimensions in the Tosaphist Period* (Detroit, MI, 2000), esp. 191–95, where the thinking of Isaac of Dampierre is discussed.

[28] For Sancto the Jew of Edmundbury, see Joseph Jacobs, *The Jews of Angevin England* (London, 1893), 83. For Benedict of Norwich, see H. P. Stokes, *Studies in Anglo-Jewish History* (Edinburgh, 1913), 124.

[29] J.W.F. Hill, *Medieval Lincoln* (Cambridge, 1948), 218. Aaron's involvement in the building of churches will be discussed further in the present chapter.

information, then tells the story of a miracle the crucifix produced when it was in Jewish possession. [30]

The English clergy were not exceptional in this respect, as evidence from Germanic lands shows. In 1213, Bishop Lutold of Basel had to redeem his ring and a silk robe reimbursing the Jew Meir six marks. Ten years later the entire treasury of the church was given as a pledge. Farther north, in Bamberg, sometime before 1257, to give yet another example, a Jew by the name of Joseph received an assortment of vessels of a monastery—including, notably, a book bound with gold (*liber aureum*)—as sureties. In 1272–73, a ministral of St. Gallen handed over a chalice to a Zurich Jew, while in 1295 in Bern some books, including an antiphonary, changed hands. In 1275 the famous monastery of St. Emmeran in Regensburg deposited a gold censer bearer, a silver lamp, a liturgical book and two sacramental gowns into the hands of a Jew. Also in southern Germany in 1344, Bishop Nicolaus of Constance pledged his clothes and probably a precious silver vessel and used the money for charity. A most uncertain piece of information concerns the Verdun Altar (a tourist attraction today) in Klosterneuburg Abbey in Lower Austria, close to Vienna. A sixteenth-century chronicle notes that after a disaster caused by a fire in 1329, the abbot Stephan of Sierndorf was forced to hand over to a Jew, presumably against a loan, the very famous enameled biblical panels attached to the altar. These panels, the work of the famous French artist Nicholas of Verdun, were created in 1181 and considered one of the greatest achievements of pre-Gothic art. Even though the chronicle reporting this event is not dependable and its dates are certainly truncated, the fact that sacred objects were given as pledges is not impossible in itself. The abbot would simply have been doing the same as other prelates both before and after him.[31]

[30] See Joe Hillaby, "The London Jewry: William I to John," *Transactions of the Jewish Historical Society of England* 33 (1992–94), 1–44, esp. 9; see also Stokes, *Studies*, 124–25.

[31] For the pledges of the Swiss clergy see Zvi Avneri (ed.), *Germania Judaica*, vol. 2.1 (Tübingen, Germany, 1968), 52; and Augusta Steinberg, *Studien zur Geschichte der Juden in der Schweiz während des Mittelalters* (Zurich, 1902), 76. For the "Golden Book" of Bamberg, see Julius Aronius, *Regesten zur Geschichte der Juden im fränkischen und deutschen Reiche bis zum Jahre 1273* (1902; reprinted Hildesheim, Germany, 1970), 264–65, doc. no. 629. For the St. Emmeran monastery's pawns, see Siegfried Wittmer, *Jüdisches Leben in Regensburg vom frühen Mittelalter bis 1519* (Regensburg, Germany, 2001), 68. On bishop Nicolaus of Constance see Phlipp Ruppert (ed.), *Die Chroniken der Stadt Konstanz* (Konstanz, Germany, 1891), 44–45. See also Floridud Rohring, *Der Verduner Altar* (Vienna, 1955). The text of the alleged Klosterneuburger "transaction" and its analysis are presented in Brugger and Wiedl, *Regesten zur Geschichte der Juden in Osterreich im Mittelalter*, 284–85. Jörg Müller recently assembled considerable evidence from Germanic lands pertaining to the subject in his "Zur Verfändung sakraler Kultgegenstände an Juden in mittelalterchen Reich," *Trier Historiche Forschungen* 68 (2012): 179–204. Jörg Müller,

As already noted, the archives of the province of Umbria contain dozens of documents dealing with pawnbroking. As we might expect, we find there information about Jews being custodians of Christian sacred articles. A record from the year 1304, for example, describes a canon of the Church of Santa Maria della Pieve in Cascia giving an embossed silver chalice to a local Jew.[32] The most detailed list was drawn up in March 1385 (no. 363), when the city of Assisi asked for a loan of the considerable amount of 1,200 florins. The Jew Anselmo and his associates evidently demanded securities corresponding in value to the sum they were to risk, and the leaders of the commune persuaded the Church of St. Francis to provide them with a great number of sacred articles. The list included twenty-one objects, most of them made of silver, and weighing a total of sixty-three pounds. Among the liturgical vessels the church lent to the municipality, of particular interest are two statues of the Virgin Mary, one of which weighed ten pounds and the other more than five. There were also two silver censers (*thuribules*), a pedestal for a standing cross, and four silver candelabra. Six silver chalices were accompanied by a gold one weighing almost four pounds. Embroidery also formed part of the deal: one piece, decorated with pearls, served as a cover for Mary's altar. Two other tapestries had gold embroidered on them, one in the form of a griffin. There was also a priest's robe of red cloth decorated on each side with a cross made out of pearls. Finally, the Jewish moneylenders of Assisi kept an object that belonged to the Franciscan pope Nicholas the Fourth (1288–92) as a pledge—a cape for wet weather decorated with pearls. Considering the importance of these articles, it was no surprise that the Church of St. Francis insisted that they must all be returned to its treasury within two months.

Church vessels and "Christian books" also served as pawns in Alsace, Savoy, and Burgundy, all regions that form part of present-day France. In the town of Rosheim in Alsace the pledges made in 1215 included, besides books and church vessels, a gilded cross that belonged to the Benedictine abbey of St. Leonard.[33] In 1390, a Jew of Mainz received a Bishop's miter among other articles from the chapter of the cathedral.[34] In 1404, Josson Aaron of Chambery in Savoy had in his possession a richly

Christoph Cluse, Gerd Mentgen, and other disciples of Professor Alfred Haverkamp in Trier offered me much support and saved me from many errors. I thank them wholeheartedly.

[32] See Toaff, *The Jews in Umbria*, doc. no. 50. In the following pages I shall use parentheses around the numbers of the calendared documents in this book.

[33] Mentgen, *Juden im mittelalterlichen Elsaß*, 31. The court registers of Naples for the beginning of the year 1470 show the Jew Isach di Salam da Campobasso in possession of two crosses, each lavishly decorated. See Filena Patroni Griffi, *Banchieri e gioielli alla corte aragonese di Napoli* (Napoli, 1992), 21.

[34] See Mentgen, *Juden im mittelalterlichen Elsaß*, 480–81.

decorated gold reliquary with bells attached to it.[35] But it is the region of
Burgundy that deserves special consideration in this context. The inventory of Joseph of Saint Mihiel of Dijon, mentioned in chapter 1, included
a Christian book (*I livre escript en loy crestienne*). The partners of Vesoul
received, among other pledges, two cups, a goblet, and a crown—"all
silver."[36] However, anticipation reaches a particularly high level when we
consider the possibility that none other than the famous Abbey of Cluny
was indebted to Jews as early as the mid-twelfth century. Present-day
historians debate whether this indebtedness really existed and whether
Cluny's most famous abbot, Peter the Venerable, actually redeemed holy
articles from his Jewish creditors. The late Georges Duby answered both
questions in the affirmative and it seems that there is enough evidence to
support his opinion.[37] Peter's indignation over the fact that monks borrowed from Jews can be easily discerned from words he put into the
mouth of another admired abbot, the then already deceased Matthew of
Albano: "What agreement could there be between Christ and Belial?"
exclaimed Matthew (though in reality probably Peter). He called on the
friars of SaintMartin des Champs to settle their debts and then sever their
commerce with the enemy of Christ "and his sweet Mother."[38] Matthew's
sermon, which might have been delivered in 1117, certainly reflects Cluny's situation in 1144, when Peter wrote of it as part of his treatise *About
Miracles*. By that date, and in fact since 1125, the Abbey's finances were
in trouble because of a reduction in external contributions that was coupled with irresponsible expenditures and an increase in the price of agricultural products.[39] Having no other way out, Peter turned for help to
Jews in the neighboring city of Mâcon and handed over the gold plaques

[35] Thomas Bardelle, *Juden in einem Transit und Brückenland: Studien zur Geschichte
der Juden in Savoyen-Piemont bis zum Ende der Herrschaft Amadeus VII* (Hannover, Germany, 1998), 185–86. Bardelle (181–83, 187) describes Josson and another Jew by the
name of Bonion as "specialists in precious stones" who were working with ducal houses.
[36] See Roger Kohn, "Fortune et genres de vie des Juifs de Dijon à la fin du XIVe siècle,"
Annales de Bourgogne 44 (1982): 171–92, esp. 187, 191. For Vesoul, see Isidore Loeb,
"Deux livres de commerce du XIVe siècle," *Revue des études juives* 8 (1884): 161–96; and
9 (1884): 22–50, 187–213.
[37] See Georges Duby, *La société aux XIe et XIIe siècles dans la région mâconnaise* (Paris,
1971), 310–11, 369; and Georges Duby, "Le budget de l'abbaye de Cluny entre 1080 et
1155. Économie domaniale et économie monétaire," in *Hommes et structures du Moyen
Âge* (Paris, 1973), 61–101 (published originally in *Annales E.S.C.* [1952]: 155–71). Dominique Iogna-Prat did not endorse Duby's conclusions in his *Ordonner et exclure: Cluny et
la société Chrétienne face à l'hérésie, au judaïsme et à l'Islam* (Paris, 1998), 276, 429n23.
[38] See Jean Pierre Torrel, "Les Juifs dans l'œuvre de Pierre le Vénérable," *Cahiers de civilisation médiévale* 30 (1987): 331–46.
[39] See Duby, "Le budget de l'abbaye de Cluny." Duby also remarked that on later occasions when the Abbey sought loans, Peter dealt more readily with Christian financiers than
with "the enemies of the Cross."

that covered the abbey's crucifix. In the year 1135 he thanked the Bishop of Winchester, Henry of Blois, an ardent supporter of the abbey, for (in his words) returning to Christ his "vestments, which the Jews of our time did spoil." A younger contemporary of Henry of Blois, Prince Geoffrey, son of King Henry II of England, redeemed a minster plate some forty years later (in 1173) that the above mentioned Aaron of Lincoln got as a pledge from Bishop Chesney. He was ready to invest no less than three hundred pounds in this demonstration of Christian piety.[40]

A recovery of sacred objects is recorded also in a document from the end of May 1313 from southern Germany. Its subject was the Ottakar Cross, a magnificent piece of art ordered by King Ottakar the Second of Bohemia some time between 1261 and 1278. It was also a reliquary, as it allegedly housed a fragment of the cross from Christ's crucifixion. And yet, just a few years after its creation it was used to secure a loan extended by a powerful financier of Prague, Nikolaus of Turri, a Christian. This man then passed the cross to a Jew in Regensburg with whom he must have maintained business relations. When the prelate Nikolaus of Ybbs (1313–40) became bishop of the city he considered it his most urgent task to redeem the sacred object. He reasoned that to leave it in the possession of the Jews would cause derision and injury to the Lord Jesus Christ (*in subsannationem et opprobrium domini Jesu Christi*). The bishop was successful in his pursuit. Today the cross is exhibited in the museum of the Cathedral of Regensburg.[41]

Four illustrations in painted codices from the High Middle Ages help us to visualize the danger that the Jewish documents tried to convey. They are illuminated manuscripts of the well-known law book *The Saxon Mirror* (*Sachsenspiegel*; composed c. 1220–25). The paragraph they illustrate reads, "If a Jew buys or accepts in pawn chalices, books or priest-clothing, for which he has no warrantor, and if it is found in his possession, he shall be tried as a thief." Three of these four illustrations date from the fourteenth century and describe a trial concerning a chalice found in the possession of a Jew. Today, one of these codices is kept in the library of the University of Heidelberg (Cod. Pal. Germ. 164, fol. 13v). The other three are in Saxony. One is in the State Library in Dresden (Ms. Dres. M. 32.)

[40] See Giles Constable, *The Letters of Peter the Venerable* (Cambridge, 1976), vol. 1, 136–37, letter no. 56. For the recovery of the minster plate of Lincoln, see Robin R. Mundill, *The King's Jews: Money Massacre and Exodus in Medieval England* (London, 2010), 25.

[41] See Wittmer, *Jüdisches Leben in Regensburg*, 69–70; see especially Achim Hubel, *Der Regensburger Domschatz* (Munich, 1976), 18, 170–75, and figs. X and XI in the appendix.

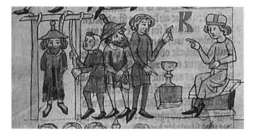

FIGURE 1. The trial and execution
of a Jewish pawnbroker portrayed
in the early-thirteenth-century Ger-
man law book the *Sachsenspiegel*.
This illustration can be found in
four codices in German libraries.
Herzog August Library,
Wolfenbuttel, Germany. Cod. Guelf.
3.1 Aug.2, folio 43v.

and another in the Herzog August collection in Wolfenbüttel, Lower Sax-
ony (Cod. Guelf. 3.1.Aug). The illustrations of the Wolfenbuttel (see fig.
1) and Dresden codices (fols. 43v and 36v, respectively) are probably
copies of the same model, or imitate one another.[42] On the right side of
each folio the judge is seated and the denouncer stands. In the middle of
the illustration we see a table on which the holy object (the chalice) is
placed. On the left can be seen the executioner and the hanged Jew. The
fourth codex of the illustrated *Sachsenspiegel* is found at the State Li-
brary of Oldenburg in Lower Saxony (Cim I 410), dated 1336, but is in-
complete. Only 12 of its 135 folios are fully colored. They are followed,
as of folio 21, by dozens of rough drafts, and after folio 88 there are no
illustrations whatsoever. The work of the illuminator seems to have been
abandoned in the middle or even close to the beginning. Folio 66r, in
which the trial is taking place, shows the judge on the left and the hanged
Jew on the right. The faces of the participants are blank. The lines of the
drawing, however, are clear and strong. We notice that the Jew's hands,
while he is still alive, are cuffed and that the chalice in question stands not
in the center but rather on a small box, as if it was included in the picture
at the last moment. The message the painting wished to convey, like the
three previous ones, was that a Jew would not escape the horrific verdict
of the court. The worries raised in Rabbi Tam's synods are now better
understood.

An additional five illustrated pieces that concern sacred Christian ob-
jects in Jewish hands are all of Catalan origin. The message of the first of
the five, the most interesting one, is not easy to interpret. It is part of the
richly decorated manuscript of the *Feudal Customs of Aragon*, known
also as the *Vidal Mayor*, a legal treatise compiled between 1247 and 1252
by the Bishop of Huesca and possibly decorated by a certain Michael
Lupi Candiu. Today it is the property of the Getty Museum in Malibu,

[42] See Maria Dobozy (trans.), *The Saxon Mirror: A Sachsenspiegel of the Fourteenth
Century* (Philadelphia, 1999), 118. On Jews in the Sachsenspiegel, see Christine Magin,
*"Wie es umb der iuden recht stet": Der Status der Juden in den mittelalterlichen deutschen
Rechtsbüchern* (Göttingen, Germany, 1999), 50–55.

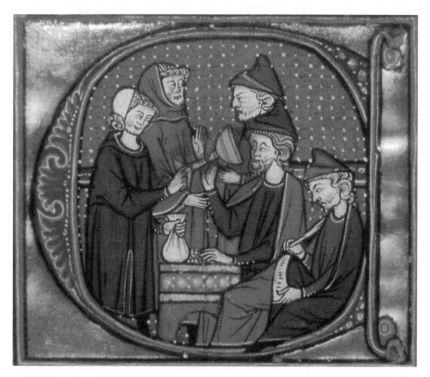

FIGURE 2. The money market: activity in a pawnbroker's shop in Catalonia. Illumination in the *The Feudal Customs of Aragon* (composed at the second half of the thirteenth century).

The J. Paul Getty Museum, Los Angeles. Ms. Ludwig XIV6, fol. 114. Artist: possibly Michael Lupi de Candiu; Title: *Vidal Mayor*; Date: about 1290–1310; Size: leaf 36.5 x 24 cm; Medium: Tempera colors, gold leaf, and ink on parchment.

California (call number 83.MQ; Ms. Ludwig XIV-6). Among the 156 miniatures painted by Michael, five deal with the exchange of items of gold. Most relevant to the present discussion is that of folio 114v, which illustrates a transaction between two entering Christians and three Jews(see fig. 2).[43] A gilded goblet and a small sack of money change hands; a Christian layman, accompanied by a cleric, still holds the two items in his hands. The other three persons, all Jews, are seated. Two of the three seem to be running the shop while the third, busy recording the transaction, is obviously a professional scribe. The scribe receives all the attention from the original compilers of the code. According to them the min-

[43] See Diputación Provincial Instituto de Estudis Altoaragoneses de Huesca, *Vidal Mayor* (facsimile ed.), 2 vols. (Madrid, 1989). The gilded items are to be found on folios 21v, 114r, 175v, 180r, and 243v.

iature is intended to indicate that a shop's scribe must always be of the same religion as its owners. A distinguished medievalist, Father Robert Ignatius Burns of Los Angeles, looked at the painting with different eyes. For him the two Jews are simply in the process of selling the gilded goblet to the two Christians.[44] As I see it, the layperson is actually receiving, not giving away, the sack of coins. Looking closely at his hands we notice that he holds the sack in his right fist, which is firmly closed, while he has lost almost all contact with the chalice; in fact, he directs the object with the forefinger of his left hand toward the Jews. Thus our illustration shows a layman obtaining a loan in return for collateral, a gilded goblet (chalice). In doing so he is probably acting on behalf of the clergyman who stands beside him and whose presence in the scene would otherwise have been unnecessary. The illumination may refer therefore to the prevailing church legislation according to which a cleric should never act in person in defiance of ecclesiastical councils' interdictions. A cleric could however circumvent the ruling by employing a layperson as a "straw man."

Much agitation marks the second piece of this small portfolio.[45] It comes from a Hebrew manuscript dating from the first quarter of the fourteenth century. Known as the Golden Haggadah, it is of Catalan origin and is today in the British Library, London (Add. Ms. 27210). On the lower left side corner of folio 13r, a miniature (H: 2.5 cm; W: 5 cm.) tells the story of the first stage of the Jewish exodus from Egypt, once Pharaoh had finally agreed to let them go (see fig. 3). "The children of Israel," states the Bible, "asked of the Egyptians jewels of silver and jewels of gold and garments: and the Lord gave the people favor in the sight of the Egyptians so that they gave them such things as they required. And they despoiled Egypt" (Exod. 12.35–36). As its caption confirms, this despoiling is the subject of the miniature. The event takes place in a treasury of a church. Four Israelites are present; one of them is adolescent, and other two are engaged in the act of plundering. The open doors of a cupboard reveal articles that the two adult Israelites are about to grab, while the youngster already holds what appears to be a sack of coins. The cupboard's articles include a chalice, a ciborium (eucharistic container), and a small plate (a paten). Unrelated to these sacred articles is a long box that a third, bearded, man is carrying on his back without (it would seem) much difficulty. It is in all probability Moses, carrying Joseph's bones, "for he (Joseph) had laid an oath on the children of Israel saying . . . you

[44] Robert I. Burns, S.J., *Jews in the Notarial Culture: Latinate Wills in Mediterranean Spain 1250–1350* (Berkeley, 1966), ii.

[45] See Bezalel Narkiss (ed.), *The Golden Haggadah* (London, 1997), 45, fig. 28. Julie A. Harris discussed this miniature in her "Polemical Images in the Golden Haggadah (British Library, ADD. Ms. 27210)," *Medieval Encounters* 8 (2002): 105–22. Harris's interest in the illumination is different from mine, as her study lies in the history of polemics.

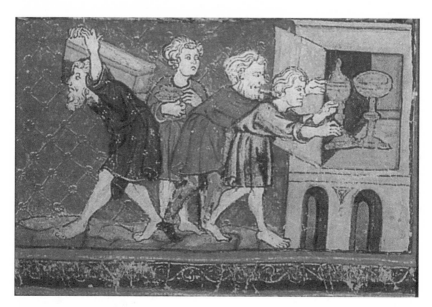

FIGURE 3. Israelites looting Egypt on the eve of the exodus. Illustration from a Spanish
Codex of c. 1320 known as the Golden Haggadah.
 The British Library Board. Ms. Add. 27210, fol. 13r. The illustrations follow the
biblical verses from Exodus (12:35–36) and also an ancient rabbinic legend in the
Mekhilta According to Rabbi Ishmael ("*Beshallaḥ*," chap. 1.)

shall carry up my bones away from here with you" (Exod. 13:19). The
Jewish ancient sages maintained that while all the people were busy plun-
dering, Moses fulfilled Joseph's wish.
 The third visual piece, another Hebrew Haggadah, is also a mid-
fourteenth-century Catalan work of art (Manchester, John Rylands Li-
brary, Ms. 6). In contrast to the previous illustration, this one shows the
peaceful way in which the Israelites got their "spoil." On folio 18r they
are still in the land of the Nile, receiving the gifts (obviously church ob-
jects) handed to them amicably by the Egyptians (see fig. 4). Then, on
folios 18v and 19r in their march to the desert, several persons have in
their hands the sacred objects already mentioned. The forth document, in
the Kaufmann Haggadah (Budapest, Hungarian Academy of Sciences,
Ms. 422, fol. 4r) also shows the Israelites on their way out of Egypt in an
orderly manner, carrying the vessels of silver and gold. The fifth illustra-
tion (British Library, Or. Ms. 1404) is also a Hebrew Catalonian manu-
script of the fourteenth century, and conveys a different dynamic alto-
gether. It is also known as the "brother" of the John Rylands Haggadah
because of the resemblance between them. The items that the Israelites of
this panel (fol. 6v) appear to share among themselves are indeed the same

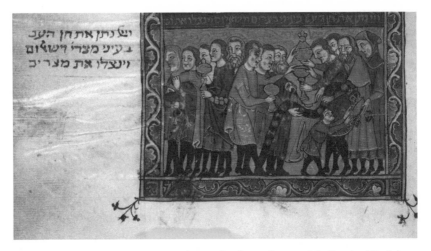

FIGURE 4. Egyptians presenting Israelites with gifts on the eve of the Exodus. The John Rayland Haggadah, fourteenth century. John Rayland Library, Manchester, England, Ms. 6, fol. 18r.

Gutmann, Joseph. *Hebrew Manuscript Painting*. Reprinted with permission from George Braziller, Inc.

church objects seen in the previous illustrations, but, unexpectedly, the ambience is altogether different. The outstanding feature of this scene is disarray, unexpected among "brothers."[46]

It is my opinion that the painter who decorated the Golden Haggadah was a Christian. But even if he was not, a description of an interior of a church treasury would not necessarily have been beyond the reach of a medieval Jew; Jews of these centuries were often not strangers to the edifices of their rival religion. Evidence of such familiarity with the interior of churches comes first and foremost from England. In the twelfth century, the abbot of Bury St. Edmunds was reproached because "under the protection of the sacristan [the Jews] enjoyed not only free entry and exit to the monastery but walked around in it, wandering by the altar and around the effigies while solemn Mass was being celebrated."[47] The reason for such indiscretions had to do with the prevailing custom of the time, by which people stored valuables objects and business records in

[46] In 1988, a facsimile edition under the title *The Rylands Haggadah: A Medieval Sephardi Masterpiece in Facsimile: An Illuminated Passover Compendium from Mid-14th-century Catalonia in the Collection of the John Rylands University Library in Manchester, with a Commentary and a Cycle of Poems* was published by Raphael Loewe in London. For the panel of the Brother Haggadah, see Sarit Shalev-Eyni, "The Antecedents of the Padua Bible and Its Parallels in Spain," *Arte medievale*, n.s., 4 (2005): 86, fig. 4.

[47] Grayzel, *The Church and the Jews*, vol. 1, 35n76.

ecclesiastic buildings for safekeeping. Bonds belonging to Jews that had been deposited in the Minster of York during the years that preceded the month of March 1190 were destroyed by the mob during the well-known massacre. In Bury St. Edmunds, the abbot continues, "their money was deposited in our treasury under the care of the sacristan, and [Jews] and their wives and children were hiding with us in time of War."[48] In 1222, unhappiness with this state of affairs drove the church council of Oxford to forbid Jews from entering their churches and in particular from storing goods there. "Jews shall not in future presume in any way to enter churches" decreed the council, led by Archbishop Stephan Langton. "And lest they have an excuse for entering, we strictly forbid any properties of theirs to be stored in churches." Later thirteenth-century diocesan synods repeated these interdictions, while in 1253 King Henry III made it the law of the land.[49]

England, the "Land of the Island" as some Hebrew sources called it, was not the only region where such activities took place. The moralists of the Sefer Hasidim refer to such practices in several of their exempla in order, of course, to dissuade the faithful in Germany from following the same path. They tell a story about a Jew "who entered the court of a church. He heard a heavenly voice [Hebrew: *Bat Kol*] admonishing him, quoting 2 Kings 14:9 'And me they threw behind.' The man subjected himself to doing penance for the rest of his life" (no. 1357). Another Jew who regretted having taken the same course accepted the instruction of a "sage" to mortify himself yearly, on the anniversary of the day he committed the transgression (no. 1358). In another example, the pious writers related the case of an indebted cleric who took refuge in a church, knowing very well that his creditor, a pious Jew, would not follow him (no. 1362). Another virtuous man made it a point never to enter a church. Deservedly, miracles happened on the day of his interment (no. 1356). Still, the pious authors instructed their followers that when in real danger of death one should not indulge in excessive righteousness: A Jew who exclaimed "I shall not enter this house" when compelled to do so by gentiles should have given in and saved his life (no. 1032). These last exem-

[48] Ibid., 35.

[49] For York in 1190, see R. B. Dobson, *The Jews of Medieval York and the Massacre of March 1190*, Borthwick Papers 45 (York, England, 1974), 28. See also Zefira Entin Rokeah, "The Jews as Church Robbers and Host Desecrators of Norwich (ca. 1285)," *Revue des études juives* 141 (1982): 331–62, esp. 333–34. I refer to the canons of 1222 and to Henry's "Provisions" of 1253 as published by F. M. Powicke and C. R. Cheyney, *Councils and Synods with other Documents Relating to the English Church*, vol. 2.1 (Oxford, 1964), 106–25 (esp. 121), and 472–74 (esp. 473, canon no. 10), respectively. The translation of the canon of 1222 is in J. A. Watt, "The English Episcopate, the State and the Jews: The Evidence of the Thirteenth-century Conciliar Decrees," in P. R. Coss and S. D. Lloyd, *Thirteenth Century England*, vol. 2 (Woodbridge, England, 1988), 137–47, esp. 141.

pla lead us to the conclusion that in German Jewish society around the year 1200, entering the churches was part of daily practice for some Jews but constituted a religious challenge for others. In any event, England was not the only region where Jews were familiar with the interiors of churches. We have yet to discover whether such practices existed in Catalonia, where the Golden Haggadah was painted.

To conclude, medieval Jews had more close and direct contact with churches and other Christian institutions than their modern descendents. Some of them entered almost daily to the buildings of the "rival religion." Others kept in their own premises objects considered sacred by the members of the governing society. Christian authorities were furious about this state of affairs, which they considered humiliating. For the Jewish pietist movement in Germany this commerce in Christian objects of cult constituted Jewish support of idolatry. But the marketplace had its own needs and demands, which meant that both Jews and Christians ignored, on the whole, the orders of their religious leaders. While we do not find a Christian thinker who mitigated the ire of the prelates, some Jewish rabbis did so, insisting that Christianity should not be considered idolatry, that the objects were not considered sacred even by its adherents and that the commitment Christians had to their religion was quite superficial. Whether they really believed this must be left unanswered. What counts is the fact that this way of thinking permitted Jews to deal with objects considered sacred by members of the "rival religion." This had been one of the venues through which Christian craftsmanship penetrated the Jewish world. It sounds paradoxical, but it is true that Christian holy objects must have taught medieval Jews about contemporary craftsmanship and about what was considered to be beautiful. This was, so to say, a "religious channel of transmission." However, a nonreligious one existed as well, as we shall see in chapter 3, and it was no less important.

Chapter Three

HIGH FINANCE

Urban and Princely Pledges

Monks and priests, monasteries and cathedrals were not the only ones to turn to Jews when in need of credit. Citizens of the flourishing urban centers, even the well off, found themselves in a similar quandary. The same was the case for members of the elite social circles, including nobles, counts, and even royalty. The findings relating to the activity of some of the very affluent Jewish businessmen and women, which will be presented in this chapter, expose extraordinary pledges. Dealing with princes and prelates, Jews were exposed to magnificent works of art.

The radiant Mediterranean metropolis of Marseille offers scholars a most interesting series of court registers. In examining court records from the second half of the fourteenth century, Juliette Sibon recently found more than a dozen cases of litigation concerning precious objects. Five of these are of particular interest because of the kind of precious objects to which they relate. In February 1363, a Jewish lady, Ginella of Nîmes, who was in disagreement with a certain Raymond Seguier and his wife Marthend, originally agreed to an out-of-court procedure. At issue was a necklace adorned with pearls and a silver ring. But as the arbitration did not succeed, the case was turned over to the municipal court. As in most other cases, the tribunal's judgment is unfortunately not known, but we do know the quality of the object that was in contention. Some thirty years later, in 1394–95, a necklace and eight silver rings were claimed by a certain Honorade, wife of Paulet Constantini. She demanded that the heiress of a Jewish lady named Blancheta should return the necklace and the rings together with two boxes full of silver marks, several rosaries

made of amber, and a crystal piece weighing around two ounces. Of particular interest is the third procedure that the court dealt with in December 1395, in which Jews were involved on both sides. Leon Passapayre handed over to physician Bondavin a set of twenty-four silver cups, each worth one florin, against a loan of twenty florins. For some reason, the physician's father-in-law, Anthol Samson, served as intermediary in the transaction. Leon Passapayre was willing to reimburse the twenty florins but the physician claimed thirty. Among other precious objects Sibon discovered in the documents were two silver crowns. The first belonged to a lady named Bertrande Manoel and was, in December 1378, held by Vidon Maymon. He refused to return the object until properly reimbursed. The litigation dragged on and was still unsolved almost twenty years later in 1396–97. The second crown was the property of a certain Stella Viguier, who had deposited it with Joseph Abon eight years earlier. This was not the first time she had confronted her creditor: years earlier a witness, a Jew named Massip Maurelli, had heard Joseph Abon saying to the lady that she should hand back the money and he would then return your pledge.[1]

References to luxurious objects that served as securities against substantial loans also appear among the many thousands of documents from the city of Frankfurt am Main. The documents were assembled by Isidore Kracauer in his two-volume *Urkundenbuch zur Geschichte der Juden in Frankfurt am Main von 1150-1400* (Frankfurt am Main, 1914). Like Jews elsewhere, the small number that were admitted to the city in the second half of the fourteenth century (after the annihilation of the community in 1349) dealt mostly with small loans that required cheap collateral like households textiles or used personal clothing. Medium-size sums were insured by silver belts, rings, or chains, at times of gilded silver. An astonishing number of items of body armor secured several of these loans. But members of the governing elite needed greater sums than thirty, fifty, or seventy gulden, so they turned to the richest woman of the city, the Jewess Zorline and her large extended family (she was married three times). One hundred and seventy three entries were made in a register of redeemed pawns and promissory loans that were returned to Christian clients from the year 1391 (Kracauer, vol. 1, pp. 162–77), more than forty of them related to Zorline's moneylending activities and to those of her son-in-law, Wolf. A variety of documents indicate that the premises of her family were replete with precious objects, many of them presumably of much beauty. The register of 1391 mentions that a squire (*Edelknecht*),

[1] See Juliette Sibon, "Les Juifs de Marseille au XIVe siècle," vol. 2 (PhD diss., Université Paris X Nanterre, 2006), 839 (on Ginella of Nîmes), 863 (on Honorad), 865 (on the two Jews), 850 (on the first crown) and 865 (on the second crown).

Chapter Three

HIGH FINANCE

Urban and Princely Pledges

Monks and priests, monasteries and cathedrals were not the only ones to turn to Jews when in need of credit. Citizens of the flourishing urban centers, even the well off, found themselves in a similar quandary. The same was the case for members of the elite social circles, including nobles, counts, and even royalty. The findings relating to the activity of some of the very affluent Jewish businessmen and women, which will be presented in this chapter, expose extraordinary pledges. Dealing with princes and prelates, Jews were exposed to magnificent works of art.

The radiant Mediterranean metropolis of Marseille offers scholars a most interesting series of court registers. In examining court records from the second half of the fourteenth century, Juliette Sibon recently found more than a dozen cases of litigation concerning precious objects. Five of these are of particular interest because of the kind of precious objects to which they relate. In February 1363, a Jewish lady, Ginella of Nîmes, who was in disagreement with a certain Raymond Seguier and his wife Marthend, originally agreed to an out-of-court procedure. At issue was a necklace adorned with pearls and a silver ring. But as the arbitration did not succeed, the case was turned over to the municipal court. As in most other cases, the tribunal's judgment is unfortunately not known, but we do know the quality of the object that was in contention. Some thirty years later, in 1394–95, a necklace and eight silver rings were claimed by a certain Honorade, wife of Paulet Constantini. She demanded that the heiress of a Jewish lady named Blancheta should return the necklace and the rings together with two boxes full of silver marks, several rosaries

made of amber, and a crystal piece weighing around two ounces. Of particular interest is the third procedure that the court dealt with in December 1395, in which Jews were involved on both sides. Leon Passapayre handed over to physician Bondavin a set of twenty-four silver cups, each worth one florin, against a loan of twenty florins. For some reason, the physician's father-in-law, Anthol Samson, served as intermediary in the transaction. Leon Passapayre was willing to reimburse the twenty florins but the physician claimed thirty. Among other precious objects Sibon discovered in the documents were two silver crowns. The first belonged to a lady named Bertrande Manoel and was, in December 1378, held by Vidon Maymon. He refused to return the object until properly reimbursed. The litigation dragged on and was still unsolved almost twenty years later in 1396–97. The second crown was the property of a certain Stella Viguier, who had deposited it with Joseph Abon eight years earlier. This was not the first time she had confronted her creditor: years earlier a witness, a Jew named Massip Maurelli, had heard Joseph Abon saying to the lady that she should hand back the money and he would then return your pledge.[1]

References to luxurious objects that served as securities against substantial loans also appear among the many thousands of documents from the city of Frankfurt am Main. The documents were assembled by Isidore Kracauer in his two-volume *Urkundenbuch zur Geschichte der Juden in Frankfurt am Main von 1150-1400* (Frankfurt am Main, 1914). Like Jews elsewhere, the small number that were admitted to the city in the second half of the fourteenth century (after the annihilation of the community in 1349) dealt mostly with small loans that required cheap collateral like households textiles or used personal clothing. Medium-size sums were insured by silver belts, rings, or chains, at times of gilded silver. An astonishing number of items of body armor secured several of these loans. But members of the governing elite needed greater sums than thirty, fifty, or seventy gulden, so they turned to the richest woman of the city, the Jewess Zorline and her large extended family (she was married three times). One hundred and seventy three entries were made in a register of redeemed pawns and promissory loans that were returned to Christian clients from the year 1391 (Kracauer, vol. 1, pp. 162–77), more than forty of them related to Zorline's moneylending activities and to those of her son-in-law, Wolf. A variety of documents indicate that the premises of her family were replete with precious objects, many of them presumably of much beauty. The register of 1391 mentions that a squire (*Edelknecht*),

[1] See Juliette Sibon, "Les Juifs de Marseille au XIVe siècle," vol. 2 (PhD diss., Université Paris X Nanterre, 2006), 839 (on Ginella of Nîmes), 863 (on Honorad), 865 (on the two Jews), 850 (on the first crown) and 865 (on the second crown).

Helmut of Cornberg, left in her keeping a gold crown, rings, and pearls, together with another crown and a number of silver cups, belts, and a bracelet. For his part Wolf received from a nun by the name of Gertrud of Reine two rosaries and a prayer book. A certain Henne Kuchmeister left in his trust five chains, three of them of silver with a silver cross hanging from each, and a silver belt.

Alongside the small and medium loans we find in the register of 1391 that Zorline extended loans of a much higher order of magnitude— namely of 200, 250, 450, and, in two cases, 600 florins. Most impressive is a loan of 1,000 florins that was made to Archbishop Adolf of Mainz on January 18, 1388, for a time span of two years (Kracauer, vol. 1, doc. no. 340, pp. 133–34). However, as Adolf died on February 6, 1390, it fell to his successor, Konrad of Weinsberg, to fulfill the promise of the agreement that was made between the parties. Pawns were not mentioned in this instance since, given the political importance of the borrower, a detailed promissory note seems to have been sufficient.

England offers us yet another example of middle and high finances. Its archives preserved an inventory, in two versions, of objects confiscated in Jewish homes of about some twenty families less than a generation before their expulsion from the island. These confiscations followed the traumatic and bloody events English Jews experienced around the year 1278. Moneylenders, mostly Jews, were accused at that time of counterfeiting and coin clipping. The justices showed no mercy toward those who were found guilty. In London dozens of Jews, perhaps close to three hundred, were executed. The total number of victims who went to the gallows may have exceeded four hundred.[2] As has been noted, the British archives preserve a document containing an inventory of many, but certainly not all of the objects that were found in the premises of about two dozen of the unfortunate pawnbrokers. These executed Jews lived in three midsize towns in the region of Wessex—namely Bristol, Devizes, and Winchester.[3] The document is preserved in two versions: the first registered the confiscated objects while the second anticipated their sale. This second version, however, enumerated objects that were not recorded in the first. On the

[2] The most recent discussion of these tragic episodes is that in Zefira Rokeah, "Money and the Hangman: Money Related to Transgressions Attributed to Jews and Christians in England at the Second Half of the 13th Century," in David S. Katz and Yosef Kaplan (eds.), *Exile and Return: Anglo-Jewry through the Ages* (Jerusalem, 1993), 27–46.

[3] The inventories were published in English translation by Michael Adler in his "Inventory of the Property of the Condemned Jews (1285)," in *Jewish Historical Society of England, Miscellanies*, part 2 (London, 1935), 56–71. For the "Principal" inventory, see 59–64.

other hand, the names of two Jews whose properties were recorded in
the first version have disappeared from the second. Their objects were
probably sold in the meantime. The only way to handle these two lists
is to work on both simultaneously. Doing this, we realize that some of
the fortunes belonged to people who were not engaged in cheap pawn-
broking, but in what can be described as high finance. Noticeable also is
that royal officials preferred to deal with the more expensive luxurious
objects. They did not wish to waste their time on trifles and were looking
only for valuable items. Hence textile items are almost entirely absent,
while precious metals and stones dominate.

Benedict of Winchester's property must have been very much to their
liking. He was by all accounts the richest Jew in the region. His mother,
Licoricia, was one of the wealthiest women of her time. She even con-
ducted business with the royal court of Henry III. In 1276 she kept as a
pledge a gold cup that belonged to the king of Scotland.[4] According to the
above mentioned second inventory, Benedict possessed 31 gold brooches,
134 gold rings, and 2 gold seals, as well as bars of gold. Silver objects are
inventoried next: they included 13 cups with feet, 9 flat cups, 1 goblet, 2
basins, and 196 spoons. Other silver objects include one pen with an ink
horn, a key, a brooch, 13 rings, a salt cellar with a cover, a girdle of silver
thread, and some broken silver. Benedict left behind 41 silver coins minted
in Tours and known as *Tournois*. Yet more was to come. In his house the
royal agents found 24 precious stones, some colored gems labeled "gar-
net," and 2 cups of Jasper, as well as 23 silk girdles and 9 girdles of
leather. Benedict, who was obviously a scholar, also possessed 49 books
"of the Laws of the Jews."

Women were quite active in the credit business, as we have just seen in
the examination of Zorline of Frankfurt, and Benedict's mother must have
been one of the richest persons in thirteenth-century England. Another
woman who figured in the inventory of confiscation, Henne de Perine,
seems to have been quite well off, although she did not control legendary
fortunes on the scale of Benedict's. While only two gold brooches were

[4] See Michael Adler, *Jews of Medieval England* (London, 1939), 39, 147–48; and H. P.
Stokes, "A Jewish Family in Oxford in the 13th Century," *Transactions of the Jewish His-
torical Society of England* 10 (1924): 193–206. See also Reva Berman Brown and Sean
McCartney, "David of Oxford and Licoricia of Winchester: Glimpses into a Jewish Family
in Thirteenth-Century England," *Jewish Historical Studies* 39 (2004): 1–34, esp. 22 (for the
gold cup of Scotland). See also Suzanne Bartlett, *Licoricia of Winchester: Marriage, Mother-
hood and Murder in the Medieval Anglo-Jewish Community*, ed. Patricia Skinner (London,
2009), esp. 67–69 (for Licoricia and England's royal court) as well as 15, 93–104 (for the
stature of Benedict in the Jewish community). See also William Chester Jordan, "Women
and Credit in the Middle Ages: Problems and Directions," *Journal of European Economic
History* 17(1988): 33–62.

discovered in her residence and no more than nine rings, the Crown's officials counted no less than seventy-three silver brooches together with sixty-six spoons, and some broken silver, as well as eight silk girdles and one of leather barred with silver.

Similar inventories regarding the property of twenty other Jews were also drawn up. The amount of credit they were able to extend is reflected in the quality of the pawns they requested as securities. Most of them contain gold and silver as well as silk and leather girdles with silver bars. In some instances the officials encountered unexpected objects. Sale of Wilton, for example, had three brass lamps while a certain Abraham was in possession of one pound of pearls. Mendaunot of Bristol, a well-to-do Jew, had, among other items, military tools that had been given to him as securities, in all probability by a certain Stephen Engayne. The equipment included two iron corselets, four pairs of iron chains, and one suit of iron armor.

Even if, presumably, they tried to avoid the recording of used textiles, the royal officials could not avoid taking account of some of these because they were quite valuable. From the property that belonged to the above-mentioned Mendaunat, they confiscated a carpet "of Rheimes" and two silk cushions. They found a larger number of textile items worth taking away from the home of Hake (probably Isaac) le Prester—namely, one crimson robe, one blue robe, one mantle, five napkins, and a trifold camelot.[5]

When in need of credit, members of the religious and secular princely class found a way to approach Jews involved in high finance. There were instances, however, in which written engagement was deemed to be insufficient—the very elevated status of the borrower notwithstanding—and the loans had to be secured by tangible collaterals of very precious objects. This is what the powerful Duke of Milan, Francesco Sforza, had to do in 1442 when he found himself in dire need of two thousand gold ducats.[6] With the help of two other Jews of Ancona, he made contact with a third Jew, Benedetto, son of Joseph, who was able to provide him with the sum, charging a rate of interest of 14 percent per year. Then, in a contract signed on May 27, 1442, he enumerated two long lists of luxurious pawned items, one a set of clothes and the other items of tableware. The first group consisted of seventeen garments typically worn by mem-

[5] A camelot was a thin textile generally made of camel hair. A product of the Middle East, it was much appreciated in Europe in the High Middle Ages.

[6] See Shlomo Simonsohn, *The Jews in the Duchy of Milan*, vol. 1, *1387–1477* (Jerusalem, 1982), 29–31, doc. no. 34; and 36, doc. no. 47.

bers of the princely class: eleven were jackets, three were gowns, and another three were overcoats (*zornea* in the Venetian language). All are described briefly in the inventory. The list started with a Jacket (*vestito*) of cream and silvered satin, covered with marten fur. Another item was a small robe (*mantellia*) of green silk and satin, also trimmed with marten fur. This robe came with its own case (*bramatura*) to keep it in, as did four other garments on the list. Not all the garments were trimmed with marten fur; one was trimmed with lynx, another with ermine. The three overcoats were no less splendid. The description of the first zornea reads as follows: "A crimson overcoat with silvery scales and bells, with green, white and red ribbons and fringes, covered with silk texture." Most of the other coats were also of creamy colored silk and covered with marten fur. But there were also, as we have just seen, garments in green and blue silk and two garments in mixed colors called *pavonazzo*—namely, that of a peacock.

So much for sartorial splendor. The thirty-nine items of tableware also must have been of very great elegance and exquisite beauty. Most of these objects, which were assembled in two boxes, were of silver and were elaborately decorated. There were nine basins, eight jugs, twelve cups, five bronze table bells, two mugs, two pitchers, and one vase. Many of the decorations were related to the extent of the Duke of Milan's political power. Two of the basins, for example, had the city of Vicenza's coat of arms, a white cross with beams surrounding it, engraved on them. Six of the cups showed the coat of arms of the city of Cremona, which was also under Sforza's rule. As a final example, one of the five bronze bells had a ball enameled in blue on its top and on its lower part the head of a serpent—a symbol of the Sforza's armory. All these details were recorded in order to facilitate identification of the objects when the time for retrieval arrived. In fact, the debt was repaid to Benedetto's heir about nine years later.

Even more astounding information about art and precious objects belonging to the princely class was culled by Renata Segre from the fourteenth-century registers of the county of Savoy.[7] In the year 1392, Count Amadeus VI and his wife Countess Bonne de Bourbon gave away figurines of a gold leopard and four gold flying deer as pledges. The meticulous description of the objects reveals that one of the four deer had a rear leg missing while another lacked a precious stone. A third deer was decorated with a ruby, a sapphire, and three large pearls, while the fourth had pearls between its horns and a sapphire stone attached to its body.

[7] See Renata Segre, "Testimonianze documentarie sugli ebrei negli Stati sabaudi (1297–1398)," *Michael* 4 (1976): 237–413.

The transaction, made with the Jews Boneonus de Parisius and Aymo de Aspermonte in 1392, also included a gold brooch with large pearls inserted in each of its four corners, and a ruby (*balays*) in its center (doc. no. 401). A year later the countess redeemed from the Jews Bonius and Aaron another golden brooch she had pledged three years earlier. This ornament had the image of the Virgin Mary in its center and was surrounded by four large rubies, a large sapphire and no fewer than nineteen pearls (nos. 271, 299). In 1380, also in Savoy, two Jews of Chambéry obtained a gold belt, over three marks in weight, together with two silver belts and three gold cups (*chapelleto*). One of the cups had eleven small emeralds attached to it and was surrounded by pearls. Another had five empty settings carved into it for five emeralds. The third cup seems to have been much more sumptuous; it originally had five rubies and eight emeralds, as well as four large sapphires surrounded by eight large pearls. One of the eight rubies and one of the emeralds were detached from their settings (no. 268). The Jews were no less keen to record these defects than the county treasurers were lest they be held responsible for the damage.

When pressed hard enough the Count of Savoy did not hesitate to use the duchy's crown as a pledge. He was not the first to do this; other European crowns also moved back and forth. More formidable princes than the Savoyard sometimes needed to separate themselves from the ultimate symbol of their authority. Thus, in 1440, the "Holy Crown of Hungary," imbued with sanctity, was handed over by Queen Elisabeth, then a widow in distress, to Emperor Frederic IV for a loan of 2,500 Hungarian florins. It was redeemed twenty-three years later by the famous Matheus Corvinus.[8] A generation earlier, in 1297, King Edward I of England had pledged the great crown of his realm to two Italian bankers.[9] In 1237, the holiest of the holy, the crown of thorns, was sold to St. Louis of France by his cousin Emperor Baldwin II, the crusader, who was then in Europe looking for support. Eleven years later the crown, together with other sacred relics (fragments of the true cross and the holy sponge) were located in the Sainte-Chapelle in Paris, where they remain to this day. Louis spent the unimaginable sum of 100,000 pounds, minted in the city of Tours, for this acquisition.[10]

Thus, Amadeus, the "Green Count of Savoy," was following an established pattern. A description of four crowns being handed over to Jews

[8] See Patrick J. Kelleher, *The Holy Crown of Hungary* (Rome, 1951), 500.

[9] See Winfried Reichert, "Lombarden als Finanziers Eduards I," in Dietrich Ebeling (ed.), *Landesgeschichte als multidisziplinäre Wissenschaft: Festgabe für Franz Irsigler zum 60. Geburtstag* (Trier, Germany, 2001), 89–96.

[10] *See* Jacques Le Goff, *Saint Louis* (Paris, 1996), 140–48. See also Daniel H. Weiss, *Art and Crusade in the Age of Saint Louis* (Cambridge, 1998), 5–6, and esp. 219 nn. 26–34.

appears in documents from the last quarter of the fourteenth century, an age, notes Ronald W. Lightbown, "when elegant fancifulness was preferred to rigid formality."[11] Indeed, the Savoy documents unearthed by Renata Segre provide many details about the magnificence of these crowns. A very detailed description is provided about a crown that was handed over to Simon Deneuvre of Strasbourg, known also as "Simon the Rich," in 1381 (doc. no. 286). It was, of course, made of gold, and encircled by eleven settings (*sedes*) with precious stones inserted. Five of the settings each contained three rubies and one sapphire. Each of the other six settings contained two large emeralds, two large rubies, and one large pearl. The crown was also surrounded by twelve other pearls. It had six large fleurons (fleurs-de-lis) and five small ones. Each of the large ones was embellished with four rubies, an equal number of emeralds, two diamonds and seven large pearls. The small fleurons should have been decorated with three rubies, two emeralds, and six pearls; however, this crown had suffered considerable damage: one of the small fleurons lacked a ruby, while only one of the five had the full number of six pearls. Another of the small fleurons had its upper part broken and had only three pearls, but was decorated with three, and not two, emeralds. The large fleurons were also damaged; in three of them, one diamond was missing. Finally, the scribe noticed the absence of one of the rubies in one of the settings mentioned above.

No such detailed information has been found for the other three crowns of Savoy, which were redeemed by the duke and his consort from the Jews Bonius and Aaron in 1383 (the manuscript reads "Haarum"; no. 299). Still, the records show that one of the three had on it forty-nine emeralds and eighty pearls while the second had eighty-eight emeralds, fifty-three rubies, seventy-nine large pearls, and eleven sapphires. The third crown, heavier in gold than the other two, seems to have been less lavishly decorated; "only" forty-three rubies were counted on it, accompanied by forty-four large emeralds, fifty-four big pearls, and an unspecified number of less precious stones.

Other Jewish bankers involved in "high finance" also held princely crowns as pledges at times. In the second half of 1346, a certain German Jew named Pfefferkorn had in his possession in Wassertrüdingen the crown of Prince Stephan "the Old" of Bavaria. In December of 1348, his wife Brunin still held it.[12] Another financier, Vivus of Brühl, living in Co-

[11] Ronald W. Lightbown, *Mediaeval European Jewellery, with a Catalogue of the Collection of the Victoria and Albert Museum* (London, 1992), 129.

[12] See Zvi Avneri (ed.), *Germania Judaica*, vol. 2 (Tübingen, Germany, 1968), 48. See

logne, extended a loan to the Duchess (*Herzogin*) of Berg, around the year 1400; he received her crown as a security, while sometime before May 1349, Jeckelin and Mannekint, Jews of Strasbourg, received the crown of the Margrave of Baden.[13] But in the most exciting transaction we find King Edward III of England, one of the most powerful monarchs of Europe, at center stage.[14] In anticipation of the war with France (which turned into the Hundred Years War), Edward sought a loan of 340,000 florins. Vivelin "the Red," a Jew of Strasbourg, led the consortium that raised the enormous sum. He met the monarch in person in January 1339, and a month later the great crown of England (*Corona dicti domini Regis ac regni Anglie*) was handed over to the creditors. The crown was kept in Trier, in the Episcopal palace of Archbishop Baldwin of Luxembourg, who had helped to clinch the deal. Five years later it found its way back to England.

None of the crowns held by these Jews has survived the centuries. In order to speculate what they may have looked like, we need to pay attention to the ones that have survived through the ages, such as "the Holy Crown of Hungary," the "reliquary of Saint Louis," or the crown of King Venceslas of Bohemia. Art historian Roger Lightbown suggests that a Savoy crown may have resembled the one that Princess Blanche of England, daughter of Henry IV, had bought in Germany before her marriage to the Count Palatine Ludwig of Bavaria.[15] However, in regard to ornaments and other sumptuous objects, we can do a bit better. Thanks to some archeological work done during the last two hundred years, buried hoards of precious objects have been discovered in what used to be medi-

also Peter Assion, "Jacob von Landshut: Zur Gesichte der jüdischen Ärzte in Deutschland," in Gerhard Baader and Gundolf Keil (eds.), *Medizin im mittelalterlichen Abendland* (Darmstadt, Germany, 1982), 386–409, esp. 395–96.

[13] Matthias Schmandt, *Judei, cives et incole: Studien zur jüdischen Geschichte Kölns im Mittelalter* (Hannover, Germany, 2002), 262; for jewelry he held from the courts of Sweden and Denmark, see 164–66. For the crown of Baden, see Hans Witte and Georg Wolfram, *Urkundenbuch der Stadt Strassburg*, vol. 5, *Politische Urkunden von 1332 bis 1380* (Strasbourg, France, 1896), 191. I owe this reference, and many others, to Gerd Mentgen of the Universität Trier.

[14] See also Gerd Mentgen, "Herausragende jüdische Finanziers im mittelalterlichen Straßburg," in Friedhelm Burgard, Alfred Haverkamp, and Franz Irsiglar (eds.), *Hochfinanz im Westen des Reiches 1150–1500* (Trier, Germany, 1996), 75–100, esp. 77–89. Part of the negotiations with the English delegates was carried on in Cologne; see Schmandt, *Judei, cives et incole,* 77.

[15] See Edward F. Twining, *A History of the Crown Jewels of Europe* (London, 1960), 390–400 (on Hungary), 296–334 (on Germany), 221–22 (on France), and 48–64 (on Bohemia). Lightbown, *Mediaeval European Jewellery*, 128–29, reproduces the picture of the crown, which is kept today in the Schatzkammer der Residenz in Munich.

eval Jewish quarters, mostly in Germanic lands.[16] Some of these have in-
cluded hundreds of gold and silver coins, along with brooches, belts,
rings, and bars of precious metal. It is generally assumed that when per-
secution broke out, the Jews would hide these precious objects in the
walls or under the floor of their dwellings before running for their lives
but were never able to return to retrieve them. That hidden treasures ex-
isted was then common knowledge. On February 10, 1440, in Palermo,
the Jew Moses de Liuzu obtained permission from the viceroy to engage
in digging, wherever he wished, alone or with as many assistants he
needed, on condition that half of what he found went to the Royal Trea-
sury. In modern times a number of medieval "treasures" have been un-
covered, almost always accidentally, when public works were being car-
ried out. The chronology of these archeological findings goes back to1820
when a hoard was uncovered in Weissenfels, Saxony. Similar discoveries
were made in Colmar in Alsace and Mainz in the Rhine Valley in 1863
and 1880, respectively. In the twentieth century, treasures surfaced in
Munster (1951) and Cologne (1953), as well as in Lingenfeld, near Speyer,
in 1969. More recent discoveries have been made in Salzburg (1978),
Regensburg on the Danube (1996),[17] and Erfurt (1998). A discovery
made in 1988 in the Silesian town of Środa Ślaska (Neumarkt), some
thirty kilometers west of Wroclaw, Poland, remains to be studied thor-
oughly before being added to the list.[18]

[16] For medieval Sicily, see Shlomo Simonsohn, *The Jews in Sicily*, vol. 4, *1415–1439*
(Leiden, Netherlands, 2002), 2469, doc. no. 2580. A list of modern discoveries is given in
Gerd Mentgen, *Studien zur Geschichte der Juden im mittelalterlichen Elsaß* (Hannover,
Germany, 1995), 189n401; and in Michael Toch, "Medieval Treasure Troves and Jews," in
Iris Shagrir, Ronnie Ellenblum, and Jonathan Riley-Smith (eds.), *In Laudem Hierosolymi-
tani: Studies in Crusades and Medieval Culture in Honour of Bejamin Z. Kedar* (Aldershot,
England, 2007), 273–96. Such (possible) treasures hiden by Jews in Basel, Switzerland; in
Poitiers; and in Ravenna are mentioned also in Marc Bompaire, "Trésor de templiers et tré-
sors de Juifs au XIVe siècle," *Bulletin de la société française de numismatique,* 53 (1998):
185–88. His study refers also to three treasures known already to the administraton of
medieval France and published in Charles-Victor Langlois, "Registres perdus des archives
de la Chambre des comptes," *Notices et extraits des manuscrits de la Bibliothèque nationale
et de autres bibliothèques* 40 (1917): 341–43.

[17] The discovery in Regensburg in the area of the medieval Jewish quarter (today's Ne-
upfarrplatz) revealed a treasure trove of no fewer than 624 gold coins, some of which date
from the last years of the fourteenth century. Also discovered was a bronze statuette of a
high priest, which the archeologist considered to be that of the Aaron, brother of Moses. In
my opinion it is impossible that a Jew of the Middle Ages would order such a three-
dimensional object, considered an idol, to decorate his dwelling. The Regensburg priest
does not carry a Jewish hat but rather a bishop's miter. He holds a glass—perhaps a chal-
ice—in his hand, but none of the objects that, according to the Bible, Aaron carried on his
chest make up any part of the statuette. The object represents rather a Christian prelate and
was probably handed over to a Jew as a pawn.

[18] See Jerzy Pietrusinski, "Le trésor de Środa Ślaska: insignes royaux et joyaux européens
des XIIIe et XIVe siècles," *Questiones Medii Aevi novae* 2 (1997): 151–68; and Jerzy

Some of these findings formed part of an exhibition held in Speyer in 2004–5, and then moved to Berlin's German Historical Museum in the summer of 2005. Two years later some of the objects were shown in the National Museum of the Middle Ages in Paris.[19] Today's jewelry designers must be humbled in the face of the dazzling artistry shown by their medieval predecessors. The splendor combined with delicacy and the refined taste of the pendants found in Munster, or the magnificent silver belt also discovered there, are just some of the many magnificent objects that visitors were lucky enough to see. The Erfurt discoveries are of a singular beauty (see fig. 5). In addition to an immense number of coins— 3,141 of them—the treasure includes fourteen silver ingots and a great number of silver vases. The jewelry includes rings, pendants, brooches, and a great number of bridal belts, some of which have inscriptions in Latin, others in German.[20] The treasures from Colmar (now part of France), which have been heavily depleted and plundered since their discovery in 1863, were recently the subject of a most elegant catalog.[21]

Discussion of these exquisite objects once again raises the question of the reaction of the medieval Jews toward the splendor they kept within their premises. Is it possible that they considered them just as "objects" that helped them to make a living and support their families, or were they rather excited, as modern museum visitors are, in the face of the beauty that emanated from them? It may be safely surmised that these objects contributed to the shaping of their aesthetic sensitivity; however, it is possible to go a step further and obtain assurances for this assumption with the help of a small group of Hebrew writings.

The first of the three documents in the dossier, which is also the earliest, does not relate to any of the art objects discussed here.[22] Rather, its

Pietrusinski, "Herrscherschmuck aus der Schatzkammer der Luxemburger im Goldschatz von Neumarkt in Schlesien," in Klára Benešovská (ed.), *King John of Luxembourg (1296– 1346) and the Art of His Era* (Prague, 1998), 189-200.

[19] A comprehensive catalog, *Europas Juden im Mittelalter*, with contributions by Javier Castaño, Renate Engels, Alfred Haverkamp, and others, was published by the Speyer Museum on the occasion of the exhibition (Stuttgart, 2004). A slim, yet handsome, catalog with the same title was published in Berlin in 2005. The Parisian exhibition also had its own catalog edited under the direction of Christine Descatoire, *Trésors de la peste noire: Erfurt et Colmar* (Paris, 2007).

[20] For the Munster and Erfurt treasures see *Europas Juden im Mittelaler*, 26–27 and 220–23, respectively; the problematic find in Lingenfeld is also discussed there on 84–85, 224–25. The Lingenfeld treasure is discussed also in Werner Transier, "Speyer: The Jewish Community in the Middle Ages," in Christoph Cluse (ed.), *The Jews of Europe in the Middle Ages (Tenth to Fifteenth Centuries)* (Turnhout, Belgium, 2004), 443.

[21] Catherine Leroy (ed.), *Le trésor de Colmar* (Paris, 1999).

[22] This well-known story is preserved in the Hebrew Ms. 58 of the Biblioteca Vittorio Emanuele in Rome. It has been published and commented upon in Jehuda Rosenthal,

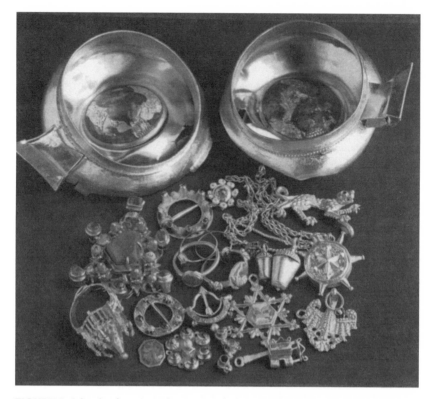

FIGURE 5. A horde of precious objects recently discovered (1998) in the Jewish neigh-
borhood of Erfurt.
 Thüringisches Landesamt für Denkmalpflege und Archäologie Weimer. Photo archive.

subject matter is architecture. It tells the story—hagiographic in all ap-
pearances—of an encounter between Emperor Henry IV (1056–1105)
and Rabbi Kalonymos, the leader of Speyer's Jewish community. The
story describes them looking at the newly erected cathedral (the Dom) of

"Chapters in Controversy," in *Salo W. Baron Jubilee Volume*, (Jerusalem, 1975), Hebrew
Section, 353–395, esp. 376. A recent reference to it is in Gerd Mentgen, "Die Juden des
Mittelrhein-Mosel-Gebietes im Hochmittelalter unter besonderer Berücksichtigung der
Kreuzzugsverfolgungen," *Monatshefte für evangelische Kirchengeschichte des Rheinlandes*
44 (1995): 37–75, esp. 43. Annette Weber, "Ein Streit zwischen Keiser Heinrich und Rabbi
Kalonymos um den neu errichteten Dom zu Speyer," *Trumah* 14 (2004): 167–83, takes
notice (179) of the rivalry between the pope and the emperor as a possible reason for build-
ing the "Salomonic" cathedral. However, her interest in the story is different from mine. It
should be noted that contemporary architecture, Romanesque or flamboyant Gothic, does
embellish a considerable number of Hebrew manuscripts. See, for example, Thérèse Metzger
and Mendel Metzger, *Jewish Life in the Middle Ages* (New York, 1982), reproduction nos.
71–87.

the city, which was, at the time, the most imposing edifice in Christendom. Built during the strife between Pope Gregory VII and Emperor Henry IV, it was intended to symbolize the superiority of the emperor as the leader of Christianity. The emperor exhorts Kalonymos to see in it a "Solomonic temple," but the rabbi, as we would expect, has a contradictory answer in his arsenal. In itself, the content of the argument is of little importance. What counts is the fact that the story revolves around an artistic triumph for Christianity and that Jews do not fail to realize it.

We are on much more solid ground with the second piece. This was written by Immanuel ben Jacob Bonfils, a Provençal mathematician and astronomer who translated *The Gests of Alexander the Macedon* from Latin to Hebrew. He undertook the project sometime between the years 1340 and 1356, having first overcome some reservations. As a person committed to science and rational thinking, he did not fail to recognize the fantasies and absurdities with which the book is replete. What helped him overcome his hesitancy, he tells us, was a Latin manuscript he had in front of him. This was decorated with wonderful illuminations and illustrations, "beautiful representations in various colors and in silver and gold."[23] The aesthetics of this manuscript enabled him to make up his mind. Today it is probably impossible to identify the manuscript that aroused our Provençal Hebraist's enthusiasm. The few "Alexander" manuscripts I had the chance to examine in Paris, and those from the German-speaking areas that were systematically surveyed by David J. A. Ross, are certainly not of breathtaking beauty. On the other hand, the Bodleian Library in Oxford possesses an Alexander illuminated by Jehan de Grise, an artist from northern France who completed his work in 1344; the manuscript (Ms. Bodleian 274, fols. 1–208) is considered to be the most glorious of all the illuminated manuscripts in the library.[24] The chance that Immanuel is referring to this manuscript is, of course, slim. Still it does show that some handsomely illuminated Alexanders existed during his lifetime. There is little wonder that he wished his translation to be decorated with similar illustrations. For this reason he actually provided

[23] See Israel J. Kazis (ed. and trans.), *The Book of the Gests of Alexander the Macedon* (Cambridge, MA, 1962), 40–41. On Immanuel ben Jacob Bonfils, see Ernest Renan, *Les écrivains Juifs français du XIVe siècle* (Paris, 1893; reprinted Farnborough, England, 1969), 346–53. About his teaching in Orange there exists a short phrase written by one of his students; it reads, "Here is what was composed in the academy of Orange when we studied with the honorable Rabbi Emanuel who authored [the astronomical book] 'Six Wings.'" See Jews College, London, Ms. 138.3; and Adolphe Neubauer, *Catalogue of the Hebrew Manuscripts in the Jews College, London* (Oxford, 1886), 40–42.

[24] For a facsimile of the Bodleian manuscript see Lambert le Tort, *The Romance of Alexander: A Collotype Facsimile of Ms. 274* (Oxford, 1933). For other illustrated "Alexanders" see David J. A. Ross, *Illustrated Medieval Alexander-Books in Germany and the Netherlands: A Study in Comparative Iconography* (Cambridge, 1971).

captions that would explain the illustrations. Indeed, the Hebrew Alexan-
der in the Bibliothèque Nationale in Paris (Ms. Héb. 750) has forty-seven
such captions. But there are no paintings there. His dream was probably
never realized.

Immanuel Bonfils seems to have been a scientist interested in mathe-
matics and astronomy. At one time he taught in the academy of Orange,
founded by the great Gersonides, but it is probable that students learned
"hard" sciences in his classes, not rabbinics. His intellectual profile would
most probably not have matched that of the third reporter on Christian
art in our portfolio, Rabbi Jacob ben Moses Molen (or, Molin), known by
the name Maharil (c. 1375–1427). Molen spent most of his life in the
Rhineland, in the city of Mainz, and was considered by his contempo-
raries as the foremost rabbinic authority in central Europe. It is therefore
astonishing to read what Maharil has to say about Christian objects,
written when he was trying to underscore the importance of the feast of
Passover and the uniqueness of the yearly celebration of the exodus from
Egypt. While, according to the rabbi, Jews should normally conduct a
somber way of life, mourning the destruction of Jerusalem throughout
the year, the evening of Passover should be an exceptional event. On this
joyous occasion, he claims it is permitted to decorate the house with glo-
rious objects; Jews can display and enjoy the sight of beautiful vessels
"even if they are pledges that belong to gentiles." He then adds that his
father, also a rabbi, used to have a display of such objects on a special
table in the main room. It is amazing that Moses Molen, a rabbi of im-
mense influence and coming from a different intellectual horizon than
that of Immanuel Bonfils, showed similar openness toward the art of the
larger society and expressed such unhesitating admiration toward it.[25]

––––––––––––––––––

The story has not yet reached its end. Jews moved beyond a passive en-
joyment of the arts and crafts of their surroundings. Some engaged in
stylistic borrowing from the environment while others who could afford
it asked Christians to produce liturgical objects that were in accordance
with their religious laws and special sensitivities. These facts are not new
to those who have read thus far in the present study.

[25] See Shlomo J. Spitzer (ed.), *Minhage Maharil (The Customs of Maharil)* (Jerusalem,
1989), 88 (in Hebrew).

PART TWO

Human Imagery in Medieval Ashkenaz

Chapter Four

THE DECORATED HOME OF
THE RABBI OF ZURICH

─────────────────────

It would seem that some highly successful Jewish financiers were not
content with just admiring the achievements of the host society; they al-
lowed themselves to be influenced in their way of life by these achieve-
ments. A discovery made in an apartment of approximately seventy-five
square meters in the center of the city of Zurich in 1996 calls our atten-
tion to this aspect of social interaction. The building where this apart-
ment is situated is known as Zum Brunnenhof, and its present-day ad-
dress is Brunnengasse No. 8. The apartment was occupied by a Jewish
family during the two decades preceding the Black Death, if not earlier.
Part of the art on its walls survived the centuries, as did the unexpected
identity of the Jewish family who lived there.

There is no doubt that the apartment was occupied by Jews in the
1330s. One of the family members, Moses ben Menahem, occupies a
distinguished place in the history of rabbinic literature. He is the author
of the *Semak Zurich*, an extensive collection of commentaries and docu-
ments regarding Jewish ritual law. During his lifetime he was considered
the leader of the small Jewish community of Zurich and is given the title
Schulmeister (probably, "rabbi of the synagogue") in a document pre-
served in the city's archives. Several of his immediate family members
also appear in the archival documents of Zurich, but their relationship to
him (or to each other) is not always clear. In 1347, a brother named Mor-
dechai (Gumprecht) may have been his business associate. A document
dated 1324 suggests the existence of a sister, or at any event, a daughter
to his mother. His wife's name was Halde, and we know that in 1345 they
both had a married daughter. In that year, the younger couple sold a
house to this daughter (of Moses) and her husband Fidel. Rabbi Moses
had a son named Vivelin (also spelled Viflin), and probably also a daugh-
ter named Eva-Guta. These two, Viflin and Eva-Guta (who may have

been a married couple rather than siblings) took care of what was left of
Moses's finances. The rabbi himself was not alive by that time. He may
have been a victim of the Black Death, which hit Zurich in February of
1349. By 1350 the city had already acquired the house that used to be-
long to Moses of Bern, probably the name by which our famous scholar
was known in Zurich.

This small clan of brothers, sisters, and children was headed by a ma-
triarch, a lady named Minne who must have been widowed by 1330 if
not earlier. Like other great Jewish matrons of her time she seems to have
taken much interest in her family's financial transactions. Actually, there
are many indications that the family was involved in the region's high fi-
nance. An archival document dated January 31, 1329, reports a loan of
850 silver marks, an immense sum that Minne's family made to Count
Habsburg-Laufenburg, the lord of the neighboring town of Rappersville.
Other evidence indicates a financial relationship with some leading aris-
tocratic houses in the region. The fact that all three men of the family—
Moses, Mordechai, and Vivelin—had an identical family seal (the carved
emblem shows three Jewish hats joined at their pointed end) probably
means that they considered it as a family ensign (*armes de famille*), which
would be useful in their business and similar to those used by their aris-
tocratic clients. It is not impossible that Mrs. Minne and her sons consti-
tuted the richest family in the Jewish community, something that may
explain the nature of the art that was discovered in their premises.[1]

The walls of Brunnengasse No. 8 still contain the remnants of some
amazing frescoes, as well as twenty-five coats of arms painted above them.[2]

[1] I visited the premises at Brunnengasse No. 8 in the summer of 2003. Silvana Lattmann,
who occupies the apartment, and her daughter Alexandra Jermann introduced me to the
wonderful world in which they live. I thank them wholeheartedly for their graciousness. For
much of the data presented in this section I am indebted to the study by Dölf Wild and
Roland Böhmer, "Die spätmittelalterlichen Wandmalereien im Hause 'Zum Brunnenhof' in
Zürich und ihre jüdischen Auftraggeber," in Ursula Koch (ed.), *Zürcher Denkmalpflege:
Bericht 1995/96* (Zurich, 1997), 15–33. Much information about members of the family of
Minne was found in the archives of the city by Augusta Steinberg, who did not realize that
the individuals she found were members of the family of the author of *Semak Zurich*. See
Augusta Steinberg, *Studien zur Geschichte der Juden in der Schweiz* (Zurich, 1902), 7, 98,
109–10, 136. A recent discussion of the members of the family and their seals is that in
Daniel M. Friedenberg, *Medieval Jewish Seals from Europe* (Detroit, MI, 1987), 156–59.
See also Sarit Shalev-Eyni,"Jews of Means in a Christian City: Artistic and Textual Aspects,"
in Richard Cohen (ed.) *Image and Sound: Art, Music and History* (Jerusalem 2007), 107–
30 (in Hebrew); and Sarit Shalev-Eyni, *Jews among Christians: Hebrew Book Illumination
from Lake Constance* (Turnhout, Belgium, 2010), 62–63, 85–88, 176–77.

[2] In discussing the paintings of Zurich, I rely on Wild and Böhmer, "Die spätmittelalterli-
chen Wandmalereien," and especially on Roland Böhmer, "Bogenschütze, Bauerntanz und
Falkenjagd: Zur Ikonographie der Wandmalereien im Haus 'Zum Brunnenhof' in Zürich,"
in Eckart Conrad Lutz, Johanna Thali, and René Wetzel (eds.), *Literatur und Wandmalerei
I. Erscheinungsformen höfischer Kultur und ihre Träger im Mittelalter, Freiburger Collo-*

According to Zurich archeologists, all of them may have been painted on the walls at the same time. The walls were originally decorated with as many as eighty-four coats of arms, and it is not difficult to identify many of the dynasties and families (all non-Jewish) represented on the walls. The Swiss State Museum in Zurich holds a catalog of almost 560 coats of arms (*Wappen*) drawn up around the years 1335–45, very close to the time of those we are considering.[3] The most prominent coat of arms still visible in Brunngasse No. 8 is that of the House of Luxembourg. In fact, the Luxembourg emperor Henry VII passed through the city on May 1, 1310, on his ill-fated journey to Italy. As for the other twenty-four coats of arms, some belonged to supporters of the emperor such as the counts of Hohenzollern, and possibly the Margrave of Brandenburg and Homburg. The powerful Archbishop of Mainz is represented as well.[4]

The Hebrew inscriptions that can still be seen beneath some of these heraldic emblems are of particular interest. While each coat of arms has the title of the dynasty or the family written above it in bold Gothic letters, Hebrew script can be detected under some of them, although not all can be deciphered easily. Chemical examination has confirmed that the paintings and the Latin and Hebrew inscriptions were all executed at the same time. The people who wrote the Hebrew instructions, or so we can surmise, were the same as those who ordered the emblems to be painted on the walls. Scribbled in cursive writing and perhaps in haste, the Hebrew words probably served as a reminder intended to tell the Christian who painted the Latin inscriptions what was to be written above each coat of arms.[5] As the Count Habsburg-Laufenburg is represented indirectly in one of the twenty-five emblems that survived (through the arms

quium 1998 (Tübingen, Germany, 2002), 329–64. For a possible romantic message of the fresco, see Mira Friedman, "The Falcon and the Hunt: Symbolic Love Imagery in Medieval and Renaissance Art," in Moshe Lazar and Norris J. Lacy (eds.), *Poetics of Love in the Middle Ages: Texts and Contexts* (Fairfax, VA, 1989), 157–75.

[3] See Walther Merz and Friedrich Hegi, *Die Wappenrolle von Zürich: ein heraldisches Denkmal des vierzehnten Jahrhunderts* (Zurich, 1930). The exact number of *Wappen* is 559. See also Wild and Böhmer, "Die spätmittelalterlichen Wandmalereien," 24–25.

[4] A set of eight coats of arms, one of them of the German Empire, embellishes a fragment of a Hebrew prayer book of around the year 1300, kept in the Biblioteca Ambrosiana of Milan (Ms. Fragm. S.P.II.252.) Published in Thérèse Metzger and Mendel Metzger, *Jewish Life in the Middle Ages* (Fribourg, Switzerland, 1982), as fig. 90, it shows the cantor, his round face practically empty of any human feature, reciting on the eve of the Day of Atonement the most sacred of the yearly prayers—the Kol Nidrei (All Vows). This prayer makes null and void almost all vows made by any member of the congregation in the year that past. The purpose of the coats of arms on this fragment is, in my opinion, only a decorative one. See Metzger and Metzger, *Jewish Life in the Middle Ages*, figs. 64–65, 67, for other (single) coats of arms, and figs. 69–70 for shields.

[5] Instructions to the painters are found in manuscript illuminations of the period. See chapters 6 and 7.

of Neu-Kyburg House), one wonders whether all the other noble families represented on the walls were also conducting business with Mrs. Minne and her sons.

At first glance we should not be surprised to discover these coats of arms decorating a private apartment in Zurich. As archeologists keep discovering, the citizens of the city seem to have been fascinated, almost bewitched, by this form of decoration. Some of the old houses of the city have dozens and even hundreds of such heraldic emblems preserved on their walls even today.[6] What renders the findings in Brunngasse No. 8 of particular interest is the fact that an Ashkenazi Jewish family joined in the enthusiasm of the surrounding society for this form of art.

Many coats of arms of lords of the regions and of cities under whose rule Jews lived appear on Jewish objects in both northern and southern Europe. Visitors to the Jewish Museum of Spain (once the church El Transito) can see in the middle of a Hebrew dedicatory inscription the coats of arms of the Kingdom of Castile-León (see fig. 6). Before becoming a church the building was a synagogue whose founder, Samuel ha-Levi Abulafia (c. 1320–61), was the treasurer for King Pedro "The Cruel." At the height of his success Samuel saw to it that his devotion to the monarch be manifested by inscribing, no less than twenty times, the kingdom's coats of arms around the central hall of the synagogue. Dozens of such emblems appear also in Hebrew illuminated manuscripts. The Budapest Mishneh Torah carries the heraldry of the counts of Bar, who governed the region that is today in northeastern France, while the Kaufmann Haggadah (both kept in Budapest, Hungarian Academy of Sciences, Ms. A77/1 and A422; see fig. 7) and the Sarajevo Haggadah (Bosnia, National Museum) show the emblems of Castile-León and Aragon, respectively. Such coats of arms could have been seen also in the embellished Torah crowns found in Aragon.[7] However, it is quite astonishing that a rabbinical scholar of the stature of the *Semak Zurich* lived with so many emblems in his dwelling. The family probably acted as a host to their clients and wanted to show them the society of which they (the clients) were part. Whatever the reason, the rabbi's family found it-

[6] See Jürg E. Schneider and Jürg Hanser, *Wandmalerei im Alten Zürich* (Zurich, 1986).

[7] For Castile, see Francisco Cantera Burgos and José María Millas Vallicrosa (eds.), *Las inscripciones hebraicas de España* (Madrid, 1956), 336–41. Interesting Aragonais evidence has been discovered by Miguel Angel Motis Dolader: in the year 1492, right after the expulsion of the Jews from Spain, a crown of the Torah was found in one of the abandoned synagogues of Saragossa that had the coat of arms (*armas reales*) of the kingdom on it. The synagogue also contained luxurious textiles that may have served as curtains to the Holy Arch or as covers to the rolls of the Torah kept within the arch. On these textiles were also embroidered the coat of arms of Aragon. See Miguel Angel Motis Dolader, "Estudio de los objetos litúrgicos de las sinagogas zaragozanas embarcados por la Corona en el año 1492," *Aragon en la Edad Media* 6 (1984): 247–62, esp. 252, 257, 258, 260.

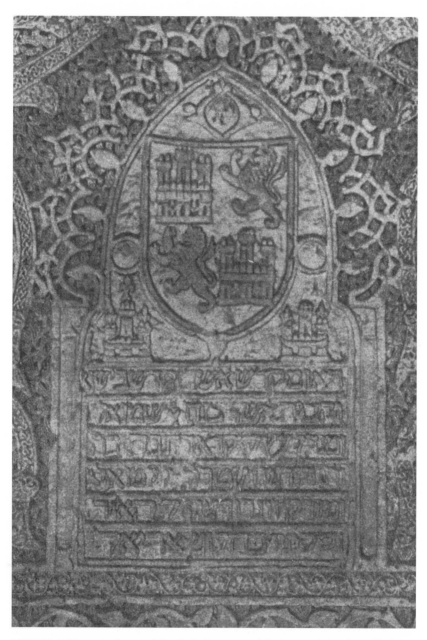

FIGURE 6. The coat of arms of Castile-León as part of the inscription on the wall of a synagogue built in Toledo around the mid-fourteenth century by Samuel ha-Levi Abulafia (c. 1320–61), treasurer for King Pedro "The Cruel"; the emblem presented is only one of some twenty. Once the synagogue was converted to a church it became known as El Transito, while today the building houses the Museo Sefardi, the Jewish Museum of Spain.
 Archive photograph, Museo del Romanticismo.

FIGURE 7. The coat of arms of Castile-León in the Kaufmann Haggadah (fourteenth century).
Courtesy of the Library of the Hungarian Academy of Sciences, Oriental Collection. Ms. A422, fol. 39r.

self at the forefront of the then current trend among the burgers of Zurich of displaying what was fashionable in home decoration.

———————

The walls of the apartment in Brunngasse No. 8 in Zurich were also decorated with large, imposing wall paintings. Three very faded frescoes survived (there most certainly must have been others). Of the three, one

was in such poor shape that it was recently covered with white ceramic tiles—a regrettable move, since this fresco may have had some biblical content. An arm holding a bow and an arrow was still recognizable: it might have been part of a painting of Esau, son of the patriarch Isaac, hunting in the field. While nothing further confirms this possibility, it is worth noting that wall paintings of the biblical narrative had already been mentioned by the supreme rabbinic authority of the Middle Ages, Rashi (Solomon Isaaci, 1040–1105), in the second half of the eleventh century. In his commentary for the Babylonian Talmud, in the tract "Shabbat" (fol. 149a), Rashi writes about wall paintings that contain "strange portraits of animals and of humans" but also of events "like the confrontation between David and Goliath." He adds that there are explanatory captions under these paintings that read, "This is the shape of a certain animal and this is his or her portrait." His words immediately bring to mind an illustration in the British Library manuscript (Add. Ms. 11369, folio 523v) that shows the encounter between David and Goliath and has such a caption beneath it. Rashi forbade the reading of these captions on the Sabbath day.

The two surviving frescoes in Mrs. Minne's family home have nothing Jewish about them. According to the reconstruction by Swiss historians, one depicts falcon hunting, the other peasant dancing. In the first of the frescoes three people are recognizable (see fig. 8): on the extreme left a gracious lady riding a black horse is setting free a falcon. She is preceded by a galloping horse led by a man who is trying to capture the bird. Then the lady appears again, this time standing on the ground. The original painting, of which only a faint fragment has survived, obviously had a longer story to tell. It is noteworthy nevertheless that similar hunting scenes were discovered in other medieval buildings in Zurich. Falcon hunting was a favorite sport of the knightly class and one that sent a message of romance and desire of the flesh.

The dancing festivity depicted in the second fresco can be interpreted more precisely (see fig. 9). Five of the eight participants in the event are fully represented—three are women and two are men. The images of two other people also survived: one, a musician playing the flute, is presented in full face. The other's role is not known, as the broken fresco shows just part of his figure. While the attire of the ladies and their body language suggests grace and refinement, the gesticulation of the men borders on the vulgar and the ridiculous. One of the two has his knee up to his waist, while the other certainly does not belong to courtly society. True, both carry swords, but this is no more than a pathetic effort on their part to pose as members of the chivalrous class. Literary critics agree with art historians in considering this fresco to be a parody influenced by the poetry of the Bavarian Neidhart of Reuental (c. 1190–c. 1250), a well-known author of farcical songs about rustic life in his time and an acerbic

FIGURE 8. Reconstruction of one of the two damaged frescoes that decorate the walls in the home of the family of Rabbi Moses of Zurich (c. 1330), Brunnengasse No. 8, Zurich. Also noticeable are several coats of arms possibly belonging to clients of the family.
 Stadt Zürich Amt für Stadtebau.

critic of peasants who strove to raise their status in life by imitating the manners and the ways of members of the genuine higher class. Peasant dancing formed a major theme in his writings. Neidhart was much appreciated in the 1330s, and his influence can be detected not only in other wall paintings in Zurich but also in buildings in neighboring towns—for example, Diessenhofen or Winterthur.[8]

 [8] See n. 2, above.

FIGURE 9. Reconstruction of the second fresco decorating the dwelling of the family of
Rabbi Moses of Zurich (c. 1330), Brunnengasse No. 8, Zurich. Faint inscriptions in He-
brew can be detected under some of the coats of arms.
Stadt Zürich Amt für Stadtebau.

Another series of frescoes reflecting Neidhart's influence has recently
(1982) been discovered in a building in Vienna. Notably, the house be-
longed to a Jew, David Steuss, in the 1370s and '80s. As for the frescoes
in Zurich, while there is no way to know who ordered the painting to be
carried out,[9] the fact that Mrs. Minne and her sons, Master Moses among
them, lived in such dwellings speaks volumes about their cultural sensi-
bilities and social habits. The documents in our possession do not provide
a clear understanding of how they managed to follow a traditional Ash-
kenazic way of life surrounded by such non-Jewish, indeed Germanic,
wall paintings. Did they consider it a problem?

The writings of Master Moses of Zurich (labeled "the Zuricher" by
some rabbis) are of some, but not much, help when looking for an expla-
nation. Anyone wanting to consult his work may turn to Manuscrit Hé-
breu 381 in the Bibliothèque Nationale in Paris or to Yitshak Yaakov Har
Shoshanim's three-volume edition of *Sefer ha-Semak mi-Tsurich* (The
Book of the Semak of Zurich; Tel Aviv, 1972–88). The book of our
"Zuricher" is an extensive commentary on the very well-known *Small
Book of Precepts* (the *Semak*, which is an abbreviation of *Sefer Mizvot
Katan*) written by a French scholar, Isaac ben Joseph of Corbeil, in 1277.

[9] See Robert Waissenberger (ed.), *The Neidhart Frescoes ca. 1400: The Oldest Secular
Mural Paintings in Vienna* (Vienna, 1982), esp. 8.

The aim of the *Semak* was to provide Jews with brief instructions as to the religious duties (*mitzvot*) they were obligated to follow. But obviously Moses of Zurich felt that the compendium was too short, and that a full understanding of its teachings required additions and elaborations. Any quest for originality, however, was not on his mind. He did not intend to criticize Isaac of Corbeil or to challenge the accepted wisdom of the rabbinic establishment. Rather, he undertook the task to explore the writings of classic authors (be they ancient or modern, Easterners or Westerners) in order to discover statements that would sustain the teachings of the *Semak*. To accomplish this aim he would rely not only on his vast knowledge and his rich library but also on comments he received from teachers and colleagues. Intriguing in this respect are references he made to decisions taken by English rabbis like Moses of London (vol. 3, p. 121) or Joseph of Lincoln (vol. 2, p. 130). This raises the question of whether he studied in England or whether perhaps he was even born and raised there.

Moses of Zurich, in the scholarly style typical of the period, devoted many dozens of folios to quoting glosses relating to issues like the right way to slaughter animals, the correct manners for celebrating the festivals, the intricacies of family laws, or the ways to conduct civil litigation. Yet, when it came to art or to the figurative representation of humans, his quill ran practically dry; his interest in the subject seems to have been quite limited. He knew, of course, about rabbinic restrictions on artistic reproduction of figurative humans and even animals, and mentioned the resentment of one of his teachers concerning the painting of human faces (vol. 2, p. 52), however he went over these issues quite quickly. Moreover, as he knew the text of Rashi about wall paintings and their captions, a text that was quoted in full in the *Semak* (vol. 3, p. 381), we might have expected to find here an extended comment. But Moses, while he broke his silence, shied away from talking about the wall paintings, focusing instead on the captions and the reading of them on the Sabbath. The reading of captions—not art—was also the subject that was dealt with by the codex on which he was commenting, the *Semak*. Moses for his part enlarged the scope of the discussion by dealing with the prohibition of reading "gentile books" written in letters of the vernacular language on the holy days. It is interesting that two of his contemporaries also dealt with this question: one was Alexander Suslin ha-Cohen (d. 1349), who was a rabbi in Frankfurt, Worms, and Cologne. This rabbi discussed the question in his *Sefer ha-Agudda* (The Book of Compilation), paragraph 136, and ruled categorically that on the Sabbath it was forbidden to read any "book of wars—like the books written in the German language." Another rabbi who dealt with the question was Peretz ben Elijah of Corbeil (d. c. 1295), a mentor of Moses of Zurich. He discussed it in the

section "Sabbath" of his book *Sefer ha Dinim* (The Book of Laws).[10]
Moses quotes, almost word for word, the section of *Sefer ha Dinim* (folio
364a of the Vienna manuscript) dealing with the reading of "foreign
books." The "Zuricher" repeats the dogma that it is forbidden in princi-
ple to read these "books of wars," but he knew also, like his mentor Per-
etz of Corbeil, that "nowadays" Jews read the vernacular books, simply
by adding a Hebrew letter to one of the pages of the manuscript. By doing
this, I gather, they were turning the book from a German work into a
Hebrew-German one.

This gloss certainly provides important information about the literacy
and the cultural profile of medieval Jews in Germany, but there is nothing
in it about wall painting. It is possible that in our author's mind any fur-
ther discussion of these decorations was superfluous, since no less an
authority than Rashi legitimized their existence, and the author of the
Semak endorsed Rashi's teaching without any comment. Nevertheless,
the following short statement may permit us to guess what might have
been Moses's own attitude toward the frescoes in his home. He and his
master, Rabbi Peretz, informed us in a matter-of-fact manner that there
were in the German Jewish society of their time (the Hebrew *olam*, which
today means "world," but also "people" in the Yiddish language) Jews
who found a way to legitimize the reading of German "romances" and
enjoyed (we should add) stories of knightly wars coupled with those
about adultery.

A hundred years before, the pietist Hasidim would not have tolerated
even the parchment of "Christian books" touching Jewish ones (exem-
plum 688).[11] That such "gentile" books should not be placed in the same
case with Jewish ones was, for them, a given. During travel each group of
books was separated and occupied opposite sides of a pack animal's sad-
dlebag. The Hasidim's attitude could even turn aggressive: The Bologna
1538 print of the Sefer Hasidim (but not the codex in Parma) tells a dra-
matic story (exemplum 141[12]) of a Jew who was about to cover his He-
brew book with parchment written in a foreign language. A righteous
coreligionist, who was present, tore the parchment into pieces. Hence the

[10] The complete copy of *Sefer ha Dinim* is lost today. The section "Sabbath" (among a
few other sections) survived, and is kept in the National Library of Austria, Vienna, (Cod.
Hebr. 18, fols. 359v–366r); the librarians were kind enough to send me a copy of it. (I owe
thanks for information about this manuscript to Judah Galinski and to Yael Okun, both of
Jerusalem.)

[11] Thanks to Julie Mell of Durham, North Carolina, for calling my attention to this
exemplum.

[12] This is published in Reuven Margalioth, *Sefer Hasidim by Yehusah he-Hasid* (Jerusa-
lem, 1964) 147–48 (in Hebrew).

warning of the authors of the story not to cover Jewish sacred books with folios of parchments on which *romans* was written (the term is transliterated in Hebrew letters)—that is, non-Jewish books that tell stories of wars and frivolities. Now, a hundred years later the teacher of Rabbi Moses in Zurich reports that for Jews of his age the reading of this "romans" literature was a fact of life. I would suggest that the same change of attitude extended to frescoes of worldly content. Visitors to the rabbi's home in the 1330s would have been less surprised by what they saw on the walls than we are. Today almost all of our knowledge about the inner life of the Jews of medieval Germany depends on rabbinic writings and on religious objects that survived the centuries, while we know close to nothing about other trends that were part of their culture. The change from the strict adherence to religious principles in daily life of the year 1200 or 1230 (when the first Hebrew illuminated manuscripts appear) to the more relaxed attitude of the worldly culture of 1300 and 1330 must have emerged during the hundred years that preceded the compilation of the *Semak Zurich*. In chapter 5, I shall try to place this development in the cultural history of the German Jewish society by tracing the changing attitudes toward the arts, and toward painting in particular, during that century.

Chapter Five

GERMAN JEWS AND FIGURATIVE ART

Appreciation and Reservation

The Jews of the High and Late Middle Ages were not the first of their people to enjoy art or to create works of lavish craftsmanship. Previous generations of Jews had similar experiences.[1] To describe them all as belonging to a nation without art is a gross misrepresentation that certainly does not reflect historical reality. One has just to open the Bible to become aware of the commitment to aesthetics and to the beautiful that these ancient writings witness. The creation of the Holy Tabernacle in the desert, the building of God's temple and the royal palace, with its wonderful throne, in Jerusalem required the investment of enormous amounts of precious metals and stones. Much care was given to the architecture of the exterior and interior of the sanctuaries as well as to their holy appurtenances. When the builder King Herod (governed 37–34 BCE) accomplished the renovation of the Second Temple, his opponents, the Phari-

[1] For most of the information in this short overview I rely on Steven Fine, *Art and Judaism in the Greco-Roman World: Towards a New Jewish Archeology* (Cambridge, 2005). There is, of course, much more to say about Jewish art in late antiquity. See the bibliography in Herbert L. Kessler, *The Frescoes of the Dura Synagogue and Christian Art* (Washington, DC, 1990). Of value is still the "old" collection of studies in Cecil Roth (ed.), *Jewish Art: An Illustrated History* (New York, 1971). Useful information is found in the articles assembled in Mireille Mantre, *L'Art Juif au Moyen Âge* (Paris, 1988). About illuminated manuscripts created under Islam and deposited today in the Public Library of Saint Petersburg, see the documentation assembled in Bezalel Narkiss, *Illuminations from Hebrew Bibles of Leningrad (Originally published by Baron David Günzburg and Vladimir Statsof)* (Jerusalem, 1990). For Spain at the age of the *Reconquista*, see Katrin Kogman-Appel, *Jewish Books Between Islam and Christianity: The Decoration of Hebrew Bibles in Spain* (Leiden, Netherlands, 2004). For Islamic influences in Iberia, see Francesco Cantera Burgos, *Sinagogas Españolas—Reimpresion* (Madrid, 1984).

sees, were overwhelmed: "He who has not seen the Temple of Herod has
never seen in his life a beautiful building" (Talmud Bavli, Baba Batra, 4a.)

Similar exclamations concerning architectural marvels are recorded in
rabbinic texts concerning the colonnade of the synagogue of Alexandria
(Tosefta, Sukkah, 4.6). Beautiful objects, even sculptures created by non-
Jews also caught the attention of the sages. The Mishnah reports that
Rabbi Gamaliel the Second (first century CE) experienced no compunc-
tion when entering the bath of Acre in which a statue of Aphrodite was
present, believing that the image of the goddess was there for the sake of
her beauty (Hebrew: *noy*), rather than to entice one to participate in an
idolatrous cult (Mishnah, Avodah Zarah, 3.4).

Written evidence of such outlooks was produced during almost all of
the first millennium CE, but luckily we are not dependent on this evi-
dence alone when surveying the story of Jews and their attitude to art and
craftsmanship. Archeology reveals material evidence that lends credence
to the literal evidence. One of the most formidable findings comes from
excavations carried out in the years 1932–35 that unearthed a synagogue
dating to about 240 CE in the city of Dura-Europos, on the middle Eu-
phrates River. The inner wall of the building was covered with multiple
colored paintings that depicted episodes of biblical history as conceived
by the sages of the time. The Durani Jews did not see in the injunction of
the Second Commandment—"no graven image" (Exod. 20.4–6; Deut.
5.7–10)—any prohibition against the painting of humans. People were
thus painted realistically, standing, sitting or running. Since it was neces-
sary, for example, for the daughter of Pharaoh to shed her clothing in
order to wade into the Nile and rescue little Moses, the painter repre-
sented the scene with most of her naked body exposed to view.

Israeli archeologists very frequently share with us news about their
discoveries, a considerable number of which are in remnants of ancient
synagogues. Dozens of houses of prayer (I have counted well over fifty)
existed in Roman Palestine, to which should be added that of several oth-
ers in the Jewish diaspora. Of much interest to viewers nowadays are the
mosaic pavements of these houses of prayer, some in almost pristine
shape. Since the accidental discovery of the floor in Na'aran near Jericho
in 1917 and down to the most recent findings in Sepphoris near Naza-
reth, a number of such pavements have been uncovered. Most famous
among them are those of Beit Alfa in the valley of Jezreel, Hammath near
Tiberias, and the oasis Ein Gedi on the shores of the Dead Sea. Alongside
dedicational inscriptions these mosaics present animals of all descrip-
tions, depict the holy vessels of the temples, and also show biblical scenes
that include humans. These pavements, since the discovery of the beauti-
ful Hammad Lif one in Tunisia as early as 1883, raise questions and

heated historical and theological debates. For our present discussion we count on the findings as evidence of Jews' sensitivity to the beautiful and to aesthetics.

Toward the end of the seventh century, however, we witness a cessation of the creation of mosaic pavements. No wall paintings on the level of Dura-Europos have since surfaced. The question is, of course, what caused the break? Why do we not find them in ensuing generations? The best guess in my opinion is that it had to do with the emergence of the new conquering religion—namely, Islam—a fact that concurred with the strengthening of the iconoclastic tendencies in the Byzantine Church. Islam, with the exception of Shiite Persia, forbade any visual representation of humans, while Byzantium slid into an unsavory confrontation around the issue. The new conditions impacted directly on Jews and their art, the vast majority living now in Islamic lands. One of the last pavements created—that of Jericho—included no humans, and somebody defaced all the figures of the neighboring Na'aran Mosaic. Similarly, the eyes of most people depicted in the Dura-Europos paintings were rubbed out.

Jews had thus to abandon the art that they cherished for generations, yet they found ways to keep alive their fascination with the beautiful and to nurse their aesthetic needs. The interior synagogue of Santa Maria la Blanca of Toledo and that of the recently reconstructed Sinagoga Mayor of Segovia manifest a profound attachment to Islamic public architecture. Impressive in both sanctuaries are the rows of octagonal columns, arches, and carved capitals. Jews showed great appreciation for the decorative value of their Hebrew alphabet. Biblical texts were painted all around the upper walls of the synagogues of Cordoba and of El Transito in Toledo. They also learned to paint inanimate or geometric images in miniature letters on the covers of their Bibles. While we have yet to discover one Hebrew illuminated book that comes from late antiquity or from the early medieval West (did they exist at all?), we have several such books that were produced under Islamic rule, kept today in the Saint Petersburg Library and elsewhere. Such books would appear in the medieval West only after a considerable Jewish immigration reached the northern shores of the Mediterranean, crossed the Alps, and settled in the parts of Europe that we today call "Ashkenaz"—namely, Germany, northern France, and northern Italy.

———————————

Sensitivity for works of art became widespread in the European society of the High and Late Middle Ages. Jews followed this general trend. We have just observed it in the murals of the apartment in Zurich (see chapter 4). However, this fashion was not universally welcomed. On the con-

trary, its introduction into Jewish society was at times quite slow and painful. Like their Christian neighbors, but much more so, Jewish lovers of the decorative had to face objections from some of their religious teachers, who vehemently expressed their reservations. A heated argument over art and decoration occurred in Cologne, a major community on the lower Rhine, as early as 1152, when some members of the community decorated the windows of the newly built synagogue with stained glass images of lions and snakes.[2] This aroused the anger of the influential rabbi Elyakim ben Joseph of Mainz, who ordered that they should be taken down. His objection was based on his understanding of the Talmudic discussions of idolatry, which led him to regard the images as idolatrous. The date and place of this incident are of great interest. The year, 1152, is very close to the period when the pioneering abbot Suger of Saint-Denis introduced the well-known stained glass windows into his abbey (1130–44). The synagogue in Cologne was therefore one of the earliest in Europe to try and follow the new trend. Like other cities, during the urban expansion Cologne witnessed the building of many new religious edifices: between 1150 and 1250 twenty-eight such buildings were erected.[3] A similar building frenzy took place in England during the same period. In Lincoln, for example, the capital of one of the most important dioceses in the country, nine Cistercian abbeys were built during the second half of the twelfth century. There was even a rumor that Aaron of Lincoln, the richest Jew in the city, contributed sometime between 1165 and 1185 to the financing of one of these Christian institutions. According to the *Gesta Sancti Albani*, Aaron boasted that "it was he who had made the windows of our St. Alban and that he had prepared for the saint a home when without one."[4]

Cologne was not the only one to experience a conflict over synagogue decoration. The community of Meissen (now Saxony) had a similar expe-

[2] See Matthias Schmandt, *Judei cives et incole: Studien zur jüdischen Geschichte Kölns in Mittelalter* (Hannover, Germany, 2002), 13–14; Ismar Elbogen (ed.), *Germania Judaica*, vol. 1, *Von den ältesten Zeiten bis 1238* (Tübingen, Germany, 1963), 71–72. The incident is frequently referred to in rabbinic literature of the Middle Ages and of modern times. See David Kotlar, *Art and Religion* (Jerusalem, 1971), 152–55 (in Hebrew). For a translation into English, see Vivian B. Mann, *Jewish Texts on the Visual Arts* (New York, 2000), 39–42.

[3] See Vivian B. Mann, "Between Worship and Wall: The Place of Art in Liturgical Spaces," in Ruth Langer and Steven Fine (eds.), *Liturgy in the Life of the Synagogue: Studies in the History of Jewish Prayer* (Winona Lake, IN, 2005), 109–19, esp. 111–13. See also Ephraim E. Urbach, *The Tosaphists: Their History, Writings, and Methods*, 4th enlarged ed., vol. 1 (Jerusalem, 1980), 437 (in Hebrew).

[4] Francis Hill, *Medieval Lincoln* (Cambridge, 1948), 218. For Aaron of Lincoln, see Joseph Jacobs, *The Jews of Angevin England: Documents and Records, from Latin and Hebrew Sources, Printed and Manuscript* (London, 1893; reprinted 1969), 79–80.

rience when under the rule of Rabbi Moses, a younger contemporary of
Elyakim ben Joseph. His son, Isaac of Vienna (c. 1180–c. 1260), who
would later become famous for his book' *Or Zaru'a* (The Shining Light),
recorded the event, explaining that the young Rabbi Moses succeeded in
having the images of "trees and of birds" removed from the synagogue
windows.[5] This anti-iconic trend did not lose any momentum in the im-
mediately ensuing generation. Around the year 1200 the authors of Sefer
Hasidim insisted (no. 1625) that no "likeness and image" [Hebrew: *tavnit
u-demut*] had a place in the house of prayer, and certainly not behind the
Ark of the Torah. The pious authors maintained that if Jews were seen to
bend with reverence toward the decorated Ark, gentiles might conclude
that "they [the Jews] worship images." This should have brought to an
end any further controversy, particularly since the Bible is adamant in
this respect. In his last words to the Israelites, Moses, the master of all
prophets, forbade such practices and warned them, "lest you become cor-
rupt and make a carved idol, the similitude of any figure, the likeness
[*tavnit*] of . . . any beast that is on the earth, the likeness of any winged
bird in the air, the likeness of anything that creeps on the ground, the like-
ness of any fish that is in the waters beneath the earth," and so on (Deut.
4.16–18). These mid-twelfth-century disputes in Cologne and Meissen
turned out to be mere preludes to what we may dare to label the "Jewish
iconoclasm" of the following centuries. The abolition of all traces of idol-
atry continued to be a major concern for the rabbis, but the nature of the
items to which they objected changed from stained glass to illustrations
and illuminations in the Hebrew manuscripts of prayer books. The pre-
sentation of human heads—and in particular, of faces—lay at the heart of
the ensuing struggle.

The first European Hebrew manuscripts that are decorated with narra-
tive illuminations date from the 1230s. Four early codices, three illumi-
nated during the 1230s and one in the 1250s, already provide informa-
tion about the tension between art and religious law that the revival
raised. The first of these manuscripts is the oldest surviving illustrated
Hebrew codex in Germany. It can be seen today in the State Library of
Munich (call number Cod. Heb. 5). The 474 folios of the manuscript
were bound into two volumes in the sixteenth century.[6] It is a commen-
tary on the Bible by Rashi and (toward the end) by his disciple Joseph

[5] *Or Zaru'a* 4:203, quoted in Kotlar, *Art and Religion*, 160. However, a more depend-
able version, which insists on Moses, the father of Isaac Or Zaru'a, as the actor in Meissen,
is produced in Moses Juda ha-Cohen Blau, *The Ancients' Interpretative System* (New York,
1991), 295n118 (in Hebrew). Cf. Urbach, *The Thosaphists*, 206n85, 437.

[6] For a description of the manuscript, see Elisabeth Klemm, *Die illuminierten Hand-*

Kara and the thirteenth-century grammarian David Kimhi. The manuscript was copied by the scribe Salomon ben Samuel of Würzburg in 1232 or 1233. The name of the patron Joseph ben Moses, who lived in Ulm, appears on folio 266v of the codex. The illuminator's identity does not appear anywhere, but modern scholarship has revealed that he was a Christian named Heinrich who was head of a workshop in Würzburg. He is also known for other, Latin illuminated books either done directly by his hand or produced in his workshop. When ordering the codex, Joseph ben Moses wished to have a painted panel at the beginning of each weekly portion of the Torah (Hebrew: *parashah*) read in the synagogue, which should be related to the subject matter. However, only seventeen panels were completed, two of which appear in what is now the second volume (fols. 183r, 209r). There is also an obvious difference between the art of the first volume and that of the second. The second volume contains no illustrations featuring people apart from the two just mentioned. Instead it is decorated with a great number of triangles, quadrangles, and circles. No explanation is given for this transition to geometric figures.

This Munich codex was subject to great intervention. Once the paintings of the first ten panels were completed, somebody erased from every panel all human frontal facial features, such as those of Joseph and his brothers (vol. 1, fol. 44v). Carefully and meticulously, eyes, noses, mouths, and chins were all scratched off and painted over with a layer of white pigment. A few unsuccessful erasures, obviously resulting from negligence, testify to the way the illumination must have been painted originally and the manner in which the effacing was carried out. A nice example is the portrait of Pharaoh on folio 37r.[7] While the identity of the person responsible remains unknown, it is not impossible that the erasing occurred while the artist was still engaged on the project. We may even imagine that when the patron saw the first results of the undertaking he

schriften des 13. Jahrhunderts deutscher Herkunft in der Bayerischen Staatsbibliothek: Textband (Wiesbaden, Germany, 1998), 198–202.

[7] During my visit to Munich in the early summer of 2005, volume 1 of the manuscript was in an exhibition in Berlin, so I could examine only volume 2 and some colored slides of volume 1. I have therefore relied on the work of Colette Sirat, who described Cod. Heb 5/1–2 thoroughly in *Hebrew Manuscripts of the Middle Ages* (Cambridge, 2002], 170. Years later I examined the volume digitally reproduced on the web. See also the recent detailed study by Eva Frojmovic, "Jewish Scribes and Christian Illuminators: Interstitial Encounters and Cultural Negotiations," in Katrin Kogman-Appel and Mati Meyer (eds.), *Between Judaism and Christianity: Art Historical Essays in Honor of Elisheva (Elisabeth) Revel-Neher* (Leiden, Netherlands, 2009), 281–305. Frojmovic deals with problematics that very much resemble mine. On the Jewish community in Würzburg, see Karlheinz Müller, *Die würzburger Judengemeinde im Mittelalter von den Anfängen um 1100 bis zum Tod Julius Echters (1617)* (Würzburg, Germany, 2004); 55–62 are devoted to the Munich manuscript.

FIGURE 10. Adam and Eve, almost entirely naked with their heads facing to the rear; figure from an early monumental Bible of three volumes. This Bible was copied sometime between 1236 and 1238, probably in Ulm, Germany. This figure appears in volume 1 (Ambrosiana Library of Milan, B30, fol. 1v).
Venetanda Biblioteca Ambrosiana, Milano/De Agustini Picture Library.

felt that the Christian artist was going too far with his frontal presentation of human faces. He may have become alarmed, and ordered the painter himself to alter his work. This could have been the reason why the figurative illuminations were abandoned in the second volume in favor of the abstract decorations.

An awareness of possible pitfalls is noticed by the commissioner of another codex of German Jewish origin, a giant Bible that today is preserved in three volumes in the Ambrosiana Library of Milan (Mss. B30, B31, B32). This codex, also created on the initiative of Joseph ben Moshe, was probably copied, sometime between 1236 and 1238 and this time in Ulm, by a scribe named Kalonymos ben Kalonymos. The illuminator of these codices was also Christian. Even though the illustrations of this Bible do not resemble the ones of the Munich codex, its volumes were also subjected to severe scrutiny. Features of human faces were either erased or avoided altogether. The first volume opens with Adam and Eve, both naked but partially covered, as the Bible describes, with leaves, their heads facing to the rear (B30, fol. 1v; see fig. 10). Frontal presentation is also avoided in the portrait of Abraham, but not in that of his son on the altar, although the features of the child's face were ultimately erased (B30, fol. 102r). As for Joseph lamenting the death of his father Jacob, the illuminator, or someone else, has painted over his head and reversed it so that only the back is seen (B30, fol. 56r). The face of King David is also effaced on three occasions: once when he plays the harp (B32, fol. 5r) and

FIGURE 11. King David in the Milan
monumental Bible (Ambrosiana Library
of Milan, B32, fol. 2v.) His face and
those of the three other persons that
surround him (Ruth the Moabite, the
prophet Elijah, and the riding Messiah)
are all covered with white paint.
 Venetanda Biblioteca Ambrosiana,
Milano/De Agustini Picture Library.

again when he is present at the coronation of his son Solomon. In this
case, the faces of the four other people who attended the ceremony were
also painted over with white paste.[8] The third instance is in a panel form-
ing part of the book of Ruth (B32, fol. 2v), where the images of Ruth, the
prophet Elijah, and the riding Messiah are all effaced. King David also
appears, and there again his face has not escaped the hand of the censor
(see fig. 11).

A third manuscript from these early years is *The Bible of Meschulam
and Joseph bar Qalonymos*, which is housed today in the library at the
University of Wroclaw (Ms. M. 1106). This codex was also copied in
Würzburg in the year 1238 and was probably illuminated around the
same time. The Bible is the subject of a study by Thérèse Metzger.[9] From

[8] See *Hebraica Ambrosiana*, part 1, *Catalogue of Undescribed Hebrew Manuscripts in
the Ambrosiana Library*, ed. Aldo Luzatto; part 2, *Description of Decorated and Illumi-
nated Hebrew Manuscripts in the Ambrosiana Library*, ed. Luisa Mortara Ottolenghi
(Milan, 1972). The catalog consists of two parts in one volume. In volume 2, plates 11–28
constitute a file of reproductions of most of the illustrations mentioned herein. For the
obliterated faces in the genealogy of Ruth see, however, volume 1, plate 1.

[9] Thérèse Metzger, *Die Bibel von Meschulam und Joseph Qalonymos: Ms. 1106 der
Universitätsbibliothek Breslau (Wrocław)* (Würzburg, Germany, 1994). Metzger added a

the extracts of this manuscript that are published as an appendix to Metzger's work, we can also observe an unwillingness to present the full frontal faces of the biblical heroes. Moses, "the lord of all prophets," is the only one whose head is depicted with all its features. He wears a pointed Jewish hat, the *pileus coronatus*, while his face, in a three-quarter view, has all the human features. He even wears a rabbinical beard (p. 123, plate 48; p. 132, plate 57). On the other hand, an aggressive intervention has erased most such features in the portrait of the "hostile enemy" Nebuchadnezzar, mounted on a lion during the siege of Jerusalem (p. 125, plate 50; p. 135, plate 60). Portraits featuring other biblical heroes were treated in another manner. For instance, King David playing the harp (p. 127, plate 52; p. 137, plate 62) must not have had any facial features painted from the beginning, with the exception of a red spot on his cheek. No erasure has been attempted on the three faces of the individuals feasting around the table in a panel that introduces the weekly reading of the Torah, *Va-Yehi* (p. 126, plate 52); their two-dimensional portraits (allowed by German rabbis) show a nose, a mouth, a chin, and eyebrows, but no eyes. The portraits of Mordechai and Esther had all the above features and would have been completely humanized if each of them had been given an eye as well(p. 138, plate 63). Obviously none of Haman's sons who were hanged on the tree deserved uncovered eyes. A hunter featured on the panel that shows Moses (p. 123, plate 48) lacks almost all human features, while King Solomon, at the beginning of the biblical book Kohelet (Ecclesiasticus) fares only slightly better (p. 124, plate 49; p. 134, plate 5). Given the precautions taken by the miniaturist of the Wroclaw manuscript, one can understand Metzger's feeling that he might have been Jewish and thus conscious of what was forbidden and what permitted. This suggestion is weakened by the fact that while the illuminator dared to show Adam and Eve nude, this proved to be too much for someone, and the illustration was erased with evidence of much emotion (pp. 128–29, plates 53–54).

The fourth codex in this group is a festival prayer book, illuminated around 1250 in the Rhine Valley, possibly in Cologne. Known today as the Amsterdam Mahzor and kept in the Netherlands in the Jewish Historical Museum (call number JHM B166), almost all its richly decorated folios feature creatures of all kind with the exception of humans. The figure of a contemporary Jew on folio 171v was probably added later, but his facial features were erased either by the patron who ordered the mahzor or by someone in the ensuing generations. Three other small human figures, painted in the zodiac symbols of "virgin" and "Gemini"

file of mostly black and white pictures to her study. My remarks are based on this publication, and citations are of the pagination in her book.

(fols. 45v, 46v), did not deserve more than a cursory distortion at the hand of the illuminator.[10]

This practice of erasure and avoidance of full facial features was not limited to these first encounters of German Jews with figurative art. It persisted for several more generations and far beyond the 1250s. None other than the most handsome Hebrew manuscripts remaining in France, the giant Poligny Pentateuch (Paris, Bibliothèque Nationale, Ms. Héb. 36), ordered by Aaron ben Jacob and copied by June 30, 1300, was censored, as its folio 283v shows. As late as 1462 (or even 1502), the Floersheim Haggadah previously in the Sassoon Collection; (Letchworth Ms. 511[11]) also underwent this form of Jewish iconoclasm. Only two out of the eighteen folios of this rather unimportant codex do not have humans in their margins. But less than a dozen out of the great number of people presented in the codex show intact frontal facial features. In many instances they are endowed with no more than an eye, a nose, or a mouth. In other instances, it is clear that erasure took place. The great majority of the illuminations were probably censored by the rather high-handed actions of a later "editor."

Blank-faced figures were yet another way of dealing with the difficulty. We have just seen it in the Meshulam and Joseph bar Qualonymos Bible and in a detached folio in the Ambrosiana Library in Milan. Another drawing of the Mount Sinai theophany in a mid-thirteenth-century German Mahzor, now in the Bibliotheca Palatina in Parma (Ms. Parm. 2887, fol. 101v) is an example of this radical solution: all six oblong faces of the Israelites are white and without features. To be sure, Moses was originally the exception to this, being depicted with all his features and also a beard, but ultimately someone ensured that they, too, were effaced. On the lower half of the same page, Moses is shown when he is about to lead the people in crossing the Red Sea. This time the Israelites and he himself all have featureless faces. Similarly, Pharaoh's daughter and her six maids were given blank faces in a painting from about 1470 that shows them bringing baby Moses out of the Nile (the first Yahudah Haggadah; Israel Museum, Ms. 180/50, fol. 7v; see fig. 12). However, a change of heart— or of artist—occurred in this same Haggadah; in another portrait on the same page a scholar is shown with all his facial features. This is also the case with many other human figures that appear in this codex.

[10] A facsimile edition of some folios has been published by Albert van der Heide and Edward van Voolen as *The Amsterdam Mahzor: History, Liturgy, Illumination* (Leiden, Netherlands, 1989).

[11] A facsimile edition of the Floresheim Haggadah was published in Zurich in 2007 by Meir Hovav and Iris Fishof. The original manuscript is the property of the Floresheim family in Zuruch.

בְּיָד חֲזָקָה וּבְזֹרִיעַ נְטוּיָה

וָאִלּוּ לֹא הוֹצִיא הַקָּבָּה אֶת

אֲבוֹתֵינוּ מִמִּצְרַיִם הֲרֵי אָנוּ

וּבָנֵינוּ בְּנֵי בָנֵינוּ מְשֻׁעְבָּדִים

הָיִינוּ לְפַרְעֹה בְּמִצְרַיִם

וַאֲפִילוּ כֻּלָנוּ חֲכָמִים כֻּלָנוּ

נְבוֹנִים כֻּלָנוּ יוֹדְעִים אֶת

הַתּוֹרָה מִצְוָה עָלֵינוּ לְסַפֵּר

בִּיצִיאַת מִצְרַיִם וְכָל הַמַּרְבֶּה

הַמְסַפֵּר בִּיצִיאַת מִצְרַיִם

הֲרֵי זֶה מְשֻׁבָּח

מַעֲשֶׂה בְּרֵבִּי אֱלִיעֶזֶר

וְרַבִּי יְהוֹשֻׁעַ

FIGURE 12. The daughter of the Pharaoh and her attendants recover the baby Moses from the Nile. All faces are blank. The illustration is from the First Yahudah Haggadah, produced in Franconia, southern Germany, between 1470 and 1480 by an unidentified scribe. It is handwritten on parchment with brown ink, gold leaf, and silver leaf, in square Ashkenazic script. H: 23.1 cm; W: 16.5 cm.

Photo: The Israel Museum, Jerusalem, by Ardon Bar-Hama. Gift of Rachel Ethel Yahuda, New Haven, Connecticut. Accession number B55.01.0109;180/050, fol. 7v.

The murals painted on the walls of the apartment at Brunngasse No. 8 in Zurich are at this point of much interest (see figs. 8 and 9 in chapter 4). An attentive examination of the faces of the eleven figures that appear in the two frescoes also raises the dilemma of empty faces. In the fresco of the dancing celebration, one person—male or female—who is standing behind the musician who plays the flute possesses all facial features while two of the dancing ladies are shown with their heads covered and only part of their facial features showing. All of the other five faces, as well as that of the musician, are featureless, due either to the ravages of time or, as I am inclined to think, to human intervention. Indeed, in the other fresco, which resisted the challenges of the centuries much better, its three figures—namely, the two ladies and the rider—are all depicted with blank white faces. In fact, the standing lady is presented with a geometrically designed circle. The message that these figures send, I would speculate, is that the rabbi intervened in the work of the painters not withstanding how tolerant to worldly culture he may have been. As in the illuminated manuscripts, here too the work of erasure was not done in a meticulous manner.

A pair of illuminated books for the high holidays dating from the late 1250s and '70s encourages us to search for a turning point in the history of a distortion that plagued German Jewish Art. It is the persistent appearance of animal headed figures in its manuscripts. The earliest of the two, the Michael Mahzor kept in the Bodleian Library, Oxford (Ms. Michael, nos. 617 and 627), was splendidly copied in 1258 by the scribe Judah bar Samuel, labeled "Saltman," and then decorated by a Christian painter, a most talented artist who illuminated the manuscript with a gentle scale of colors. Much of the artistic effort invested in this codex is devoted to the painting of twelve city gates. On the columns of these gates are painted beautiful birds, animals, and also unrealistic hybrids. The salient features of this work of art are its close attention to detail and its great delicacy. Folio 26r of manuscript Michael 617, for example, has an exact drawing of a unicorn and many other grotesques, all painted with much care. However, everything changes when it comes to human beings. While one of the "Gemini" twins of the zodiac, painted on folio 50v of the manuscript, is endowed with a two-headed bird, his sibling bears the head of a dog. On folio 59v, a horseman has a distorted face, while the heads of two knights on folios 11r and 34r are hidden beneath their metallic helmets. Folio 11r illustrates the battle in the desert between the Amalekites and the Israelites. The gentiles are depicted like medieval knights while the only Jew is presented as a bird-headed hybrid. The upper part of the same folio depicts a couple of foot combatants, both with dog's heads.

Twenty years younger than the Michael Mahzor is another Bavarian prayer codex, known as the Bamberg Mahzor, held today in the Jewish Theological Seminary of New York (Ms. 4843). This time, as well, the scribe introduces himself (fol. 162r) as Elijah ben Mordechai, native of Bamberg, and reports that his work of copying came to an end in the summer of 1279 (the twelfth of the month of Ab). This prayer book has no coloring at all, and its scribe may also have been its illuminator. Like his predecessor this illuminator is fascinated by gates (eleven of them), which he paints with much care and diligence. On other folios his geometry is perfect, and so is his depiction of animals such as the goat on folio 15v or the lion on folio 54v. But here also the art changes entirely when humans appear, and once again the illuminations are intentionally nonrepresentational: we observe a deliberate effort to distort the reality of human figures. Hence it is impossible to identify the creatures on folios 12r, 20v, 24v, or 29v. Some clarity is offered on folio 15v, on which we perceive not only human hands and their five fingers but also a face, in profile, that is endowed with a forehead, a single eye, a particularly long nose, a mouth, and a beard. No respect whatsoever is given to proportionality. That this is a portrait of a Jew is indicated by his typical hat. The man, if we just look at the right side of the panel, may even have been the cantor of the synagogue, as behind him appears what might have been the sacred Ark of the Torah, and in front of him, on a table, perhaps the Holy Scriptures. Still, our struggle with the illumination is far from over since the lower part of the Jew's body seems to be not that of a human but to have the limbs of what seems to be a bull or a cow. A more reliable interpretation, taking into consideration the image of a very lively cow painted on the left side of the panel, is that here we have the priest Eliezer, son of Aaron, preparing to slaughter a "red heifer"—a ritual of purification described in detail in the Bible in Numbers 19.

Folio 8r of this codex is easier to understand (see fig. 13). Our artist wished to illustrate the war in the desert against the Amalekites. The enemy is a foot soldier, a helmet on his head, and clothed in his chainmail armor (technically known as *hauberk*). He is stretching his hand toward what seems to be a sword or a javelin. The Jew has his hands strangely positioned, one up and the other down, a book in front of him on the table. Heaven, we may assume, will fight for him. This man is none other than Moses. Exodus 16.11–13 tells us that Moses, by then an old man, monitored the battle from the peak of a hill, even though he was weak and had difficulty using his "heavy" hands. When he made an effort and lifted his arm high, the Israelites were victorious, but when fatigue set in, luck was in the enemy's camp. Our artist, who expected us to be aware of the biblical narrative, presented the two positions of Moses rather

FIGURE 13. Moses, his body and face heavily distorted, monitoring the war against the
Amalekites. He can be identified by the hat he wears and by the position of his hands. An
Amalekite warrior is presented in his knight's armor. The image is in the Bamberg Mahzor,
copied in Bavaria in the summer of 1279.

Courtesy of the Jewish Theological Library of the Jewish Theological Seminary, New
York. Ms. no. 4843, folio 8r.

clumsily, in a single illustration. Thus, with the Bamberg Mahzor we have one of the most telling examples of the anxiety of German Jews when in search of some type of recourse in visual art. It is certainly not poor craftsmanship that caused these distortions. The artist could have done better if he had wished to, but wanted it to be this way. It is no wonder that this codex, or the previous one, did not fall prey to any kind of censorship.

The different strategies adopted by the Jews who were caught in a conundrum concerning the presentation of humans requires further discussion. There are a number of German codices, other than the two we have just discussed, dating from around the year 1300, where people appear as zoocephalic hybrids. The term *zoocephalic* refers to humans who are depicted with realistic bodies but carry the head of an animal.[12] It is well known that such surrealistic representations date back to the remote Egyptian past, to very ancient times in the Middle East, and to Roman antiquity.[13] They are not even particular to Jewish art during the period discussed here. Contemporary Christianity often depicted three of the four evangelists as animal-headed beings, each carrying the head of one of the animals in the vision of the prophet Ezekiel (1.1–28). Thus, according to the canonist bishop William Durandus (c. 1230–96), in his *Rationale Divinorum Officiorum* (I.iii.9), only the evangelist Matthew was to be presented with a human face while Mark should have a lion's head and John should have the head of an eagle. Luke's head should be that of an ox or calf (Latin: *vitulus*) as it is an animal fit for sacrifice, and repre-

[12] The problem is discussed in Bezalel Narkiss, "On the Zoocephalic Phenomenon in Medieval Ashkenazi Manuscripts," in *Norms and Variations in Art: Essays in Honour of Moshe Barash* (Jerusalem, 1983), 49–62.

[13] Thousands of Egyptian examples exist, and can be seen in important museums all over the world. Syrian hybrids which are reminiscent of those in Ezekiel's vision were discovered recently by archeologists at the site called Ein Dara. See James L. Kugel, *How to Read the Bible: A Guide to Scripture, Then and Now* (New York, 2007), 604–5. Hittite-carved ivory of animal-headed hybrids that may be prebiblical were discovered in Megiddo in the late 1930s. See Zofia Ameisenowa, "Animal-headed Gods, Evangelists, Saints and Righteous Men," *Journal of the Warburg and Courtauld Institutes* 12 (1949): 25n6, and 21–25 on the spread of deities of oriental religions in the Roman Empire. Recently a second-century mosaic with a dog's (or wolf's) head of the Egyptian God Anubis in shepherd dress has been discovered in Rimini, a commune in the Emilia-Romagna region on the Adriatic sea. Whether this is related to the cult of the Egyptian goddess Isis, which was very popular in the Roman Empire, is still the subject of scholarly debate. See Angela Fontemaggi and Orietta Piolanti, *Rimini Divina: Religioni e devozione nell'evo antico* (Rimini, Italy, 2000), 131n110. In the Norton Simon Museum in Pasadena, California, one can see a statue of the Indian god Vishnu, third in the divine hierarchy, as a hybrid carrying a boar's head.

sents "the Passion and sacrifice of Christ."[14] Indeed, an illustration in a
Latin Bible, probably produced during the lifetime of Bishop Durandus,
shows Luke, covered with a green toga, holding a book, and bearing a
beautifully painted head of an ox, colored in brown. This can be seen in
the Pierpont Library, New York (call number M436, fol. 362v). This sym-
bolic depiction of the evangelists is, of course, of much earlier origin,
going back to late antiquity and the Early Middle Ages. It can be found
in the writings of early church fathers such as Saint Augustine (354–430)
and even Saint Irenaeus of Lyon (late second century). The symbols of the
four evangelists appear at the mausoleum of Gala Placidia in Ravenna,
which dates from the years 425–430 CE, while the Romanesque tympa-
num of the church Saint-Trophime in the Provençal city of Arles, to give
a later example, shows Christ surrounded by three animals and one
human-angel that represent the four authors of the Gospels. A manu-
script in Durham Cathedral in England is another example from the
twelfth century; it shows three evangelists as animal-headed humans, as
does a prayer book from the next century kept at St. Gallen. Earlier evi-
dence also exists dating back to eighth-century codices.[15] It is worth not-
ing that the thirteenth-century Hebrew Bible of the Ambrosiana Library
in Milan, mentioned earlier in this chapter, also has an illustration that
shows such zoocephalic individuals (B32, fol. 136r). In this panel five
individuals are feasting at the messianic banquet of the righteous in
Heaven (see fig. 14). Of the five, the one on the left has a donkey's head
while his neighbors are shown, respectively, with the heads of a bear, an
eagle, a lion, and a deer. No explanation is provided.[16] It is not easy to
determine whether the original painter created this scenery or whether
this painting was added to later. Stylistically it is different from the other
illustrations of this Bible; it is not out of the question that this painting
was done about a generation later, around 1260, since zoocephalic pat-
terns had by then made strides into the world of Jewish art.

Yet before arguing that German Jews used the animal-headed art as a
means of enabling them to avoid presenting "normal" human figures in
their art, another, different explanation for the zoocephalic phenomenon
must be mentioned. This is found in the learned study published by the

[14] For William Durandus's statement, see *Corpus Christianorun—Continuatio Mediae-
valis*, vol. 140 (Turnhout, Belgium, 1995), 38–39. For the images of Luke, see William M.
Voelkle and Susan L'Engle, *Manuscrits Enluminés. Chefs-d'oeuvre de la Pierpont Morgan
Library—New York* (New York, 1998), 234. An earlier portrait of Luke, bullheaded, is kept
at the Bodleian Library, Oxford (Ms. Auct. D.2.16, fol. 71v). It was published in Jonathan
J. G. Alexander, *Medieval Illuminations and Their Methods* (New Haven, CT, 1992), 77.

[15] See Ameisenowa, "Animal-headed Gods," illumination 19c–d.

[16] See *Hebraica Ambrosiana*, part 2, plate 21; see also plate 28, which shows the sym-
bolic animals of Esekiel's vision.

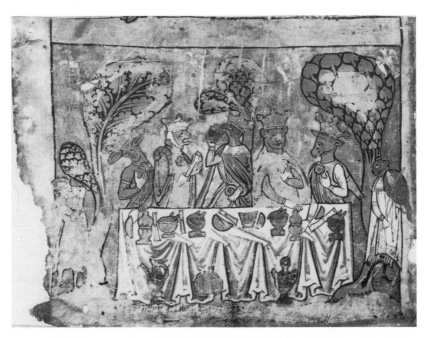

FIGURE 14. The messianic banquet of the righteous in heaven painted on folio 136r of the second volume of the monumental Ambrosiana Bible (Ambrosiana Library of Milan, B32). All six people have animal heads. This illumination may have been added to the codex some years later.
 Venetanda Biblioteca Ambrosiana, Milano/De Agustini Picture Library.

well-known Polish Jewish art historian Zofia Ameisenowa in 1946 (see n. 13, this chapter). Based on ancient Jewish literary evidence, both orthodox and apocryphal, and encouraged by the positive attitude of the zoocephalic phenomenon in medieval Christianity, Ameisenowa suggested that these hybrid forms represented "sinless pure souls" of "just Jews" known for their exemplary religiosity. The fact that this occurred only in Germanic lands and only between 1250 and 1350 CE was related to the influence exercised by the mystics whom we know as the Ashkenazi Hasidim, leaders in the German kabbalah. However, this brilliant study does not explain why this "strange iconographical motif" of Jewish art, as Ameisenowa puts it, was limited to Germanic lands only. It is well known that this fascination with Jewish mystical thinking was not peculiar to the Rhineland and that it flourished much more vigorously in Spain and Italy in this period and in the ensuing centuries. If this was the case, then why were Sephardi Jews in Iberia and Ashkenazi Jews in neighboring France and Italy spared from such surrealistic art? Why are their illustrated prayer books free of such distortions and instead replete with

straightforward depictions of men and women? Given these questions, I believe we still need to pursue our quest for an understanding of the beliefs that tormented the minds of German Jews—or at least an important segment of their community.

One of the most authentic examples of this peculiarity in German Jewish art is the giant Laud Mahzor in Oxford, probably produced around 1260 and painted by a non-Jew, perhaps under Jewish supervision. While human figures of any form are rather rare in the Michael and the Bamberg Mahzorim there are plenty of them in the Laud Mahzor (Bodleian Library, Ms. Laud 321).[17] Dozens of men and women are shown at different moments in their daily activity. The frontal presentation is avoided in favor of the two-dimensional legitimate profile, and even then most of the faces are greatly distorted (e.g., fol. 184r; see fig. 15). Some of the figures have extended and sharp lips resembling birds' bills; others have beaked noses with mouths and chins that convey the impression that they are fowl. The mouths of most people are extremely long, almost reaching their neck (see folios 43v, 49v, et al.). Some of the faces have thin and flat chins and resemble the heads of lion cubs or dogs rather than humans (e.g., fol. 97v). There is no doubt that all are Jewish, as many of them are wearing the typical hat. Scholars and rabbis do have the right to wear a noticeable beard. On the other hand, folio 53v shows a cow in its perfectly natural dimensions, while much effort and care was invested in the painting of dozens of unrealistic creatures.

The distorted faces found in the Laud Mahzor very much resemble those depicted on the frontispiece of another contemporary codex, the Worms Mahzor that now resides in the National Library, Jerusalem (Ms. Hebr. 4 781/I; see fig. 16). This mahzor has two parts, the first probably completed in Würzburg (and not in Worms) after forty-four weeks of labor by the scribe Simha ben Judah of Nuremberg on the first day of 1272, the second was completed some ten years later by a different scribe and a different illuminator. Today the codex has been bound erroneously, so that the early part comes second. For this reason scholars have to choose which sequence to follow. Some provide two numbers for each folio. I have chosen to use the numbers established by the National Museum of Jerusalem. The illuminator of the early part may have been a Jew of French origin named Shema'ayah ha-Tsarphati (fol. 95r).[18] He was

[17] A particularly beautiful colored reproduction of folio 165v of this mahzor is published in Binyamin Richler, *Hebrew Manuscripts: A Treasured Legacy* (Cleveland, OH, 1990), 50. Eva Frojmovic discovered instructions in Latin to the painter of this mahzor; see "Early Ashkenazic Prayer Books and their Christian Illustrations," in Piet van Boxel and Sabine Arndt (eds.), *Crossing Borders: Hebrew Manuscripts as Meeting-place of Cultures* (Oxford, 2009), 45–56, esp. 52 (for the Latin).

[18] A facsimile edition was published in Vaduz in 1983, the editors suggesting that the

FIGURE 15. Abraham about to sacrifice Isaac. Neither father nor son (nor the angel that points to a sacrificial lamb) have human faces. Animal-headed people are presented throughout this, the Laud Mahzor, from around the year 1260.

The Bodleian Libraries, University of Oxford. Ms. Laud 321, fol. 184r.

FIGURE 16. The frontispiece of the Worms Mahzor, which was perhaps illuminated by a Jew (fol. 237v). The body of the person is of normal proportions while his head is that of a bird. This mahzor has two parts, the first completed on the first day of 1272.
 Manuscripts Department, National Library of Israel. Ms. Hebr. 4° 781/I fol. 1v.

also fascinated by city gates; on the first of the four that he painted can be found a figure similar to those mentioned above (part 1, fols. 1v, 48v,

illuminator was Shema'ayah ha-Tsarphati. See Gabrielle Sed-Rajna, *Le Mahzor enluminé: les voies de formation d'un programme iconographique* (Leiden, Netherlands, 1983), 66. Colette Sirat, *Hebrew Manuscripts of the Middle Ages* (Cambridge, 2002), 163, also raises this possibility.

111r; part 2, fol. 73r), of a bearded Jewish man wearing the typical Jewish hat. Bird-headed men appear also in the zodiac medal of Gemini (fols. 57v–59v), in a wedding scene (fol. 34v) and at work in a bakery (fol. 129r), but not in the illustrations of the hanged sons of Haman (fols. 19r, 57r–59v). Their features are erased, a fact leading us to the conclusion that originally their faces were full. If I am not mistaken, this weakens the possibility that the illuminator was Jewish. In any event, no external intervention altered the art of the mahzor.

———————

The Leipzig Mahzor, or Mahzor Lipsiae (Universitaetsbibliothek Leipzig, Ms. V. 1102) is yet another prayer book dating from about 1320 that escaped Jewish censorship. [19] It has only one full-page panel, which is of superior artistic quality. The artist's sure hand is demonstrated in the scale of colors in the panel, the imaginative depiction of city gates and urban buildings, and the inclusion of many animals, birds, and monsters in the margins of several folios. Everything is painted with great care and remarkable ability. The body language of people at different times of the day is captured in a most exact manner. As for people's faces—most are shown in profile—it contrasts with the Laud and Worms Mahzorim, since sharp edges are systematically avoided. The noses, mouths, and chins are still beaked but they are also rounded, a fact that makes them less distorted—at least to a modern observer. Special attention is given to eyes and eyebrows. The puffed and wavy blond hair shown on many people is carefully groomed. The Jewish hat is present, but some of the men do not wear it and are recognizable only by their beards. While the identity of the artist cannot be decisively ascertained, the possibility that he was Jewish cannot be discounted, since the mahzor contains scenarios with which a Christian would not have normally been acquainted. On folio 27r, for example, Jews are in the midst of divine worship, with their ritual shawls (Hebrew: *talit*) on their shoulders (see fig. 17). Folio 59r has a humanized painting of the moon with its eyes wide open and two Jews in prayer giving the traditional welcome to the new month. Two other Jews who are blowing the shofar appear on folio 176r. In another illumination (fol. 131r) we see a teacher surrounded by his students and a fa-

[19] A CD-ROM edition was recently published by the German Historical Museum and Leipzig University Library (2004). For this discussion I consulted Elias Katz and Bezalel Narkiss, *Mahsor Lipsiae: 68 Faksimile Tafeln der mittelalterlichen hebräischen illuminierten Handschrift aus dem Bestand der Universitätsbibliothek Leipzig* (Hanau, Germany, 1964); the authors hesitate to ascribe the illuminations to a Jewish artist but entertain the possibility (104). The Schocken Haggadah of around 1400 has also such similar features. See Joseph Gutmann, *Hebrew Manuscript Painting* (New York, 1978), plate 18.

FIGURE 17. The Leipzig Mahzor, copied in southern Germany at the first quarter of the
fourteenth century, presents in this illustration (on fol. 27r) three Jews engaged in prayer.
The faces of the first two are indeed those of birds but painted with a gentle hand. The
last person in the line has a perfectly human face.

 Universitaetsbibliothek Leipzig, Ms. v. 1102/I–II .

ther bringing his son to school for the first time. As in other monuments
of Jewish art, the Leipzig Mahzor also shows King David playing the
harp, Moses handing down the Ten Commandments, and Abraham with
his son on Mount Moriah. In all these instances the artistry is benign and
gentle, and the high quality of the mahzor's art makes up for the slightly
distorted human portraits. Remarkably, no trace of Jewish censorship
can be revealed.

 The Lepzig Mahzor did not, however, change the course of art history;
distortion and surrealism continued to be present in German Jewish art.
The makers of the Bird's Head Haggadah, (which, incidentally, was cop-

FIGURE 18. The Bird's Head Haggadah. Although copied by a certain "Menahem," the same scribe as the Leipzig Mahzor (see fig. 17), it presents in a very pronounced manner all the Israelites with birds' heads, covered, however, with the typical Jewish hat. Handwritten on parchment with dark brown ink and tempera; in square Ashkenazic script. H: 27 cm; W: 18.2 cm.

Photo: The Israel Museum, Jerusalem, by Ardon Bar-Nama. Purchased through the gift of Fred Monosson, Boston. Accession number B46.04.0912; 180/057, fol. 22r.

ied by the scribe of the Leipzig Mahzor), used the system of animal heads extensively. This Bird's Head Haggadah can be found today in the Bezalel Art Museum in Jerusalem (call number Bezalel 180/057).[20] The vast majority of illuminations consist of depictions of human beings. No animals or flowers and (with one exception) no grotesques can be seen in the unnumbered folios of the codex. Birds are the only animals depicted in the hybrids. In this work I have counted ninety-one men and eight women. Most of the men are wearing the Jewish hat and some are bearded. A considerable number of them are either preparing for the feast or already celebrating the seder. As in other codices of this genre, the painter has included some "classic" events of Jewish sacred history such as the crossing of the Red Sea (fol. 22r; see fig. 18), Moses handing down the Commandments on Mount Sinai, or Abraham about to sacrifice his son. But there are also unique scenarios, such as that of the Israelites in the desert collecting the manna from heaven, or the Garden of Eden with its angels.

[20] Moshe Spitzer (ed.), *The Bird's Head Haggadah of the Bezalel National Art Museum in Jerusalem*, 2 vols. (Jerusalem, 1976). The facsimile is accompanied by a volume of studies.

Most interesting is the scene where Pharaoh at the head of the Egyptian Army (fol. 24v), carrying the flag and the insignia of the German Empire, is chasing the Israelites at the beginning of their exodus. There are eight of these German knights and their servants, and other than Pharaoh they are the only non-Jews featured in this Haggadah.

While most of the folios remain fresh, with undamaged paintings, about fourteen of the portraits have suffered degradation. In eight cases this may have been the result of negligence on the part of the proprietors, but in the other six I believe that erasures have been done deliberately by human hands. The round face of Pharaoh, when chasing the Israelites, is blank. Three, or possibly only two, of his knights are one-eyed, with no other facial features. Amazingly, a bird-headed Jew covered with his talit standing by a prayer stand and pleading for salvation has had the features of his face erased (p. 68). The face of another bird-headed Jew (p. 69) who holds a chalice and is pronouncing the blessing over the wine has also been erased. At least four other faces are scratched out as well.

––––––––––––––

The century between 1230 and 1330 seems to have been the high point of German Jewish iconoclasm. Many, perhaps most, of the decorated manuscripts from this period were heavily censored by pious Jews. However, this type of aggressive interference with artists' work was not the only means of displaying piety during these years. There were Jewish patrons who looked for more subtle ways to practice their Judaism and enjoy art at the same time. Thus, for example, the accomplished artist (or artists) of the Dresden Mahzor (Sächsische Landesbibliotek/Staat und Universitatsbibliothek Dresden, Ms. A46a) of the 1290s followed all the rules of restraint. On folio 202v of the codex (the only full-page painting in the manuscript; see fig. 19), where Moses appears twice, once receiving the Ten Commandments and once handing them over to the Jews, his face is the only one to have full features. The other nineteen Israelites at Mount Sinai, both men and women, are portrayed in such a way that their faces are either partly or totally hidden. Some have the upper part of their heads almost completely covered by some sort of headgear. One woman covers her face with her hand, while another is only seen from the back (as we have already witnessed in the Ambrosiana Bible). Other attendants raise their arms in exhilaration and thus their heads are hidden. In three other instances the people's faces are simply featureless, round blank circles and nothing more. This artist's clever strategy paid off, and nobody touched his work.

During this century, too, iconoclasm did not always prevail throughout Germany, and some of the "nonconformist" manuscripts escaped censorship. The most remarkable of these, in my opinion, is the Regens-

FIGURE 19. Theophany. Moses receives the law given to him by a heavenly hand, while the Israelites react in exaltation. Most figures on this page of the Dresden Mahzor (c. 1290) are shown from the rear and with few exceptions human faces are not presented in frontally. Kept in the State and University Library of Saxony in Dresden (Ms. A46a, fol. 202v).

SLUB Dresden/Deutsche Fotothek/Regine Richter.

burg Bible of 1300, now in the Israel Museum in Jerusalem (Ms. 180/052). The patron who commissioned it was Gad bar Peter "The Levite," a leader of the Regensburg community who bore the secular title of Parnass. This rich—and I assume powerful—man did not permit any zoocephalic hybrids, distortions, or erasures to his codex. If some of the faces have lost their features, this is due probably to the toll of time and spontaneous degradation, not to human intervention. Such is the case of the victorious Mordechai riding the horse (fol. 157v) or of three of Job's four friends (fol. 225v). All other people depicted in this ornate Bible, whether Abraham and his son Isaac (fol. 18v) or the Israelites at the foot of Mount Sinai (fol. 154v), have well-proportioned bodily features (see fig. 20). This is certainly the case with the magnificent presentation of the front-facing Aaron the High Priest, who wears a bishop's miter (fols. 155v–156r). Several Jewish men wear the typical hats and have full-featured faces in profile, while the women (fol. 18v) show three quarters of their faces.

Another nonconventional German example is that of the Coburg Pentateuch (British Library, Add. Ms. 19776) copied in 1395 by Simha bar Shmuel "the Levite" and punctuated by two other contemporaries, Shmuel bar Abraham and Gershom bar Yehuda. The patron's name must have been "Meir." This midsize codex has on folio 54v a portrait of King Solomon in three quarter view (see fig. 21) and on folio 72v, a similar face of a teacher educating a student. Folio 96r of this codex depicts a Jew praying and shows a face with almost all of its features. Among the trea-

FIGURE 20. Theophany. A scene on folio 154v of the Regensburg Bible (c. 1300), a most handsome codex produced in Bavaria. One of its scribes was a certain David ben Sabetai. The patron who commissioned the codex was a leader of the community of Regensburg and bore the secular title of Parnass; his name was Gad bar Peter "The Levite." All human figures are of reasonable proportion and all faces in the portrait have natural features. Some, however, may have been erased by time. H: 24.5 cm; W: 18.5 cm.

Photo: The Israel Museum, Jerusalem, by Ardon Bar-Hama. Ms. 180/052.

FIGURE 21. King Solomon with all facial features in three-quarter view, in the midsize Coburg Pentateuch copied in 1395.
The British Library Board. Ms. Add. 19776, fol. 54v.

sures housed in the British Library there is a German codex of around 1360 (Add. Ms. 27137), which is the fourth part of the legal code *Arba'ah Turim* (Four Columns) by Jacob ben Asher. On folio 14r the portrait of a rabbinic sage of late antiquity is shown with full face. The painting is not well preserved but it is possible to realize that the sage is surrounded by a dozen people, half of them looking straight into our eyes.

A recent discovery made in the Communal Archives of Modena may also join this short catalog of noncompliant manuscripts although chances

are it was painted outside of Germany.[21] It is an illuminated folio of an early-fourteenth-century Hebrew Bible, showing young David confronting Goliath. The folio, which had been removed from the original Hebrew Bible some centuries ago, was used as a cover for a Latin codex, and was recovered by Mauro Perani of Ravenna. It forms part of the European Geniza Project, which has been established in recent years with the aim of reclaiming such manuscripts, many of them written on parchment. Goliath, the Philistine champion, is represented here as a heavily armored knight, while curly haired David wears a simple shepherd's shift. His face is in three quarter view, almost full frontal. The face of a man carrying a shield who stands between the two combatants is in almost perfect two-dimensional profile. He is the "shield bearer" who went before Goliath, an individual mentioned in the Bible in just a few words without farther comment (I Sam. 17.41). No intervention by any censorship has altered the illumination. However, as mentioned already, it is not at all certain that the document is of German origin since the script of the manuscript suggests a possible Italian provenance.

Jews of the same period in the Apennine Peninsula seem to have been less cautious about their human portraits, as testified by a Pentateuch that is kept today in the Jewish Museum of Venice (Ms. no. 85). It leaves no doubt of its departure from the Germanic approach. The scribe, Daniel ben Shmuel, a medical doctor, started his work in Pisa in the year 1398 and completed the project in Perugia during the last quarter of 1404. Folio 2v of his codex shows the face of a musician in a full-featured frontal manner. A similar human head can be seen on folio 10r. An elaborately illuminated panel can be observed on folio 19v: here we have a bearded person, his face in profile and painted in full detail, leading a heavily charged horse. No sign of hesitation can be detected in this Pentateuch. Of particular aesthetic value is the portrait of a mystic that forms part of another manuscript of the treatise *Or ha-Sechel* (Light of the Intellect) authored in the thirteenth century by the Spanish kabbalist Samuel ha-Levi Abulafia. Kept today in the library of the Vatican (ebr. 597, fol. 113v), it is one of the most spectacular portraits in the corpus of Jewish art. The odds are, however, that it dates from the fifteenth century rather than the thirteenth, and that it is a product of Italy.

Back on Germanic soil we find yet another school of illuminators that exhibited human faces in full while at the same time presenting paradoxi-

[21] See Mauro Perani and Saverio Campanini, *I frammenti ebraici di Modena. Archivio storico comunale.* Inventari dei manoscritti delle biblioteche d'Italia 110 (Florence, Italy, 1997), 78, 100.

cally zoocephalic and hybrid creatures. For some Jewish or non-Jewish painters these distortions became simply a distinguishing feature of Jewish art. A fine representative of this group is a giant mahzor (450 folios) from about the year 1320, originating from the Lake Constance region of southern Germany, which is presently kept in Paris (Bibliothèque de l'Alliance Israélite Universelle, Ms. 24H). It is handsomely colored (see, e.g., fol. 14v) and profusely illuminated with imaginary animals (fols. 30v, 59r, 75v, 91r, 264r, 306r). The facial features were only erased in one illustration, that of a man blowing the shofar (fol. 42r), yet in this same folio the face of the rabbi, who is instructing the man to go on with the ceremony, is entirely untouched. Moreover, hybrid figures can be seen in this mahzor on folio 74v (a man with a goat's face), folio 196v (the lower part a man's body is that of a bird), and particularly folio 259v, where the lower part of a man's body is that of a dragon. Side by side with these distortions we have, however, on folios 42r, 84v, 86v, and 198v, undistorted human features painted quite realistically in profile.

A similar major work of Jewish art that comes from the same region is known as the Tripartite Mahzor. Here, too, we are offered a mixture of reality and fantasy. This mahzor, which was originally assembled in two volumes, is today bound into three different codices, one deposited in Budapest (Hungarian Academy of Sciences, Ms. A. 384) and the other two in England (Bodleian Library, Ms. Mich. 619, olim 439; British Museum, Add. Ms. 22413). Also produced in the first quarter of the fourteenth century, it depicts some hybrids in the traditional zoocephalic manner, while other figures on the same page are perfectly human. For example, the theophany (see fig. 22) is the subject of an important panel in this mahzor (British Museum, fol. 3r). It shows Moses, Aaron the priest (with a bishop's miter on his head), and all the other Israelite men with normal human heads. The women who stand behind, in a separate group, all have dog's heads.

On yet another panel of this mahzor, the two women who brought their claim to motherhood of a surviving newborn before King Solomon are also shown in a zoocephalic manner (Hungarian Academy of Sciences, fol. 183v). The king's face, when he issues his famous verdict, is perfectly human. However, this male-female dichotomy does not prevail in another panel of the Tripartite Mahzor: the same codex that shows Moses, Aaron, and the Israelites near Mount Sinai also contains (on folio 71r) an illustration depicting the entrance of Ruth the Moabite into the field owned by Boaz, her future husband. All the peasants laboring in the field have either animal heads or distorted faces. Ruth, elegant and beautifully dressed, is nevertheless depicted in a zoocephalic manner. The only man who is not engaged in any manual work on this summer day, but rather issues orders, is the landlord Boaz. He is endowed with a most

FIGURE 22. Theophany. The Israelites attend a sacred event separated in two groups: one of men and the other, behind the men, of women. The men all have complete human facial features, the women have animal heads. The illumination is found in volume 2 of the Tripartite Mahzor.
 The British Library Board. Ms. Add. 22413, fol. 3r.

pronounced dog's head. While it is difficult to understand the reason for attributing animal heads only to women in the first two miniatures, we may assume that the artists who painted this mahzor were all Christians. As has been said, they must have considered the zoocephalic distortion to be an idiomatic decoration typical of Jewish art. (This is Bezalel Narkiss's explanation, which Zofia Ameisenowa would not have endorsed.[22]) This

 [22] See Bezalel Narkiss, "A Tripartite Illuminated Mahzor from a South German School of Hebrew Illuminated Manuscripts around 1300," in *Proceedings of the Fourth World Congress of Jewish Studies*, vol. 2 (Jerusalem, 1968), 125–33; and, more recently, Sarit Shalev-Eyni, "The Tripartite Mahzor" (PhD diss., Hebrew University of Jerusalem, 2001; in Hebrew). For Ameisenowa's interpretation see her "Animal-headed Gods," 31. See also Sarit Shalev-Eyni, "Illuminierte hebräische Handschriften aus dem Bodensee-Raum," *Kunst und Architektur in der Schweiz* 51 (2003): 29–37, in which reproductions of the three panels discussed above are printed. The theophany scenery is reproduced in Colette Sirat, *Hebrew Manuscripts*, 171, plate 106. The occurrence of one zoocephalic figure in the Barcelona Haggadah of 1350–60 (British Library, Ms. Add. 14761, fol. 26v) has to be interpreted as a typical Jewish decorative idiom. That it is meaningless and carries no theological weight is evidenced from the fact that this manuscript (similar to all other Sephardic Hag-

may also explain the mixture of the zoocephalic and the realistic that marks the decoration of a small Hebrew Psalter, possibly of Tuscan provenance, which is can be found in the Bibliotheca Palatina in Parma (Ms. Parm. 1870, De Rossi catalog no. 510). In this codex from the beginning of the fourteenth century, the male-female dichotomy has no role to play as the few dozen human beings depicted in it are all men, with the possible exception of one woman (fol. 66v). About half of them have faces all with normal features, the most remarkable of which appear on folios 56v, 107v, 118v, and 213v, showing a conductor and his choir while the lower part of his body is hidden. The bodies of the other half are also normal, but they have animal heads. In this second group can be seen the heads of several dogs, a cat, a griffin, and a lion. On folio 105v there is an eagle-headed man playing a string instrument. But unlike the Tripartite Mahzor, the Parma Psalter has only one example (folio 66v) in which both animal and human heads appear on the same panel.[23]

German Jews thus had to engage in a rather long struggle over the introduction of art into their prayer books. Particularly difficult was the issue of representing full-frontal faces. Around the year 1200 the Ashkenazi pietists went so far as to insist that Hebrew Bibles should not be adorned with micrography—that is, designs in the shape of animals and flowers—lest the devout not display the intense concentration that is required during the prayers (see Sefer Hasidim, exemplum no. 709).[24] About a century later, Rabbi Me'ir of Rothenburg (known as Maharam Rothenburg, c. 1220–93) also expressed similar concerns that worship might be distracted by the images of birds and animals that could catch the eyes of the

gadoth) has hundreds of men and women who all, without exception, have full human heads. Even the dozens of animals and birds that decorate the margins of many folios carry human heads. See Jeremy Schonfield (ed.), *The Barcelona Haggadah: An Illuminated Passover Compendium from 14th-century Catalonia in Facsimile (MS British Library Additional 14761)*, 2 vols. (London, 1992). See also Isidoro G. Bango, *Remembering Sepharad: Jewish Culture in Medieval Spain* (Washington, DC, 2003), 125.

[23] See Malachi Beit-Arié (ed.), *The Parma Psalter: A Thirteenth Century Illuminated Hebrew Book of Psalms with a Commentary of Abraham Iben Ezra*, 2 vols. (London, 1996). This companion to the facsimile edition includes studies by Malachi Beit Arié, Thérèse Metzger, and Emanuel Silver in its second volume. See especially Thérèse Metzger, "A History and Analysis of the Manuscript," 29–148.

[24] See Joseph Gutmann, "Masorah Figurata: The Origins and Development of a Jewish Art Form," in *Sacred Images: Studies in Jewish Art from Antiquity to the Middle Ages* (Northampton, England, 1989), article 15; Leila Avrin, "A Note on Micrography: A Jewish Art Form," *Journal of Jewish Art* 6 (1979): 112–14; and Leila Avrin, *Hebrew Micrography* (Jerusalem, 1981). See also, more generally, Johann Maier, "Bilder im *Sefer Chasidim*," in Michael Graetz (ed.), *Ein Leben für die jüdische Kunst: Gedenkband für Hannelore Künzl* (Heidelberg, Germany, 2003), 7–14.

cantor (the only one in many congregations that was praying from a book), and thus the faithful would "not be directing their hearts to their Father in Heaven." His thinking had nothing to do with any rejection of art as a matter of principle. For him the inclusion of illuminations did not constitute any transgression of the Deuteronomy commandment "you shall not make other sculpture or image." Only three-dimensional sculptures are forbidden by Jewish law, Maharam explained, not two-dimensional spots of color on parchment or paper. Given his immense authority, Maharam's teaching did not, of course, go unnoticed. Two scribes who claim to have been disciples of "Master Me'ir" were actively involved in the production of two of the mahzorim mentioned earlier—namely, the Dresden Mahzor (Sächsische Landesbibliothek, Ms. A46a, fol. 285r), and also one of the codices of the Tripartite Mahzor (Budapest, Hungarian Academy of Sciences, Ms. A384, fol. 100r).[25]

In the Late Middle Ages, a successor of Rabbi Me'ir, Jacob ben Moses Molen (or Möhlin?), known as the "Maharil," a rabbi of Mainz (c. 1360–1427), also adopted this attitude of moderation. He limited his disagreement to praying from elegant illuminated prayer books (Hebrew: *mahzorim na'im*) on the Day of Atonement, the most holy day in the Jewish calendar.[26] But he must have been aware that he was engaged in an uphill battle. By this time German tradition highly appreciated lavishly decorated manuscripts even for such holy prayer books. The following examples are just a few out of the many volumes that must have existed in the rabbi's time. Thus the bibliographer Benjamin Richler reports the acquisition of an ornate Mahzor for Yom ha-Kippurim of German origin, which is housed in the National Library of Jerusalem (JNUL 38 5214.) Our distinguished colleague published folio 84r of this mid-fourteenth-century codex, which is indeed colored in a most refined manner. A south German mahzor copied in Ulm at the end of 1345 is today kept in the Vatican (ebr. 438) and introduces the morning prayers of the holy day with two full-page panels (fols. 107v–108r) gloriously decorated. The portrait of an almost naked woman in the lower part of folio

[25] The responsum number 97 of Meir of Rothenburg can be found in the 1891 Berlin edition of his *Responsa*, 134–36, and also in the Tosafot to tractate Yoma in the Talmud, fol. 54a–b. For a translation of the responsum, see Kalman P. Bland, "Defining, Enjoying and Regulating the Visual," in Lawrence Fine (ed.), *Judaism in Practice: from the Middle Ages through the Early Modern Period* (Princeton, NJ, 2001), 281–97, esp. 292–94. For the information on Maharam's disciples and the production of two illustrated mahzorim, see Sed-Rajna, *Le Mahzor enluminé*, 67–68, 71.

[26] See *Sefer Maharil, Hilchot Yom Kippur*, [Maharil's book, *The Rules of the Day of Atonement*] (Savionetta, 1556), fols. 61v–62r; my friends Judah Galinsky and Simcha Emanuel directed me to this rare edition. I consulted also Shlomo J. Spitzer, *The Book of Maharil: Customs by Rabbi Yaakov Mulin* (Jerusalem, 1989), 340–41 (in Hebrew). For the Jerusalem Mahzor see Richler, *Hebrew Manuscripts*, 53.

107v of this codex, as well as the two small hybrids in the next folio, could have been seen to easily distract the cantors' attention from the prayer. The already mentioned Worms Mahzor of 1272, starts the series of Yotzeroth, prayers of the day, with an illumination that occupies the upper half of the panel with a magnificently ornate urban gate (fol. 73r). Finally, a fragment of a prayer book of around 1300, kept in the Ambrosiana Library of Milan is profusely decorated at the beginning of the most sacred prayer, the Kol Nidrei (see chapter four, n. 4).

The uneasiness (to say the least) that we have revealed among German Jews as far as art is concerned and, in particular, about the depiction of frontal faces of humans, is not very difficult to explain. Hybrids and grotesques of all kind appeared by the thousands in the art of the environment, whether in painting or sculpture, or in literary fantasies such as the *Deeds of Alexander*. Animal-headed creatures are also there and do not necessarily symbolize the four evangelists.[27] It is not surprising at all that many of these fantasies found their way into the Jewish art of the time. However, the presence of animal-headed creatures in medieval Jewish art is not to be attributed to an unavoidable acculturation only. Its function is not merely to entertain or to astonish; rather, one has to look in the realm of theology for the reason for its frequent appearance. This is particularly true when we consider the refusal to engage in simple frontal facial depiction of humans. It appears that a rather widespread consensus in support of this prohibition existed in Germany. Even an independent thinker like Rabbi Ephraim ben Isaac ben Abraham of Regensburg (c. 1110–75), who did not hesitate to stand up against Elyakim ben Joseph in the 1152 Cologne imbroglio,[28] shared the prevailing view. He relied in this on the Talmudic teaching that portraits of all animal faces with the exception of human ones (Hebrew: *parzufot*) may be reproduced (Avodah Zarah 42b). More than a hundred years later the most revered Meir of Rothenburg repeated this axiom.[29] The reasoning behind

[27] See Hannes Kastner, "Kosmographisches Weltbild und Sakrale Bildwelt: Meerwunder und Wundervölker im mittelalterlichen Kirchenraum," in Katrin Kröll and Hugo Steger (eds.), *Mein ganzer Körper ist Gesicht: Groteske Darstellungen in der europäischen Kunst und Literatur des Mittelalters* (Freiburg, Germany, 1994), 216–37. See also Sarit Shalev-Eyni, "Obvious and Ambiguous in Hebrew Illuminated Manuscripts from France and Germany," *Materia giudaica* 7 (2002): 249–71.

[28] The text of Rabbi Ephraim is transmitted by other rabbis. See Kotlar, *Art and Religion*, 161–65. See also note 29, below. For a translation into English, see Mann, *Jewish Texts*, 39–52; 84. See also Urbach, *The Thosaphists*, 200–201. Rabbi Ephraim may have resided in Speyer when the controversy broke off.

[29] Kotlar, *Art and Religion*, 161–65. Rabbi Ephraim's discussion is reproduced in the Prague edition of Maharam's *Responsa*, no. 610. The responsum of Meir of Rothenburg is

the consensus seems, of course, to rely on the famous Second Command-
ment forbidding the misrepresentation of God, "Thou shall not make for
thyself any carved idol" (Exod. 19.4; Deut. 5.8), but also—and in a more
pertinent manner—on the frequently repeated statement, first found in
Genesis 1:26–27, that God created humankind in his image: "And God
said, 'let us make mankind in our image after our likeness'; so God cre-
ated mankind in his own image, in the image of God created him [the
man]." A German kabbalist of this generation, David ben Judah he-Hasid,
who was imbued with the theories of this doctrine and its terminology (I
rely here on the analysis of Moshe Idel),[30] expressed it less dogmatically
when he wrote that "man is called the microcosm in relation to the super-
nal world" and that humankind is in fact nothing but a replica of a higher
anthropomorphic realm. In consequence, the way Moshe Idel renders the
thinking of David ben Yehudah he-Hasid, "the Divine name is inscribed
on the human face in order to generate affinity to the supernal form."[31] In
consequence (this is what one would learn from David ben Yehudah's
teaching), painting a human face borders on idolatry. Much more so since
Moses, "the father of all prophets," was warned by God himself—"Thou
canst not see my face" (Exod. 33.20). Would not the faithful be commit-
ting a horrendous transgression in depicting humans realistically? The
disciples of Maimonides in Spain, Italy, and even northern France did not
have to struggle with this dilemma, as the great philosopher forcefully
rejected any anthropomorphic concept of God. This must be the reason
why Catalan and Castilian patrons did not hesitate to present human
faces, and avoided the zoocephalic avenue altogether. As far as they were
concerned, the human faces had nothing divine about them. *Image* and
likeness should not be understood in physical terms, explained the anon-
ymous Catalan author of *Sefer ha-Hinuch* (Book of Education) around
1300. The real meaning of Genesis—"Let us make mankind in our image
and in our likeness"—is that God shares with humans his brain, which he
does not share with any other of his creations.[32] And while it is true that

translated in Mann, *Jewish Texts*, 43-46, 109–11. For a translation and a thorough discus-
sion see Kalman P. Bland, "Defending, Enjoying and Regulating the Visual," 292–94.

[30] See Moshe Idel, "Panim: On Facial Re-Presentations in Jewish Thought: Some Cor-
relational Instances," in Nurit Yaari (ed.), *On Interpretation in the Arts: Interdisciplinary
Studies in Honor of Moshe Lazar* (Tel Aviv, 2000), 21–56.

[31] Ibid., 38.

[32] The passage is quoted in Kotlar, *Art and Religion*, 172. The author of *Sefer ha-Hinuch*
presents himself as a "Levite of Barcelona," which suggested to the early printers of his
book that he should be identified with Aharon ha-Levi, a disciple of the great rabbi Salomon
ben Adret. This possibility was rejected as lacking any documentary support by the Jerusa-
lem erudite Sha'ul Chana Kook in a note he published in *Kiryat Sefer* 1 (1924): 160–61 ti-
tled "On the Burial of Maimonedes" (in Hebrew) and in a study that followed, "The Au-
thorship of Sepher ha-Hinukh," *Kiryat Sefer* 17 (1940): 83–86 (in Hebrew).

the Maimonidean teachings reached the Germanic lands fairly early, they were accepted very hesitantly. On the face of it, almost all German rabbis rejected a literal and simplistic understanding of Genesis 1.26–27, but their voices were not loud enough. In a recent study Ephraim Kanarfogel detected hesitation in the treatment of the Maimonidean doctrine in their writings.[33] As far as I understand it, the issue of anthropomorphism still governed the thinking not only of the less educated Ashkenazi Jews but also of many of their religious leaders. Of course, there were exceptions. The "Parnass" Gad bar Peter of Regensburg was not isolated in his non-conformist attitude, as we have seen. Gad, about whom we know nothing, may have belonged to the segment of the Jewish society that had integrated to a certain degree in the surrounding non-Jewish culture. He may have dared to commission his Pentateuch from an artist who was inspired by the Iberian or French school of Jewish art.[34] But neither his nonconformist Bible nor the magnificent and gently painted Leipzig Mahzor could help all German Jews to overcome immediately the quandary surrounding the depiction (or lack thereof) of facial features. I doubt that even Moses of Zurich fully endorsed the Maimonidean thinking; in any event, very little of it forms part of his writings. They had to wait for more than a century and a half until they become part of the northern Italian Jewish artistic circuits (like the Italo-German Joel ben Simon) before reaching full emancipation from this self- imposed interdiction. This was achieved in the fifteenth century with the famous and spectacular Darmstadt Haggadah (Codex Orientalis 8, Hessische Landes und Hochshulbibliothek, Darmstadt). In the Darmstadt Haggadah, writes Evelyn M. Cohen, "there was no longer an avoidance of complete representation of humans." In fact, even lesser-known manuscripts from Germany of the 1450s–70s already depicted fully featured frontal faces. Among the examples is the small manuscript of the Ashkenazi prayer book (siddur) at the Bodleian Library in Oxford (Mss. Opp. 154 and Opp. 776) as well

[33] See Ephraim Kanarfogel, "Varieties of Belief in Medieval Ashkenaz: The Case of Anthropomorphism," in Matt Goldish and Daniel Frank (eds.), *Rabbinic Culture and Its Critics* (Detroit, MI, 2007), 117–59. See also Ephraim Kanarfogel, "Anthropomorphism and Rationalist Modes of Thought in Medieval Ashkenaz: The Case of R. Yosef Bechor Shor," *Jahrbuch des Simon-Dubnow Instituts* 8 (2009): 119–37. Much appreciated also is the clarity and vigor of the analysis of Haym Soloveitchik, "The Halakhic Isolation of the Ashkenazic Community," *Jahrbuch des Simon-Dubnow Instituts* 8 (2009): 41–47. Katrin Kogman-Appel, "Jewish Art and Non-Jewish Culture: The Dynamics of Artistic Borrowing in Medieval Hebrew Manuscript Illumination," *Jewish History* 15 (2001): 187–234, attributes the dissimilar ways of Ashkenaz and Sefarad not to different theological points of view but to the "different political situations and cultural surroundings in which the medieval Jews lived . . . in Iberia and Central Europe" (199).

[34] See Katrin Kogman-Appel, "Sephardic Ideas in Ashkenaz—Visualizing the Temple in Medieval Regensburg," *Jahrbuch des Simon-Dubnow Instituts* 8 (2009): 246–77, esp. 249.

as a siddur kept in the Bibliotheca Palatina in Parma (Ms. Parm. 2895). Then there is the unfinished Hamburg Miscellany (Staats- und Universitätsbibliothek Ms. Heb. 4/37) in which many of the folios are illuminated. They show people's full faces while wearing Jewish hats; in one instance the artist has painted a naked person. This codex was produced in 1431, even earlier than those mentioned above. There is no sign that anyone has interfered with any of these panels. However, the transition was not all unrestricted, and the old school did not give up entirely. Anxiety, animosity, and even actual interventions continued to exist, as is witnessed by the poor state of the Floersheim Haggadah. This codex originated in Germany and dates from either 1461 or as late as1501. And yet, at that late date, and perhaps even later, somebody exercised uncompromising censorship on its paintings.[35]

———

The data assembled in this chapter permits us to conclude that German Jews, once having discovered the attraction of decorative art, were not ready to give up their interest in it. Those who could afford it must have made large investments in its cultivation. The surrounding society was there to influence them, mostly by its own fascination with the arts and crafts and by the importance that was imputed to these works of art. However, with regard to iconography Jews insisted on having their own style, even if it resulted at times in compositions that were far from engaging. It was not any external pressure that caused this; rather, theological hesitations drove them to develop their own figurative art. Most of these Jews probably knew to distinguish between permitted paintings and forbidden ones. However, of great interest are the patrons who were strong enough to resist the Jewish authorities who watched with a critical eye the work of decoration. The works that these nonconformist patrons left us testifies to the existence of a segment of the Jewish society in Germany that was familiar with the dominant secular culture and actually

[35] See Evelyn M. Cohen, "The Decoration of Medieval Hebrew Manuscripts," in Leonard Singer Gold (ed.), *A Sign and a Witness: 2000 Years of Hebrew Books and Illuminated Manuscripts* (New York, 1988), 46–64, esp. 49. A facsimile of the Darmstadt Haggadah was first published in Leipzig in 1927–1928 under the title *Die Darmstädter Pessach-Haggadah: Codex orientalis 8 der Landesbibliothek zu Darmstadt aus dem vierzehnten Jahrhundert*, edited by Bruno Italiener, Adolf Schmidt, and Aron Freiman. A more recent facsimile is Joseph Gutmann, Hermann Knaus, Paul Pieper, and Erich Zimmermann (eds.), *Die Darmstadter Pessach Haggadah Codex Orientalis 8 der Hessischen Landes- und Hochschulbibliothek Darmstadt*, 2 vols. (Berlin, 1972). References to the Oxford, Parma, and Jerusalem manuscripts can be found in Thérèse Metzger and Mendel Metzger, *Jewish Life in the Middle Ages* (Fribourg, Switzerland, 1982), passim, and esp. their catalog, 296–310. For the Floersheim Haggadah, see also Yael Zirlin, "Discovering the Floersheim Haggadah," *Ars Judaica: The Bar Ilan Journal of Jewish Art* 1 (2005): 91–108.

enjoyed its achievements. We explored this "worldly" segment in chapter 4 when discussing the testimony of Rabbi Moses of Zurich, who talked about people (*Olam*) who read secular literature. In fact, the language should have been more precise, as our rabbi wrote *ha-Olam*, which means "the people." This might lead us to conclude that it was a widespread phenomenon and that many of the Jews, or perhaps most of them, adopted this attitude. But are we allowed to deduce such a far-reaching statement while depending on one Hebrew letter (The letter *He* becomes *Ha* and means "the")? Is there a significant chapter of the German Jewish civilization that eludes us? How did this segment of society come to be? Had it to do with the dynamics of give and take between Jews and Christians that governed the marketplace?

PART THREE

At the Marketplace

Professionals at the Service of the "Other"

Chapter Six

CHRISTIAN ARTISTS AND JEWISH PATRONAGE

Cursory remarks in the previous chapters have already suggested that the artists who produced zoocephalic panels on Hebrew manuscripts were not necessarily Jewish. Rather, there is evidence that Christian artists contributed greatly to the creation of the corpus of decorated medieval Jewish objects. However, before engaging in a discussion on this topic we need to clarify that there were also Jewish artists in the marketplace, working alone or collaborating with Christian colleagues. Following the then prevailing custom, many of them did not leave their signature on their work, but circumstantial evidence sometimes overrides their quest for anonymity. Thus it is not impossible on close examination that a Jewish painter worked on the Schocken Haggadah of about 1400 CE (Ms. 24085 when in it was part of the Schocken Library; now deposited at the National Library, Jerusalem, its temporary number is D-26). The scribe of the manuscript did not write down any verbal instructions in the margins of the folios but instead used signals like the fleur de lys to indicate the part of the text for which an illustration was requested. Ten out of the seventy-four illustrations of the codex followed such instructions. Only a Hebrew-reading person could follow them. The illustrator may have been Jewish, or he may have been a Christian that was assisted by a Jew.[1]

Knowledge of Hebrew, or at least its alphabet, was also needed for those who wanted to make use of a treatise devoted to the preparation of

[1] See Andrew Martindale, *The Rise of the Artist in the Middle Ages and Early Renaissance* (New York, 1972), which maintains that the discretion of Christian artists had to do with the fact that they were considered craftsmen. Such may be the case of their Jewish counterparts as well. See also Hava Lazar, "Instructions to the Illustrator of the Schocken Haggadah," *Kiryat Sefer* 53 (1978): 373–76 (in Hebrew). For instructions to illuminators in the Middle Ages, see Richard H. Rouse and Mary A. Rouse, *Illiterati et uxorati: Manuscripts and Their Makers. Commercial Book Producers in Medieval Paris 1200–1500.* (Turnhout, Belgium, 2000), 1:164–65; and 2:171–72.

colors (Parma, Bibliotheca Palatina, Ms. Parm. 1959, De Rossi catalog no. 945) which was written by a certain Abraham ben Juda ibn Hayim as early as 1262 but copied much later. The language of this short text is Portuguese, but the script is in Hebrew. The booklet entitled *Como se fazen as cores* (authored, or just copied, by Abraham) provides formulas for over forty colors. Although intended for a Jewish readership, this short treatise does not necessarily prove that Jewish painters were already working in Portugal at this time. It may have been intended for the use of the "chemists" who produced colors for all painters and maybe even for other professionals.[2]

The names of a considerable number of medieval Jewish artists are known today. One of the earliest is Bonin Maimo (his Hebrew name was Asser; modern-day Asher) who, together with an associate, Abraham Tati, agreed to copy and decorate three books for a coreligionist named David Isaac Cohen. We learn about this assignment from a notarial agreement signed in Majorca on February 22, 1335.[3] The first of the three books was a treatise on the calendar (Hebrew: *ibbur*) attributed to Moses Maimonides. Next came Maimonides' *Guide for the Perplexed* (*More ha Nvochim* in Hebrew, *More Ennahbohim* in the text). The third item was a copy of the Bible, under its Spanish-Jewish title *Magdesia* (Hebrew: *Miqdash Yah*). Bonin's role was principally that of a scribe (*scriptor*). He promised to produce careful calligraphy and ensure that a high quality of parchment was used. As far as decorations were concerned, his responsibilities were to be rather limited. The two Maimonidean books were to be illuminated with simple colors, but the holy *Magdesia* would have the initial words gilded. The price the parties agreed upon was the considerable sum of thirty-five pounds. The artist promised to deliver three written and decorated quires every week, and not to undertake any other project before this one was completed. Bonin was probably able to work at this pace because he had people helping him.

Art historians would certainly appreciate having more contracts of this kind at their disposal.[4] As we shall see later in this chapter, this is one

[2] The book was translated by D. S. Blondheim in "An Old Portuguese Work on Manuscript Illumination," *Jewish Quarterly Review*, n.s., 19 (1928): 97–125. Extracts were published in Harold J. Abrahams, "A Thirteenth-century Portuguese work on Manuscript Illumination," *Ambix: The Journal of the Society for the History of Alchemy and Chemistry* 26 (1979): 93–99. For similar treatises see Daniel Verney Thompson, "Liber De Coloribus Illuminatorum sive Pictorum for the Sloan Ms. No. 1754," *Speculum* 1 (1926): 280–307, 448–50. On preparation of colors, see Jonathan J. G. Alexander, *Medieval Illuminators and Their Methods of Work* (New Haven, CT, 1992), 39.

[3] Jocelyn N. Hillgarth and Bezalel Narkiss, "A List of Hebrew Books and a Contract to Illuminate Manuscripts (1335) from Majorca," *Revue des études juives* 120 (1961): 297–320. The authors published and translated the document into English. Another work of the same scribe-artist exists in the archives of Majorca; it is seemingly in very bad shape.

[4] For similar Florentine contracts of the mid-fifteenth century see, for example, Luisa

of three contracts relating to the illuminating of Hebrew books. Luckily, scholarship does not depend solely on notarial contracts. The colophons on the last page of some of the codices reveal the names of Jewish illuminators active during this period, like Elisha ben Abraham ben Benveniste ben Elishah, also known as Crescas, who was working between 1366 and 1382 and painted the Farhi Bible (once in the Sassoon Collection, Letchworth Ms. 368), or Joseph ha-Zarfati "the Frenchman," who illuminated in 1299–1300 the Cervera Bible.[5] Joseph ibn Hayim, to mention a third person, produced a beautifully illuminated copy of the First Kennicott Bible (Oxford, Bodleian Library, Kennicott 1) in 1476.[6] Our list should not miss the names of Nathan ben Simon ha-Levi, Israel ben Meir, Meir ben Israel, and Isaac the son of Elijah Hazzan, who all worked in Germany, as well as of Abraham ben Yom Tov ha-Cohen, who worked on an Italian Bible in 1284.[7]

The most famous of all these medieval Jewish artists—nowadays, in any event—is Joel ben Simon, known also as Feibush Ashkenazi.[8] Born in

Mortara Ottolenghi, "Scribes, Patrons and Artists of Italian Illuminated Manuscripts in Hebrew," *Journal of Jewish Art* 19–20 (1993–94): 86–98, esp. 91–93; and Luisa Mortara Ottolenghi, "'Figure e imagini' dal secolo xiii al secolo xix," in Corrado Vivanti (ed.), *Gli ebrei in Italia*, Storia d'Italia, Annali 11 (Torino, 1996), 965–1008, esp. 973–90; see also Annarosa Garzelli (ed.), *Miniatura fiorentina del Rinascimento: un primo censimento, 1440–1525*, vol. 1 (Florence, Italy, 1984), 207. For other medieval contracts see Jonathan G. Alexander, *Medieval Illuminations and Their Methods* (New Haven, 1992), 52–71, and esp. 179–83, where a sample contract is presented. See also Françoise Gasparri, "Un contrat de copiste à Orange au XVe siècle," *Scriptorium* 28 (1974): 1285–86.

[5] See Joseph Gutmann, *Hebrew Manuscript Painting* (New York, 1978) plate 13. See also the very detailed study of Therese Metzger, "Josue ben Abraham ibn Gaon et la Masora du Ms. illuminado 72 de la Biblioteca Nacional de Lisbon," in *Codices Manuscripti* 15 (1990): 1–27.

[6] On the First Kennicott Bible, see Cecil Roth, "A Masterpiece of Medieval Spanish Jewish Art: The Kennicott Bible," in *Gleanings* (New York, 1967), esp. 298–319. See also Bezalel Narkiss, *Hebrew Illuminated Manuscripts* (Jerusalem, 1978), 72, 74.

[7] For lists of Hebrew painters, see Narkiss, *Hebrew Illuminated Manuscripts*, 15; and Gutmann, *Hebrew Manuscript Painting*, 13. A list according to regions is given in Yael Zirlin, "Celui qui se cache derrière l'image: Colophons des enlumineurs dans les manuscrits hébraïques," *Revue des études juives* 155 (1996): 47–51, esp. 50.

[8] Few Jewish illuminators have received as much scholarly attention as did Joel ben Simon. Some of his works were published in facsimile. Interested readers may obtain almost complete bibliographical information by consulting studies like Yael Zirlin, "The Early Works of Yoel ben Simon, a Jewish Scribe and Artist" (PhD diss., Hebrew University of Jerusalem, 1995; in Hebrew); Malachi Beit Arié, "Joel ben Simon's Manuscripts: A Codicologer's View," in *The Making of the Medieval Hebrew Book: Studies in Paleography and Codicology* (Jerusalem, 1993), 93–108; and Joseph Gutmann, "Thirteen Manuscripts in Search of an Author: Joel ben Simeon, 15th Century Scribe Artist," *Studies in Bibliography and Booklore* 9 (1970): 76–95. Yael Zirlin, "Joel Meets Johannes: A Fifteenth Century Jewish-Christian Collaboration in Manuscript Illumination," *Viator* 26 (1995): 264–82, suggests that in one of the periods Joel (Yoel) spent in Germany he was in contact with the workshop of the then famous Johannes Bamler. The name of another wandering illuminator, a younger

Cologne or Bonn, he left more than twenty manuscripts to posterity, far more than any other medieval Jewish professional. His first signed piece is dated 1449 and his last 1485. He wandered between Germany and Italy, and his art reflects this itinerant way of life, as the style of his illustrations depended on where he was working at any given moment. This applies also to the form of the letters he produced as a scribe, to his choice of marginal ornamentations, and to the codicological structure of his books. Recently another of his Mahzorim, carrying his "trademark," a mask of a devil in profile, has been identified. This discovery may help to identify even more works of this prolific artist. His Italian connection and the late date of his activity may explain, for example, why he appears to have had no difficulty with the frontal presentation of the faces of the five sages of Bnei Brak on folio 7v of a Haggadah kept in the British Library (Add. Ms. 14762; see fig. 23).

Did these Jewish painters collaborate with their Christian counterparts? Were some of them present in the workshops of their colleagues, giving them access to the models that were found there? Collaboration must have existed, as non-Jewish artists were working on manuscripts written in a language they did not know and Jewish scribes, for their part, would have had to get instructions from the illuminator as to how much space should be left blank and in what form. But lack of written documentation renders the study of these questions rather difficult. The case of Joel ben Simon is in a sense the easiest of them all. At least two scholars have recently raised the possibility that when in Germany he worked in the atelier of the famous Johannes Bamler of Augsburg (1430–1503). Counting on the iconography and style of the Haggadah in the British Library, Yael Zirlin opts for the possibility of the actual presence of Joel in the Frankfurt workshop while Sheila Edmunds maintains that Balmer just redecorated the manuscript after Joel finished his work.[9]

contemporary of Yoel, also from Germany, should also be mentioned. Before converting to Christianity, his name was Israel, son of Meyer of Brandenburg (afterward, Wolfgang), and he was looking for work in northern Italy. For more information on these artists see chapter 7. We know that the young artist was paid one ducat to copy and illuminate Hebrew books for one Ritzard of Brixen. See R. Po-Chia Hsia, *Trent 1475: Stories of a Ritual Murder Trial* (New Haven, CT, 1992), 95–104, esp. 98. Israel-Wolfgang was a victim of the blood accusation of Trento in 1475. His conversion notwithstanding, he was executed along with other Jews from the city.

[9] See Sheila Edmunds, "The Place of the London Haggadah in the Work of Joel ben Simon," *Journal of Jewish Art* 7 (1980): 25–34. See the recent facsimile edition, Shlomo Zucker, *The Moskowitz Mahzor of Joel ben Simeon* (Jerusalem, 2005; in Hebrew). Another three recent facsimile editions of Yoel's works are David Goldstein, *The Ashkenazi Haggadah* (New York, 1985); David Stern and Katrin Kogman-Appel (eds.), *The Washington Haggadah, Copied and Illustrated by Joel ben Simeon* (Cambridge, MA, 2011); and a manuscript kept by the Fondation Martin Bodmer in Cologny, near Geneva (Codex Bodmer

FIGURE 23. A page of an illustrated Haggadah, illuminated by Joel ben Simon, a fifteenth-century scribe and painter. The compressed bodies of the five men do not detract from the beauty of the piece. The presentation of the faces of the five sages, and of other people in his works, is executed with confidence.

The British Library Board. Ms. ADD. 14762, fol.7v.

Joel ben Simon may not have been the only Jewish artist to collaborate with non-Jews. Zirlin has noticed stylistic affinities between the Schocken Haggadah and the paintings found in a copy of the pharmaceutical treatise *Tacuinum Sanitatis* produced toward the end of the fourteenth century by a member of the Lombard school of Giovanni De Gressi (Bibliothèque Nationale, Paris, Nouv. Acq. Lat. 1673). On the other hand, iconographic elements of the colorful and richly illuminated Hispano Moresque Haggadah dating from around 1300 (British Library, Ms. Or. 2737) can also be seen in the Schocken Haggadah. Then, quite surprisingly, Zirlin discovered that elements of the Hispano Moresque Haggadah may also have infiltrated the paintings in the Parisian *Tacuinum*. This complicated and rather confusing triangular give and take suggests in the scholar's mind not only mutual influences but some kind of collaboration between the Jewish artist and members of De Gressi's Lombard school.

The possibility of Jewish artists present in Christian workshops in Catalonia hinges, as far as I can tell, on unsubstantiated evidence. It is raised in connection with the famous codex of Maimonides' *Guide to the Perplexed*, kept today in the Royal Library of Denmark (Heb. 37). The codex's colophon has a date (1347–48) and provides the names of the scribe and of the patron, but is mute when it comes to the identification of the illuminator. Among the several suggestions that were raised by students, the one that is the most acceptable to the majority of scholars is that the codex was painted by master Ferrer Bassa, who ran a workshop in Barcelona; together with his assistants he produced many illuminated books and church decorations that survived the centuries. As it happened, Bassa's workshop was situated near the Jewish quarter (El Call) of the city, and he also had some financial relationships with members of Barcelona's Jewish community. The possibility that the Jewish scribe of the codex, Levi ben Isaac Hijo Caro, may have helped by painting parts of the marginal decoration of the Maimonidean book is not rejected by the specialist Rosa Alcoy i Pedros, but in her opinion it is a mere suggestion, bereft of any documentary support. She insists that the main panels of the codex were executed by master Ferrer Bassa.[10]

81), published as *Haggadah de Pessah* (Paris, 2011) in collaboration with the Presses Universitaires de France and introduced by Maurice Ruben Hayoun.

[10] Yael Zirlin, "The Schocken Italian Haggadah of c. 1400 and Its Origins," *Jewish Art* 12–13 (1986–87): 55–72; see esp. 55: "the illuminations of this manuscript are closely related to the school of Giovannino da' Grassi, a north Italian artist." For Hebrew illuminated manuscripts produced in a catalonian workshop see Gabrielle Sed-Rajna, "Hebrew Manuscripts of Fourteenth Century Catalonia and the Workshop of the Master of St. Mark," *Journal of Jewish Art* 18 (1992): 117–28 and Rosa Alcoi i Prades, "The Artists of the Mar-

Most observers tend to agree that the output of these Jewish artists was influenced and even modeled on the aesthetic of Gothic art that prevailed in the environment in which they lived. Katrin Kogman-Appel recently wrote that "it is only when Christian art emerged from monastic scriptoria in the early thirteenth century to engage in new forms of artistic expression in urban secular workshops that Jewish patrons and scribes developed a renewed interest in narrative painting." Kogman-Appel claims that "many iconographic motifs have been adapted to Jewish purposes from both Christian and Islamic models" and that "Jewish miniaturists . . . turned to Christian pictorial models" for inspiration, or even that "[t]here is nothing particularly Jewish in Medieval Jewish art." Such statements are common in the historiography.[11]

This raises the question of the extent to which Christian artists actually participated directly in the decoration of Hebrew manuscripts and in the production of other objects that constitute the body of medieval Jewish art. Two esteemed Hebraic scholars, Cecil Roth in Oxford and Bezalel Narkiss in Jerusalem, tended to minimize the extent of this foreign participation.[12] "In light of recent research," wrote Roth, "it is more logical to assume that even the most sumptuous Hebrew manuscripts were as likely as not to have been illuminated as well as written by Jews." Narkiss was at first even more emphatic. He claimed that "undoubtedly most of the illuminators of Hebrew books were Jewish." But a few years later, in a lecture delivered in Spain, he was more reserved, saying, "Even though it is impossible to prove, one can suppose that the majority of the illuminators of Hebrew books were Jewish."[13] And in his introduction to the Leipzig Mahzor we read, "Even though it cannot be established that the artist was a Jew, it is certain that he has been instructed and guided by a Jew."[14]

ginal Decorations of the Copenhagen Maimonides," *Journal of Jewish Art* 18 (1992): 129–39.

[11] Katrin Kogman-Appel, *Illustrated Haggadoth from Medieval Spain: Biblical Imagery and the Passover Holiday* (University Park, PA, 2006), 2; Katrin Kogman-Appel, "Coping with Christian Pictorial Sources: What Did Jewish Miniaturists Not Paint?" *Speculum* 75 (2000): 816–58; the quotation given here is on p. 816. Kogman-Appel's book is almost entirely dedicated to the study of "acculturation and borrowings from Christian art."

[12] See Cecil Roth, introduction to Narkiss, *Hebrew Illuminated Manuscripts*, 9; see also Narkiss, *Hebrew Illuminated Manuscripts*, 15.

[13] It is worth our while to quote the original as appeared in Elena Romero (ed.), *La vida judía en Sefarad* (Madrid, 1991; reprint Toledo, 1992), 175: "Aunque non se puede probar, supone que la maioría de los iluminatores de libros hebreos eran judíos."

[14] See the introduction by Elias Katz to his and Bezalel Narkiss's facsimile edition *Machsor Lipsiae: 68. Faksimile-Tafeln der mittelalterlichen illuminierten Handschrift aus dem Bestand der Universitätsbibliothek Leipzig* (Leipzig, 1964), 85.

An entirely different assessment comes from another distinguished art historian, Robert Suckale, who worked in Bamberg before moving to Berlin.[15] As far as the Gothic manuscripts in Bavaria are concerned (Suckale works in Regensburg), it is his opinion that no Jewish artist of any stature worked on any of the Hebrew codices produced there. All the important miniature work was accomplished, in his opinion, by Christian hands. In his judgment, even where a remote possibility of Jewish creativity exists, as is the case with the Leipzig Mahzor and the Darmstadt Haggadah, it is certain that the art found there emulated Christian models. After the crisis of 1348–49, Suckale posits (and one does not have to agree with his reasoning here), that impoverished German Jews could no longer afford the services of high quality professionals and had to be satisfied with the works of dilettantes, whether Christian or Jewish. In Suckale's opinion Joel ben Simon does not deserve the honorific title of "artist-painter."

Turning away for a moment from the world of manuscript illumination and focusing our attention on other objects of visual art may help to untangle the complex issue of Christian contribution to Jewish art. For Jews, as for Christians, a variety of ceremonial vessels have an important role in their worship. Decorated metal objects are used in the synagogue's services and also play a particularly important role in sacramental ceremonies practiced by Jews in the intimacy of their homes. Jewish smiths were able to produce these gold and silver items, and probably did so often. Still, there is evidence that private individuals as well as communal dignitaries turned to Christian craftsmen when necessity demanded it. A contract concluded in the Sicilian capital of Palermo in 1479 is a case in point. The notarized agreement concerned the decorative finials capping the top handles of the Torah scroll(Hebrew: *tapuḥim*, "apples," or *rimonium*, "pomegranates"): Benedictus de Besnay, "artisan, citizen of Palermo," was to produce two silver "apples" at the instance of the secretaries of the city's synagogue (*miskita*). The Jews who would supply the necessary silver and gold promised to pay the artist a salary of two ounces of gold.[16] A similar contribution of a non-Jew to the splendor of the synagogue is recorded in a contract drawn up in Arles, in the heart of Provence, in 1439. Here Master Robin, a Parisian who then lived in Avignon, agreed

[15] Robert Suckale expresses his ideas on the Munich codex in the concluding section of his study "Über den Anteil christlicher Maler an der Ausmalung hebräischer Handschriften der Gotik in Bayern," in Manfred Treml and Josef Kirmeier (eds.), *Geschichte und Kultur der Juden in Bayern: Aufsätze* (Munich, 1988), 123–34.

[16] Geneviève Bresc-Bautier, *Artistes, patriciens et confréries: Production et consommation de l'œuvre d'art à Palerme et en Sicile occidentale (1348–1460)* (Rome, 1979), 115n1.

to produce a crown to embellish the Torah (Hebrew: *Atarah—Hattara* in the Latin text) at the instance of the elected leaders (*bayloni*) of the community.[17]

Information of particular interest, though from a later period, comes from the city of Frankfurt. It is found in the papers of the Chisel Probes' Committee of the Goldsmiths (Probierbuch der Frankfurter Goldschmiede) for the years 1512–76 (call number: Handwerker Akten 474). The aim of this institution was to supervise the quality of all the work undertaken by the city's artisans.[18] Twelve entries in the register recorded agreements between local artists and Jews. They all related to fragrance boxes (*besamim* boxes) which, as was discussed in the introduction to this volume, are used in the concluding ceremony of the Sabbath and of holy days (see fig. 24).

We should also recall that in Hebrew the such a box is called a *hadass* ("myrrh") because of the myrrh it often contains. The Frankfurt scribes, who distorted the Hebrew here and there, referred in the register to "Juden Hedesh," "Hedes," or even "Heddish." A disagreement that occurred in 1553 requires special attention. A Jew, Joseph Goldschmidt, had commissioned a haddas from the artisan Heinrich Heidenberger. Unhappy with the result, he took the silversmith to task. A copy of the box's design was presented as part of the file of a process that ensued (Judicialia G 168). The document, which has survived in the register, shows a particularly handsome and heavy box designed in the form of a town's tower. [19]

―――――――――――

Returning to the illuminated Hebrew manuscripts, Christian participation in their production can be surmised in dozens of instances, even if the artists' identities more often than not escape us. However, on occasion we do have their names. Thus, for example, two Florentine agreements discussed by Luisa Mortara Ottolenghi in her "Scribes, Patrons and Artists of Italian Illuminated Manuscripts in Hebrew" each identify

[17] The original contract is in the Bibliothèque Municipale at Arles, Ms. 886, 152. See Louis Stouff, "Chrétiens et Juifs à Arles: Leurs relations," in *Les sociétés urbaines en France méridionale et en péninsule Ibérique au Moyen Âge (Actes du Colloque de Pau)* (Paris, 1991), 519–37; see esp. 523n25. It was published in Georges Stenne, *Collection de M. Strauss. Description des objets d'art religieux hébraïques* (Poissy, 1878). I have not seen the original contract nor its publication and am relying on Vivian B. Mann's English translation in *Jewish Texts on the Visual Arts* (Cambridge, 2000), 111–14.

[18] The above information is derived from the study of Mordechai Narkiss, "Origins of the Spice Box," *Journal of Jewish Art* 8 (1981): 28–41. See also Victor A. Klagsbald, *A l'ombre de Dieu: dix essais sur la symbolique dans l'art juif* (Louvain, Belgium, 1997), 113.

[19] The Israel Museum in Jerusalem published in 1982 an exhibition catalog titled *Besamim Towers* (in Hebrew), where dozens of such boxes are presented and commented upon.

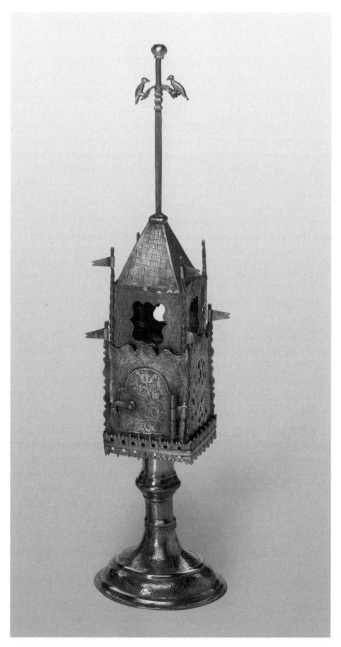

FIGURE 24. Silver spice box of eighteenth-century Eastern Europe. Silver, pierced, en-
graved, cut and cast; H:33, W: 5 cm.
 Photo: The Israel Museum, Jerusalem, by Ardon Bar-Hama. The Stieglitz Collection,
donated to the Museum with the contribution of Erica and Luddwig Jasselson, New York,
to the American Friends of the Israel Museum. Accession number B86 0087:124/538.

the name of a non-Jewish miniaturist.[20] The first, concluded in 1441, shows that two brothers Jacob and David, the sons of Solomon of Perugia, entrusted the illustration of a mahzor to Zenobi Strozzi di Benedetto (1412–68) the city's leading artist. Today, this mahzor is apparently housed in the British Library (Add. Ms. 19944–19945). Jacob and David, we may recall, were associated with the Florentine bank known as the Quattro Pavoni (see chapter 1). The artist, Zenobi Strozzi, was the disciple of the "most Christian" painter of the city, the Dominican priest Fra Angelico (c. 1387–1455). Another biblical codex in Hebrew that Zenobi probably decorated is kept today in the Bibliotheca Palatina of Parma (Ms. Parm. 3236, De Rossi catalog no. 490). Annarosa Grazielli, following the earlier work of Mirella Levi-D'Ancona, suggests that the artist worked on this Bible sometime between 1450 and 1455.[21] The second notarial agreement was ordered by the banker Jacob (Jacomo), son of Benjamin of Montalcino, in 1476. He charged the artist Marriano de Bono (or Mariano del Buono; 1433–1504), who was popular with the local Jewish community, with the task of embellishing three biblical books: Psalms, Proverbs, and the Book of Job. Mortara Ottolenghi, who discovered these documents, informs us that this codex can be seen today at the Beinecke Library of Yale University (Ms. Marston 409).[22]

These two Florentine artists are among a group of half a dozen Christian illuminators whose names can be associated, with various degrees of certainty, with the ornamenting of Hebrew codices. Mattheo di ser Cambio di Bettolo (active in 1377), who illuminated the first forty folios of the Jerusalem Mishneh Torah, is another (National Library, Jerusalem, Heb.

[20] Luisa Mortara Ottolenghi, "Scribes, Patrons, and Artists of Italian Illuminated Manuscripts in Hebrew," *Journal of Jewish Art* 19/20 (1993–94), 91–93. See also by the same scholar "'Figure e emangini' dal secolo XIII al secolo XIX," in Corrado Vivanti, ed., *Gli ebrei in Italia*, Storia d'Italia Annali 11 (Torino, 1996), pp. 965–1008, in particular pp. 973–990.

[21] See Annarossa Garzelli (ed.), *Miniatura fiorentina del Rinascimento 1440–1525* (Florence, 1984), 1:11–25, 113; and for the Parma Bible see 1:20–21. Garzelli does not provide the call number of the codex, yet she counts no doubt on the opinion of Mirella Levi D'Ancona as given orally to Valeria Antonioli Martelli and Luisa Mortara Ottolenghi and recorded in their *Manoscritti Biblici ebraici decorate provenienti da biblioteche italiane pubbliche e private* (Milan, 1960), 59–60. On Fra Angelico and his disciple Zenobi Strozzi, see Giorgio Vasari, *The Lives of the Artists*, trans. J. Gonway Bondanella and Peter Bondanella (Oxford, 1992), 168–77, 536.

[22] See Mirella Levi D'Ancona, *Miniatura e miniatori a Firenze del XIV al XVI secolo* (Florence, Italy, 1962), 175–81; and Thérèse Metzger, "The Iconography of the Hebrew Psalter from the Thirteenth to the Fifteenth Century," in Clare Moore (ed.), *The Visual Dimension: Aspects of Jewish Art Published in Memory of Isaiah Shachar (1935–1977)* (Boulder, CO, 1993), 47–81, esp. 79n49. See also the recent study of Evelyn M. Cohen, "A Woman's Hebrew Prayer Book and the Art of Mariano del Buono," in Katrin Kogman-Appel and Mati Meyer (eds.), *Between Judaism and Christianity: Art Historical Essays in Honor of Elisheva (Elisabeth) Revel-Neher* (Leiden, Netherlands, 2009), 371–78. About eight works done by him for Jewish patrons are known today.

4 1193).[23] The admired *Rothschild Miscellany*, also in Jerusalem (Israel Museum, Ms. 180/51) may as well be the work of three Christian artists. Mortara Ottolenghi suggests the names of Bonifacio Bembo of Cremona or Christoforo Predis (active, respectively, 1447–77 and 1452–87). A third, unidentified, artist who possibly worked on the *Miscellany* might have been a disciple of the famous Venetian painter Giovanni Bellini (c. 1426–1516).[24]

For his part the eminent Hebraist and paleographer Giuliano Tamani of the University of Venice emphasizes the preponderance of Tuscan artists, most of them from Florence, as illuminators of Hebrew books. For example, a dozen names are suggested to identify the anonymous artist that decorated the wonderful manuscript *Sefer ha-Iqqarim* (The Book of Dogmas) by the Spanish philosopher Josep Albo (c. 1380–1444). The manuscript itself is kept in the Academy of Rovigo (Ms. Silvestriana 220). According to Annarosa Garzelli, one of these Florentines, Francesco Roselli, who was active between 1470 and 1485, spent years decorating a Hebrew Bible, which is housed today in the city's Laurentian Library (Ms. Plau. 1.31). Roselli, who was interested in Greco Roman classics, also worked on a Latin version of *The Letter of Aristeas* in about 1477. Today, the manuscript is kept in the Vatican Library (Ottob. Lat. 1558). It is a Hellenistic legendary account, from the second century BCE, about the origin of the translation of the Bible into Greek, which is known as the Septuagint.[25]

Last to be mentioned, but certainly not least, is the "prince of Florentine miniaturists," Attavante di Gabriello di Vante di Francesco di Bartolo degli Attavanti, better known as Attavante degli Attavanti (1452–1517 or 1525).[26] He was highly appreciated by the great families of Florence, as

[23] See Narkiss, *Hebrew Illuminated Manuscripts*, 134, plate no. 47. See also the short entry about him in Paolo D'Ancona and Erhard Aeschlimann, *Dictionnaire des miniaturistes du Moyen Âge et de la Renaissance dans les différentes contrées de l'Europe* (Milan, 1940; reprinted 1969), 147.

[24] A facsimile edition was published as Iris Fishoff, *The Rothschild Miscellany*, 2 vols. (London, 1981). See also Alexander, *Medieval Illuminators*, 122. Another identification is proposed in Thérèse Metzger, "The Iconography of the Hebrew Psalter," 77n41. Metzger raises there the possibility of the participation of an anonymous artist close the Venetian Leonardo Bellini, active between 1457 and 1469. The names of Bembo and Predis are suggested in this volume of studies, 242–46, and esp. 243.

[25] A study of the Silvestriana manuscript was published in Michela Andreatta, Pier Luigi Bagatin, and Giuliano Tamani (eds.), *Il trattato sui dogmi (Sefer Ha-Iqqarim) di Yosef Albo* (Treviso, Italy, 2003). See especially the overview offered by Pier Luigi Bagatin in "Ir sefer ha-'Iqqarim miniato dell'Accademia del concordi," 108–22. On Francesco Rosel, see Grazelli (ed.), *Miniatura fiorentina*, 1:183–85. Cecil Roth attributed the codex in the Mediceo Laurenziana library to the appreciated miniaturist of the time, Francesco di Antonio del Cherico. See Antonioli Martelli and Mortara Ottolenghi, *Manoscritti*, 38.

[26] On Attavante and his spectacular career, see Levi D'Ancona, *Miniatura e Miniatori*,

well as by prelates and ecclesiastical institutions, and his reputation spread beyond the Italian Peninsula. In Portugal he produced a seven-volume Bible known as *De Belem*, while in Hungary the bibliophile monarch Mathias Corvinus gave him dozens of commissions. Attavante also worked for Jews. A Pentateuch in the Bibliotheca Palatina of Parma (Ms. Parm. 2162) is his work, and he may also have created the codex that is kept in the Casanatense Library in Rome (Ms. 2830).[27] Of particular importance is the gigantic Bible kept in the Bibliothèque Nationale in Paris (Ms. Héb. 15), "the most glorious Hebrew manuscript in France," painted partly in Portugal sometime between 1494 and 1497 and completed in Italy. As Attavante had earlier illuminated a magnificent missal for Thomas James, Bishop of Dole, it has been suggested that the frontispiece of the Hebrew Bible of Paris was originally intended to decorate the prelate's missal.[28] An examination of the manuscript in the Latin Municipal Library of Lyon (Ms. 5123) does not support this possibility.[29]

When working on Hebrew manuscripts, Christian artists asked for help and directions from Jews conversant with the laws and customs of their religion. These Jews, who were probably even the patrons themselves, were of course happy to lend a supporting hand. Thus, traces of the instructions provided for the artist can be found in the Bayerische Landesbibliotek in Munich, in the form of short notes written in Latin (Ms. Heb. 5); they led to the discovery that the artist was a non-Jew. It was Robert Suckale who was able to reveal some of the instructions, using an ultraviolet lamp; on folio 37r he discovered a notice, *somnium pharaonis*, under a panel illustrating Pharaoh's dream. A short note in Latin— *Job uxor*—found on folio 183r, shows Job, his wife, and a friend.[30] Munich's Hebrew manuscript is only one of several that have similar Latin instructions.[31]

254–59; and Garzelli (ed.), *Miniatura fiorentina*, 1:217–45. See also Alexander, *Medieval Illuminators*, 181–82, for a contract Attavante signed in the year 1494.

[27] For another possible work of his, see Antonioli Martelli and Mortara Ottolenghi, *Manoscritti*, plate no. 11.

[28] See Gabrielle Sed-Rajna, "Ateliers de manuscrits hébreux dans l'Occident médiéval," in Xavier Barral i Altet (ed.), *Artistes, artisans et production artistique au Moyen Âge*, vol. 1, *Les hommes* (Paris, 1986), 339–52, esp. 344–45.

[29] Gabrielle Sed-Rajna raises the possibility in *Les Manuscrits hébreux enluminés des bibliothèques de France* (Leuven, Belgium, 1994), 127–36, plate no. 53. But she did not repeat it in later works. On the missal kept in the Municipal Library of Lyons, see John W. Bradley, *A Dictionary of Miniaturists, Illuminators, Calligraphers and Copyists*, 3 vols. (London, 1887–89). Vol. 2 reprinted (New York, 1958), 141–42.

[30] Suckale, "Über den Anteil christlicher Maler," 127–30.

[31] Instructions in Latin are signaled also in Colette Sirat, "Notes sur la circulation de livres entre Juifs et Chrétiens au Moyen Âge," in Donatella Nebbiai-Dalla Guarda and Jean-

Some artists may have inadvertently committed mistakes that help identify their non-Jewish provenance. For instance, a Jewish scribe in the *Rothschild Miscellany* (Israel Museum, Ms. 180/51, fol. 369r) is shown writing from left to right while in Hebrew one would write from right to left.[32] Ruth Mellinkoff identified some Christological elements that only a non-Jew could have introduced into a Hebrew manuscript. The Wroclaw Mahzor, kept in the Wroclaw State and University Library (Ms. Or. I.1, fol. 46v), to give one example, shows a Pashcal candle, which usually lights a church on Holy Saturday, placed near the altar on which the boy Isaac was about to be sacrificed.[33] In yet another example, the Hammelburg Mahzor in Darmstadt's Hessiche Landes- und Hochschulbibliothek (cod. Or. 13, fols. 65v, 349v) twice shows a Jewish couple holding a chalice and a host, objects that were used in the Eucharist.[34] The painter of the Michael Mahzor had a page (fol. 4v) upside down and managed to illuminate a detailed scene of a deer hunt before somebody made him turn the page right side up (see fig. 25).[35] Bezalel Narkiss found at least two mistakes in the Mishneh Torah now in the National Library in Jerusalem (Heb 4 1193), which, as already noted, is perhaps the work of Matheo di Ser Cambio of Perugia.[36] According to Jewish law (Mishnah, Sanhedrin 6.3–4) an execution by stoning should show a condemned man naked, not dressed, while a Jewish priest, when blessing the congregation should hold his hands in a sacral manner. Both of these elements are wrongly portrayed in this manuscript. The Kaufmann Haggadah of Budapest (Hungarian Academy of Sciences, Ms. 422, fol. 42v) also contains errors (see fig. 26); it shows a man and a woman sitting side by side with their child and listening to a sermon; this does not agree with the

François Genest (eds.), *Du copiste au collectionneur: Mélanges d'histoire des textes et des bibliothèques en l'honneur d'André Vernet*, Bibliologia 18 (Turnhout, Belgium, 1999), 383–403, esp. 394. Eva Frojmovic also discovered traces of instructions to the painter in Latin in the Laud Mahzor; see Frojmovic, "Early Ashkenazic Prayer Books and Their Christian Illuminators," in Piet van Boxel and Sabine Arndt, *Crossing Borders: Hebrew Manuscripts as a Meeting-place of Cultures* (Oxford, 2009), 45–51, and esp. 52, 56n11.

[32] See Colette Sirat, *Hebrew Manuscripts of the Middle Ages*, ed. and trans. Nicholas de Lange (Cambridge, 2002), 180.

[33] Ruth Mellinkoff, *Antisemetic Hate Signs in Hebrew Illuminated Manuscripts from Medieval Germany* (Jerusalem, 1999), 44–45.

[34] Ibid., 51, and figs. 43–44.

[35] See Eva Frojmovic, "Early Ashkenazic Prayer Books and Their Christian Illuminators," in Piet van Boxel and Sabine Arndt, *Crossing Borders: Hebrew Manuscripts as a Meeting-place of Cultures* (Oxford, 2009), 45–56, 58n3.

[36] Bezalel Narkiss, "An Illuminated Ms. of Maimonides' Code in the JNUL (with 8 Facsimiles)," *Kiryat Sefer* 43 (1967–68): 285–300. Elimelech (Elliott) Horowitz casts doubts on some of the arguments raised by Narkiss; see "About an Illuminated Manuscript of the Mishneh Torah," *Kiryat Sefer* 61(1986–87): 583–86 (in Hebrew).

FIGURE 25. A mistakenly placed thirteenth-century illumination in the Michael Mahzor in Oxford. The Christian artist turned the Hebrew written page upside down; hence one has to turn the codex right side up in order to view the illumination.

The Bodleian Libraries, University of Oxford. Ms. Michael 617, fol. 4v.

FIGURE 26. A Jewish couple in Castile listening to a preacher. They are sitting side by side as if they were in a church rather than a synagogue. The illumination is found in the Spanish Kaufmann Haggadah (c. 1300), Budapest.

Courtesy of the Library of the Hungarian Academy of Sciences, Oriental Collection. Ms. A422, fol. 42v.

medieval Jewish separation of sexes during synagogue services. An even more serious flaw occurs on folio 59v of this Haggadah, where Moses is shown being charged with his divine mission. The Bible relates in Exodus 3.2 that an "angel of the Lord appeared to him in a flame of fire out of the midst of a bush." The painter, a non-Jew in all probability, has depicted a bearded man whose head is surrounded by a halo facing Moses. Haloes are, of course, commonplace in Christian iconography, but, to my

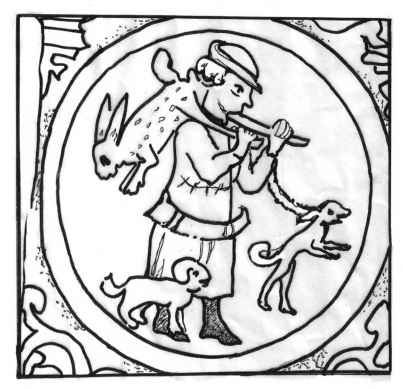

FIGURE 27. Esau returning from hunting in the field is ready to prepare a meal for his father Isaac. The hare that he has caught is forbidden for consumption by Jewish law. The figure is a medallion illuminating the frontispiece of the (once) Schocken Bible (c. 1300; Ms. 19440). Today it is part of a private collection.

Drawing by Architect Natali Lashko (in private collection).

knowledge, this is one of two instances where a divine messenger endowed with a halo appears in a Hebrew manuscript. The other instance is in the Golden Haggadah at the British Library (Add. Ms. 27210, folio 10v), which also illustrates Moses in front the burning bush.[37] In both cases, I submit, we are dealing with painter's mistakes. Another possible

[37] See the new facsimile of *The Kaufmann Haggadah* edited by Gabrielle Sed-Rajna (Budapest, 1990), fol. 42r. For a couple listening to a preacher or a teacher, the wife holding a book, see also the Barcelona Haggadah (British Library, Ms. Add. 14761), fol. 51v. A woman appears in this codex also on folio 59v as one of the four students of Rabban Gamaliel. For a facsimile of the Golden Haggadah, see Bezalel Narkiss (ed.), *The Golden Haggadah* (London, 1997).

mistake that passed unnoticed by the rabbis is in one of the forty-six me-
dallions painted on the frontispiece of the Schocken Bible of about 1300
CE (Ms. 14940 when it was in the Schocken Library, Jerusalem; now in
private hands): it shows Esau returning from the field with a large hare
on his back (see fig. 27). By serving a hare, Esau would have prepared for
his father a meal that was utterly nonkosher.

Two major mistakes, even more serious than those already described,
were hidden in the Budapest Mishneh Torah. They must have been no-
ticed shortly after they were made and were immediately painted over.
Both occur in a highly important scene, the theophany, when Moses
brings down the law from Mount Sinai.[38] Talmudic legend (Shabbat 88a;
Avodah Zarah 2b) alleges that the Israelites were actually forced to ac-
cept the law. God threatened to overturn the mountain (Sinai) upon them
like an "inverted tub" (Hebrew: *Har ke-Gigit*) if they persisted in their
refusal. The representation of that story in the Budapest codex (Hungar-
ian Academy of Sciences, Ms. A.77/IV, fol. 32r.) shows the Israelites
within the mountain, as if they were in the mouth of a volcano (see fig.
28). Dr. Evelyn M. Cohen, who examined the original in Budapest with
an ultraviolet lamp, discovered that before being painted over the origi-
nal contained two alarming mistakes. First, Moses coming down from
the mountain was shown as a "horned Moses"; the painter had followed
a Christian tradition that started with Jerome, who translated the He-
brew verb *krn* as "cornuta," which means "horned." Jews, on the other
hand, understand that the verb refers to facial luminosity, and means that
Moses's face was "beaming" or "radiant." No Jewish artist would have
attached horns to Moses' head. The second mistake in the original was
even graver: God was personified by the painter, something which no
Jewish artist, even today, would dare to do. Perhaps the artist himself cor-
rected these mistakes. However, God's hand was neither erased nor
painted over. This is in accordance with the practice found in other Jew-
ish manuscripts and apparently followed a tradition that went back to
the frescoes of Dura-Europos (c. 240 CE). The detail caught Cohen's at-
tention and led to her important discovery. Further study of other illumi-

[38] Evelyn M. Cohen, "The Artists of the Kaufmann *Mishneh Torah*," in *Proceedings of
the Ninth World Congress of Jewish Studies, Division D*, vol. 2 (Jerusalem, 1986), 25–30;
and Evelyn M. Cohen, "The Kaufmann Mishneh Torah Illumination," in Eva Apor (ed.),
David Kaufmann Memorial Volume (Budapest, 2002), 97–104. A more successful solution
to the depiction of this difficult legend was realized by the painter of the Regensburg Bible
(see fig. 20), as well as in the illumination published in Paul Johannes Müller, *Jüdische Min-
iaturen aus sechs Jahrhunderten* (Wiesbaden, Germany, 1998), 115, plate 54. Katrin
Kogman-Appel has indicated to me that this last illumination comes from the miscellany
kept at the State and University Library of Hamburg (Cod. Hebr. 37, folio 29v).

FIGURE 28. Moses imposes the Divine Law on the Israelites. The illumination is in the Budapest Codex of Maimonides, the Misneh Torah. Research has shown that originally the image in this folio was different and had to be painted over in order to conform to Jewish law.

Courtesy of the Library of the Hungarian Academy of Sciences, Oriental Collection. Ms. A.77/IV, fol. 32r.

nations in this Budapest codex convinced her even more of the Christian identity of the painter.[39]

Historians are tempted to point at least to schools that could have served as sources of inspiration and to workshops where Hebrew illuminations could have been produced. A comparative analysis looking for resemblances in stylistic and iconographic features concerning the color scales or the examination of technical features has sometimes proved successful, though on other occasions it has yielded inconclusive results. Thus, at an

[39] Ellen S. Saltman, "The 'Forbidden Image' in Jewish Art," *Journal of Jewish Art* 8 (1981): 42–53, deals with several instances in which the Jewish taboo was not observed. Special attention is given in her study to the illustrations in a Mantuan *ketubah* (marriage contract) of the year 1689. The hand of God appears twice in the Bird's Head Haggadah. Elisheva Revel-Neher discussed the meaning of the hands that appear in the Dura-Europos frescoes in "Seeing the Voice: Configuring the Non-figurable in Early Medieval Jewish Art," in Bracha Yaniv (ed.), *Timorah: Articles in Jewish Art* (Ramat Gan, Israel, 2006), 7–22 (in Hebrew). For the understanding in Western Christianity, since the eleventh century, of Moses's descent from Mount Sinai (Exod. 34.29), see Ruth Mellinkoff, *The Horned Moses in Medieval Art and Thought* (Berkeley, 1970); and Ruth Mellinkoff, "More about Horned Moses," *Jewish Art* 11–12 (1987): 184–98.

exhibition of fifty Hebrew illuminated Bibles in Milan in 1966,[40] Mirella
Levi D'Ancona had difficulty establishing the authorship of most of the
exhibits. She was only able to suggest, with varying degrees of certitude,
the names of three artists (Attavante, Strozzi, and Littifredo Corbizzi) as
possible illuminators of some of the codices. Her many years studying
medieval miniatures enabled her to distinguish among the German, Span-
ish, and French origins of some of the manuscripts but not to go beyond
that. Things turned out a bit better as far as Italian paintings were con-
cerned, as distinctions could be suggested between the Umbrian and
Emilian schools and between the Ferrarais and Veronais workshops.

Other professionals concentrating their attention on a single manu-
script have been able to explain their reasoning in more detail. The far
reaching analysis of the Budapest Mishneh Torah by Gabrielle Sed-Rajna
provides us with an excellent example.[41] The four volumes of this legal
summa were copied by Nathan ben Simon, who started the work on April
26, 1295, and finished it sixteen months later on August 8, 1296. The
information that can be culled from its fifteen frontispieces and numerous
marginal decorations has been analyzed meticulously in this study. Facial
expressions, forms of foreheads and noses, and the shapes of hair ar-
rangements were literally examined under magnifying glasses and then
compared to other works of art of the period. Everything led to the con-
clusion that the Budapest Mishneh Torah was illuminated in France. Min-
iaturists from workshops in Cambrai or in the county of Barr may well
have helped to decorate this Mishneh Torah or at least provided models
from their workshops. Sed-Rajna was careful and hesitant when the time
came to pronounce a verdict. She concluded that, while the artist(s) could
have been Christian, Jewish input could not be ruled out. Cohen's discov-
eries, published several years later, do not permit any such vacillation.[42]

Bezalel Narkiss, in his introduction of a facsimile edition of the Golden
Haggadah (British Library, Add. Ms. 27210) is, in my opinion, overly
cautious in drawing his conclusion. His study led him to reveal a "dia-
logue" between illuminations painted in the leading school of Catalonia

[40] The catalog was edited by Antonioli Martelli and Mortara Ottolenghi as their *Mano-
scritti*. See also Luisa Mortara Ottolenghi, "Scribes, Patrons and Artists of Italian Illumi-
nated Manuscripts in Hebrew," *Journal of Jewish Art* 19–20 (1993–94): 86–98.

[41] Gabrielle Sed-Rajna, "The History of a Hebrew Codex: A Hebrew Codex as History,
Maimonides' Mishneh Torah at the Library of the Hungarian Academy of Sciences," in
Joseph Dan and Klaus Herrmann (eds.), *Studies in Jewish Manuscripts* (Tübingen, Ger-
many, 1999), 199–219. Sed-Rajna published in facsimile selected pages of this manuscript;
see *A Majmuni Kodex* (Budapest, 1980; English translation, Budapest, 1984). She also pub-
lished other studies about this manuscript, among them "The Illustrations of the Kaufmann
Mishneh Torah," *Journal of Jewish Art* 6 (1979): 64–77.

[42] Another more recent example of careful and detailed stylistic analysis is that of Sarit
Shalev-Eyni, "Illuminierte hebräische Handschriften aus dem Bodensee-Raum," *Kunst +
Architektur in der Schweiz* 51 (2003): 29–37, regarding mainly the Tripartite Mahzor.

in the 1320s and the illuminations in this Haggadah. And, since the Cata-
lan artists were, for their part, influenced by the iconography of both
Italian and French workshops, Narkiss paid particular attention to the
question of Parisian inspiration. He also pointed to the fact that well-
known subjects of Christian iconography, like Mary's flight to Egypt, had
crept into this Hebrew codex. Armed with all this information, and not
having noticed the halo around the angel of God on folio 10v, he was
only slightly more daring in stating his conclusion, which he formulated
thus: "The illuminator . . . may have been Christian. The high quality of
the illuminations could imply that the Haggadah was illuminated by a
secular Christian Craftsman." Not a strong statement. A similar careful
assessment still prevails in a recent study of this Golden Haggadah by
Katrin Kogman-Appel. Even though she found in different folios of the
codex close resemblances to panels in the Church of the Santa Restituta
in Naples; to cloister sculptures in Montreale, Sicily; and to mosaics in St.
Mark's Church in Venice she hypothesized that "it is likely that [these
images] . . . were copied from a motif book available in the Spanish Jew-
ish workshop that produced the 'Golden Haggadah.' "[43] Her conclusion:
the painter was a Jew and not a Christian.

Without doubt a French Pentateuch, accompanied by the commentaries
of Rashi, is of Jewish hand (Oxford, Bodleian Library, Ms. Opp. 14,
Ol.102). It was produced at L'Albenc, a small town in the Dauphiné, in
the year 1340 and was copied by a scribe named Shlomo bar Eliezer
Hayyim ha-Cohen, also known as Deiaya (perhaps Yeda'ayah) for a pa-
tron by the name of Moshe bar Yehuda. The scribe, a very modest painter,
decorated the text, presenting Rashi's commentaries and the massoretic
notes in a variety of micrographic forms of perfect circles or triangles. He
also included a painting of a dragon (fol. 72v) and of another frightening
monster (fol. 46v). In his pen-drawn illustrations in some margins of the
Pentateuch's folios he did not hesitate to present human faces in portrait
or in full frontal manner. One can see them, for example, on folios 11r,
12v, 22v, and 30r, among others.[44]

No hesitation governs any of the discussions about the illuminating of a
codex in the British Library in London (Add. Ms. 11639). This codex

[43] See Narkiss, *The Golden Haggadah*, 50–67, and Kogman-Appel, *Illuminated Hagga-
doth*, 56, 64, 71.
[44] The only study of this Bible is Bezalel Narkiss, "The Seal of Solomon the Scribe: The
Illustrations of the Leblanc Pentateuch of 1340," in Katrin Kogman-Appel and Mati Meyer
(eds.), *Between Judaism and Christianity: Art Historical Essays in Honor of Elisheva (Elisa-
beth) Revel-Neher* (Leiden, Netherlands, 2009), 319–49.

raises scholarly excitement as does no other.[45] Consisting of 749 small folios, it is a miscellany comprising more than fifty different works, most of them of a religious nature. The scribe—his name was Benjamin—copied the entire manuscript single-handedly. (The patron may have been a certain Aharon.) There is universal agreement among scholars that both the copying and decorating were carried out in northern France during the last quarter of the thirteenth century. Sed-Rajna noticed a striking resemblance between some of the forty-nine full-page miniatures in the codex and the iconography produced during the same period in the workshop of the great master Honoré (c. 1250–c. 1313) of Amiens (and later in Paris).[46] Some of the stylistic features she had noticed in the Budapest Mishneh Torah also appear in this manuscript: people's gestures and other body language, the shape and coloring of clothing, the folding of drapery, and the architecture of buildings and furniture all point to the Amiens-Paris axis. The hand of master Honoré himself is perhaps recognizable in the painting of the confrontation between David and Goliath on folio 523v. It does, in fact, closely resemble an identical scene painted on the upper half of folio 7v of King Philip the Fair's breviary (Paris, Bibliothèque Nationale, Ms. Latin 1023), which most scholars have attributed to this illustrious master. It should be noted that the famous artist moved to Paris in the 1280s and was attached to the royal court; the workshop he ran in Rue Erembourg de Brie employed apprentices and assistants who helped him in completing his commissions.[47]

[45] A facsimile of the manuscript has been edited by Jeremy Schonfield under the title *The North French Hebrew Miscellany (British Library Add. Ms. 11639)*, 2 vols. (London, 2003), with a detailed, most original introduction by Yael Zirlin. A pioneering study of the manuscript is Zofia Ameisenowa, "Die hebräische Sammelhandschrift Add. 11639 des British Museum," *Wiener Jahrbuch für Kunstgeschichte* 24 (1972): 10–48.

[46] See the very detailed examination in Gabrielle Sed-Rajna, "The Paintings of the London Miscellany: British Library Add. Ms. 11639," *Journal of Jewish Art* 9 (1983): 18–30; and Gabrielle Sed-Rajna, "Les manuscrits enluminés (en France)," in Bernhard Blumenkranz (ed.), *Art et archéologie des Juifs en France* (Paris, 1980), 159–86. A critique of these publications is that of Thérèse Metzger and Mendel Metzger, "Les enluminures du Ms. 11639 de la British Library, un manuscrit hébreu du nord de la France (fin du XIIIe siècle–premier quart du XIVe siècle)," *Wiener Jahrbuch für Kunstgeschichte* 38 (1985): 59–113. A less enthusiastic appreciation of the importance of Master Honoré in his time is Ellen Kosmar, "Master Honoré: A Reconstruction of the Documents," *Gesta: International Center for Medieval Art* 124 (1975): 63–68.

[47] On Master Honoré, see Eric Millar, *The Parisian Miniaturist Honoré* (London, 1959). The recent, most authoritative study is that of Rouse and Rouse, *Illiterati et uxoratii*; see also the classic, Georg Vitzthum von Eckstädt, *Die Pariser Miniaturmalerei: von der Zeit des hl. Ludwig bis zu Philipp von Valois und ihr Verhältnis zur Malerei in Nordwesteuropa* (Berlin, 1907), 39–59, 163–95. The David and Goliath scenery is reproduced in Vitzthum as plate 8; it also appears on the cover of *Journal of Jewish Art* 9 (1982). It comes from *La Somme le Roi*, London, British Library, Add. Ms. 54180. For another David and Goliath

A facsimile edition of the 746 folios of a British Library codex was published in London in 2003; Jeremy Schonfield is the editor and its title is *The North French Hebrew Miscellany (British Library Add. Ms. 11639)*. This occasion led Yael Zirlin to offer a very detailed and highly original reconstruction of the process by which the codex was created in a volume of studies accompanying the publication.[48] Although endorsing the idea that the illuminations originated in northern France, Zirlin suggests that the enterprise was undertaken in the city of St. Omer in the Artois rather than in Amiens in the Picardy. In her view, also, Master Honoré offered a rather limited and even belated contribution to the accomplishment of the work. These new observations are supported by the study of heraldry. The coat of arms of the Vermandois within the codex, noticed by Michel Garel, certainly leads to the region of the Artois and the Oise. And, since the coat of arms of the family who governed the town of Boulogne-sur-Mer is also found on the codex, it is not impossible that the Jew who commissioned the work lived in Boulogne or in the vicinity. This may have enticed him to turn to one of the then flourishing ateliers in St. Omer, a town situated only about forty kilometers east of Boulogne. It is in St. Omer that the saga of the codex's production started. The illuminations, and this is one of the original discoveries in Zirlin's study, were painted in three stages (Zirlin, pp. 135–39). When the first of the three phases had been accomplished, the scribe Benjamin added notes in the margins of several folios and sent back the bulk of the quires— thirty-six of them—to St. Omer for redecoration. There, no fewer than eight groups of artists, quite easily distinguishable from one another, went back to work under the supervision of the ever-present Jewish scribe Benjamin (pp. 139–47). Only then do we come to the third stage, in which the parchments were transferred to Paris (pp.147–58). This transition may have resulted from the royal decree of 1283 which forbade Jews to sojourn in villages and small towns. It was then that Benjamin engaged Master Honoré's workshop, as well as two other workshops headed by unidentified artists. The venture was not completed in the early 1280s,

encounter (Paris, Bibliothèque Nationale, Ms. Latin 1023, fol. 4v), see Alexander, *Medieval Illuminators*, 120.

[48] Yael Zirlin, "The Decorations of the Miscellany, Its Iconography and Style," in Schonfield (ed.), *The North French Hebrew Miscellany*, 2:75–161. Note also the short but highly suggestive study in Michel Garel, "The Provenance of the Manuscript," also in Schonfield (ed.), *The North French Hebrew Miscellany*, 2:27–39. Support for rejecting the possibility that the workshop was in Amiens is provided in William Chester Jordan, "A Jewish Atelier for Illuminated Manuscripts in Amiens?" *Wiener Jahrbuch für Kunstgeschichte* 37 (1984): 155–56. Zirlin further developed her ideas about Judeo-Christian polemics in the manuscript in a recent study, "The Jewish-Christian Polemic in Pictures: *The North French Miscellany* (BL. Ms. Add. 11639)," in Bracha Yaniv (ed.) *Timorah: Articles on Jewish Art* (Ramat Gan, Israel 2006), 61–72 (in Hebrew).

however. For some reason an additional group of quires was attached to
the codex between 1296 and 1298 (pp.158–61). Stylistic considerations
suggest that this group was illuminated in eastern France, possibly in the
Champagne region. However, we remain in the dark about the reasons
and the conditions under which this addition was made. Noticeable also
is the lack of any colored illumination in the last 212 folios (fols. 528r–
739v). Does this signify a crisis of some sort?

Another question concerning the history of the makings of the codex
is raised by the last group of four full illuminations (fols. 740r–743v) at
its very end. It shows on the second panel of the group the biblical char-
acter Lot, Abraham's nephew, escaping from Sodom, leading his two
daughters and wife. According to the Bible, Lot's wife, who looked back
on the destruction, was turned to a pillar of salt. In this illumination (see
fig. 29) she is very much human and certainly not immobile—unlike, for
example, her depiction in the Sarajevo Haggadah (National Museum of
Bosnia and Herzegovina, Passover Haggadah, fol. 7v). Dressed entirely in
white, her white hands move and her beautiful marble white face is
shown in three quarters with her eyes open (fol. 740v). Her appearance
remains very much lifelike. No caption explains the scene that appeared
earlier in a smaller illumination on folio 119v. There, two angels lead the
same group out of the mayhem. I wonder therefore if we do not have on
folio 740v a portrait of the family of the patron of the codex. I am en-
couraged to raise the possibility given that the Budapest Mishneh Torah
illuminated around this time in Northern France shows (vol. 2, fol. 48r)
realistic portraits of the couple who ordered the manuscript. The scribe
shared with us their names: Yentil is the wife and Abraham the husband.
Were the family members of the patron of the codex also willing to have
their images on the folios, for which they must have paid a great deal?

Yael Zirlin takes for granted that the artists involved in the production
of the codex were all Christians. No Jewish community, not even that in
Paris, would have included the number of painters and assistants that the
realization of that particular project required. As the iconographic mod-
els for the biblical episodes could have been readily discovered in the
"picture Bible" or "moralized Bible" (Bible moralisée) and in the illus-
trated moral treatises that were based on animal stories ("bestiaries"),
non-Jews would have had easy access to them (pp.115–23, 130–31). She
also discovered traces of tension between the scribe-supervisor Benjamin
and the non-Jewish artists. Benjamin, for his part, did not hesitate to in-
clude elements of religious polemics in the miscellany. Thus, for example,
he could not restrain himself from labeling St. Peter as Peter the Ass
("Peter Hamor"). For their part, the illuminators omitted some momen-
tous events in the sacred history of the Jews. For instance, Moses coming

FIGURE 29. Lot and his family escaping Sodom. Could it be a portrait of the family who commissioned the codex?
 The British Library Board. Ms. Add. 11639, fol. 740v.

down from Mount Sinai with the Torah, the paramount event in biblical history, has no place in the miscellany. Another very popular illustration in Jewish-illuminated codices, the defeat of Haman, the archenemy of the Jews, is also missing. The victory of the Israelites over the Amalekites (Christians) in the battle of Refidim (Exod. 17.8–13) is painted, it is true, but with less energy than is shown elsewhere in the miscellany.

It is, of course, not surprising to find hostility toward the Jews expressed by these Christian artists. A long sequence of studies about the image of Jews in medieval art have animosity as their principal subject. But to discover signs of hostility in Hebrew illuminated codices, even if

only faint and accidental ones, is certainly surprising. In this respect the findings of Yael Zirlin receive much support in Ruth Mellinkoff's important study, published in Jerusalem in 1999, about the negative message of some Hebrew illuminated manuscripts.[49] Mellinkoff, an art historian with many accomplishments to her credit, was intrigued by the deformed and distorted manner in which Jews are represented in some of the Hebrew manuscripts. What caught her attention in particular were the bizarre images found in illuminated manuscripts like The Bird's Head Haggadah and in other, similar ones produced in Germany between 1260 and 1310. She noticed that the anti-Semitic images found in these Hebrew manuscripts had no uniformity and that individual Christian artists had a free hand in producing images close to caricatures: noses are hooked or bulbous, mouths and eyes are enlarged, and lips are particularly fleshy. Especially noticeable are the small, pointed ears that are in fact pigs' ears. All must have been painted in bad faith. Of particular interest is a beautifully painted wedding scene found in the Hamburg Mahzor produced between 1300 and 1330 (Universitätsbibliothek, cod. Lev. 37, folio 169v), which shows the bride's eyes covered with a veil.[50] This does, of course, bring to mind the dozens of "veiled synagogue" illuminations that Bernhard Blumenkranz found in Latin "moralized Bibles" as well as in many statues at cathedral entrances.[51]

How did Christian artists manage to interweave so much hostility into the Hebrew manuscripts? Why did the Jewish patrons not see to it that such monstrosities were deleted? In her search for an answer, Mellinkoff turns to epistemology and explains the difference between "looking" and "seeing": in her thinking, the stereotypical demonic image was so heavily ingrained in Jewish minds that the patrons did not see any particular animosity in the illuminations they were looking at. And if the Worms Mahzor (see chapter 5) was really illuminated by the Jew Shema'ayah, as some scholars suggest, then we are even dealing with a "self-made" distortion. A short Hebrew statement written in Germany around the mid-fourteenth century in part supports Mellinkoff's insight. In one section of

[49] See Mellinkoff, *Antisemetic Hate Signs*.

[50] Ibid., 51, and plate 50. A beautiful reproduction of this illustration has been published in the exhibition catalog *Europas Juden im Mittelalter*, published by the Historisches Museum der Pfalz Speyer (Stuttgart, 2004), 175. For a more benign interpretation of this painting, see Ivan G. Marcus, "A Jewish-Christian Symbiosis: The Culture of Early Ashkenaz," in David Biale (ed.), *Cultures of the Jews: A New History* (New York, 2002), 449–516, esp. 496–98; the painting is reproduced on 499 in black and white.

[51] Bernhard Blumenkranz, "La représentation de *Synagoga* dans les bibles moralisées françaises du XIIIe au XVe siècle," *Proceedings of the Israel Academy of Sciences and Humanities* 5 (1970): 70–91.

the fourteenth-century book of religious polemic known as *Nizzahon Yashan* (*Nizzahon vetus* in Latin), the Jew recognizes that "in most places" gentiles "are fair and handsome" while Jews "are dark and ugly."[52] What may sound offensive to many contemporary Jews today may not have seemed so painful to their medieval ancestors. Indeed, the Jewish polemicist treated the issue with much pride and assertiveness. Add to it that such distortions may have been welcomed by the iconoclastically motivated leaders of Jewish society who were described in the previous chapters. Some of the faithful may have been more comfortable with zoocephalic and distorted figures than with realistic presentations of human faces. And since what creates fascination with an artwork is not necessarily the beauty of its people nor its objects but the overall sensation that the composition conveys, Jewish patrons may have been content with the products they received.

A note that may surprise many would be in order in this concluding section: the decorating of manuscripts by non-Jews would not necessarily have been a measure of last resort for patrons nor would they have agonized over their decision. Quite the contrary, some Jews would have preferred this option. By entrusting a Christian to embellish their Hebrew codex they would be able to enjoy contemporary art and to placate at the same time their religious leaders. Although this sounds paradoxical it is not, since rabbinic dogma distinguished between creations produced for Jews by coreligionists and those produced for them by "others." The gentile artists would be considered "others" by a Talmudic technical concept (*aherim* in Hebrew, plural of the Hebrew *aher*), and medieval rabbis, like their predecessors the Talmudic sages, considered the art work of "others" done for Jews as being legitimate. A nonconformist rabbi like Ephraim of Regensburg relied on this distinction when he intervened in the controversy in Cologne in 1152, claiming that the decorated windows of the synagogue were installed by "others," not by Jews.

This dogma was related to a quandary in which the venerated patriarch Gamaliel II (fl. c. 80–116 CE) found himself (Talmud Bavli, Avodah

[52] David Berger (ed. and trans.), *The Jewish-Christian Debate in the High Middle Ages: A Critical Edition of the Nizzahon Vetus* (Philadelphia, 1979), 165 (in Hebrew). Amazingly, a Provençal contemporary, Joseph ibn Caspi (1279–c. 1340), took a more defensive stance, writing, "Christians recognize a Jew by his face. They will say that he has a Jewish face because of its distinctive features, since he is not of rosy completion and does not have beautiful eyes like that of Christians and other successful people." For Joseph the difficult conditions under which Jews lived explained this fact. See Isaac Last (ed.), *Adne Keseph: Commentary on the Prophetical Books of the Bible by Joseph ibn Caspi, Part 1* (London, 1911), 166.

Zarah, 43a). He, the illustrious head of the Palestinian academy, kept in his attic a series of models of different shapes of the moon, a fact that constituted a blatant transgression of the biblical interdiction. But Gamaliel needed the models in order to establish the calendar, since the Jewish year is "lunar" and depends on the actual observation ("fixing") of the new moon. The Talmudic sages found a way out of the difficulty. In their thinking the Second Commandment (Exod. 20.4–6) was addressed to each individual directly, employing the imperative in second person singular (Hebrew: *lo ta'ase lecha*): "You shall not make for yourself a graven image, or any likeness of anything that is heaven above," and so on. The admired patriarch Gamaliel did not transgress this law; he did not create these models with his own hands, "others" built them for him. These "others" were presumably non-Jews. He could therefore use the models in good conscience. Similarly, when medieval Jews had to face the embarrassing fact that King Solomon, the son of King David, had sculptured animals on his throne, entirely against biblical injunction, the great rabbi Meir of Rothenburg took refuge in the theory of "others."[53] Such may also have been the thinking of these Jewish patrons who willingly engaged non-Jews to create the treasures we enjoy so much today.

[53] See Thérèse Metzger and Mendel Metzger, "Meir ben Baruch de Rothenbourg et la question des images chez les Juifs au Moyen Âge," *Ashkenas* 4 (1994): 33–82; and Kalman P. Bland,"Defining, Enjoying and Regulating the Visual," in Laurence Fine (ed.), *Judaism in Practice: From the Middle Ages through the Early Modern Period* (Princeton, NJ, 2001), 281–97.

Chapter Seven

JEWISH CRAFTSMANSHIP AT THE
SERVICE OF THE CHURCH

There is another side to this story: Jewish professionals shared their ex-
pertise with members of the Christian society and with its religious insti-
tutions. Ample documentation points to Jewish silversmiths, bookbind-
ers, painters, and coral craftsmen helping Christians decorate their
devotional articles. The churches, in their quest to embellish their sacred
spaces, did not hesitate to seek out the help of Jews. Just as Christians
turned a deaf ear to the prohibitions preached by the prelates, Jews, too,
did not stringently follow the exhortations of the leaders of their quarter.
Barriers were broken. The participation of Jews in what can be labeled as
a "professional community" is another factor that contradicts the pre-
vailing notion that an insurmountable wall separated Jews from their
neighbors.

A good place to start is the island of Sicily, where Jews became heavily
involved in the coral industry. After generations of neglect, interest in
coral was revived during the eleventh and twelfth centuries. The coral
grew mainly in the western part of the Mediterranean; it was extracted
from the sea in Provence, Liguria, Catalonia, Sardinia, Corsica, and—
most of all—Sicily. Products made from coral were much appreciated in
northern Europe, in the Middle East, and even as far away as India. Be-
sides being used for religious purposes—rosaries in Christianity and their
equivalent in other religions—it was also used in all sorts of ornaments,
and even had a place in medical practices of the period.[1] Sicilian Jews

[1] For the economic history of coral production, I have mainly relied on the works of my
friend Henri Bresc, known for his two-volume masterpiece *Un monde méditerranéen: Écon-
omie et société en Sicile, 1300–1450* (Rome, 1986), as well as for his most recent *Arabes de*

seem to have had a dominant role in one particular branch of the coral industry, the manufacture and sale of rosaries. Information from the coastal city of Trapani leaves no doubt about their prominence.[2]

In the year 1418 an exceedingly rich deposit of corals was discovered in the Bay of Trapani.[3] That Jews participated actively in exploiting this new treasure trove can be gathered from a handsome corpus of documents relating to the period between the years 1412 and 1500 that was published in 1986 by a team of scholars under the direction of Aldo Sparti.[4] Of the 370 documents in this collection, no fewer than 199 show Jewish *coralerii* as laborers, representing 54 percent of the total workforce. Other Jews were involved in the commerce of the raw materials and of the finished products. The percentage is even more significant for the last forty years of Jewish existence in Sicily (they were expelled in 1492): no less than 78 percent of the available documentation from that period is related to their activities. Out of the thirty-three workshops that processed the raw materials, thirty-one had a Jewish owner.[5] Some of them entered into partnerships with the Christian navigators who brought the raw materials out of the sea (Sparti, document nos. 85, 86, 89,) while others hired non-Jewish workmen to render the raw materials salable (no. 226). But Jewish artisans formed the majority of the labor force in these workshops: in as many as two-thirds of the contracts enacted by or for young apprentices who intended to join the profession, (thirty-six out of fifty-six[6]), the applicants were Jewish. While there is no way to calculate the number of Jewish coralerii working in Trapani in any given year, a total of some 150 names appear in these fifteenth-century documents.[7]

langue, *Juifs de religion: l'évolution du judaïsme sicilien dans l'environnement latin, XIIe–XVe siècles* (Paris, 2001). See also Henri Bresc, "Pêche et commerce du corail en Méditerranée de l'Antiquité au Moyen Âge," 41–53, and "De sang et d'or. Traces artistiques et archéologiques du corail médiéval et moderne," 217–24, both in Jean-Paul Morel, Cecilia Rondi Constanzo, and Daniella Ugolini (eds.), *Corallo di ieri corallo di oggi* (Bari, Italy 2000). For Marseille's corals, see Géraud Lavergne, "La pêche et le commerce de corail à Marseille aux XIVe et XVe siècles," *Annales du Midi* 64 (1952): 199–211. See also note 7, below.

[2] Bresc, "Pêche et commerce du corail," 45–46.
[3] Ibid., 42.
[4] Aldo Sparti, *Fonti por la storia del corallo nel Medioevo mediterraneo* (Trapani, Italy, 1986). Sparti also presented the data in "Gli ebrei siciliani e l'arte de corallo," in Nicolo Bucaria, Michele Luzzati, and Angela Tarantino (eds.), *Ebrei e Sicilia* (Palermo, Italy, 2002), 137–61.
[5] For the percentages cited herein, see Bresc, "Pêche et commerce du corail," 47.
[6] Ibid., 48.
[7] It is of interest that at the first quarter of the fourteenth century there were twenty-five Jews working on corals in Marseille. A list of these coral laborers—all considered very poor—is in Juliette Sibon, "Les Juifs de Marseille au XIVe siècle," vol. 2 (PhD diss., Université Paris X Nanterre, 2006), 699. There is much more information about work and

Chapter Seven

JEWISH CRAFTSMANSHIP AT THE SERVICE OF THE CHURCH

There is another side to this story: Jewish professionals shared their expertise with members of the Christian society and with its religious institutions. Ample documentation points to Jewish silversmiths, bookbinders, painters, and coral craftsmen helping Christians decorate their devotional articles. The churches, in their quest to embellish their sacred spaces, did not hesitate to seek out the help of Jews. Just as Christians turned a deaf ear to the prohibitions preached by the prelates, Jews, too, did not stringently follow the exhortations of the leaders of their quarter. Barriers were broken. The participation of Jews in what can be labeled as a "professional community" is another factor that contradicts the prevailing notion that an insurmountable wall separated Jews from their neighbors.

A good place to start is the island of Sicily, where Jews became heavily involved in the coral industry. After generations of neglect, interest in coral was revived during the eleventh and twelfth centuries. The coral grew mainly in the western part of the Mediterranean; it was extracted from the sea in Provence, Liguria, Catalonia, Sardinia, Corsica, and—most of all—Sicily. Products made from coral were much appreciated in northern Europe, in the Middle East, and even as far away as India. Besides being used for religious purposes—rosaries in Christianity and their equivalent in other religions—it was also used in all sorts of ornaments, and even had a place in medical practices of the period.[1] Sicilian Jews

[1] For the economic history of coral production, I have mainly relied on the works of my friend Henri Bresc, known for his two-volume masterpiece *Un monde méditerranéen: Économie et société en Sicile, 1300–1450* (Rome, 1986), as well as for his most recent *Arabes de*

seem to have had a dominant role in one particular branch of the coral industry, the manufacture and sale of rosaries. Information from the coastal city of Trapani leaves no doubt about their prominence.[2]

In the year 1418 an exceedingly rich deposit of corals was discovered in the Bay of Trapani.[3] That Jews participated actively in exploiting this new treasure trove can be gathered from a handsome corpus of documents relating to the period between the years 1412 and 1500 that was published in 1986 by a team of scholars under the direction of Aldo Sparti.[4] Of the 370 documents in this collection, no fewer than 199 show Jewish *coralerii* as laborers, representing 54 percent of the total workforce. Other Jews were involved in the commerce of the raw materials and of the finished products. The percentage is even more significant for the last forty years of Jewish existence in Sicily (they were expelled in 1492): no less than 78 percent of the available documentation from that period is related to their activities. Out of the thirty-three workshops that processed the raw materials, thirty-one had a Jewish owner.[5] Some of them entered into partnerships with the Christian navigators who brought the raw materials out of the sea (Sparti, document nos. 85, 86, 89,) while others hired non-Jewish workmen to render the raw materials salable (no. 226). But Jewish artisans formed the majority of the labor force in these workshops: in as many as two-thirds of the contracts enacted by or for young apprentices who intended to join the profession, (thirty-six out of fifty-six[6]), the applicants were Jewish. While there is no way to calculate the number of Jewish coralerii working in Trapani in any given year, a total of some 150 names appear in these fifteenth-century documents.[7]

langue, Juifs de religion: l'évolution du judaïsme sicilien dans l'environnement latin, XIIe–XVe siècles (Paris, 2001). See also Henri Bresc, "Pêche et commerce du corail en Méditerranée de l'Antiquité au Moyen Âge," 41–53, and "De sang et d'or. Traces artistiques et archéologiques du corail médiéval et moderne," 217–24, both in Jean-Paul Morel, Cecilia Rondi Constanzo, and Daniella Ugolini (eds.), *Corallo di ieri corallo di oggi* (Bari, Italy 2000). For Marseille's corals, see Géraud Lavergne, "La pêche et le commerce de corail à Marseille aux XIVe et XVe siècles," *Annales du Midi* 64 (1952): 199–211. See also note 7, below.

[2] Bresc, "Pêche et commerce du corail," 45–46.

[3] Ibid., 42.

[4] Aldo Sparti, *Fonti por la storia del corallo nel Medioevo mediterraneo* (Trapani, Italy, 1986). Sparti also presented the data in "Gli ebrei siciliani e l'arte de corallo," in Nicolo Bucaria, Michele Luzzati, and Angela Tarantino (eds.), *Ebrei e Sicilia* (Palermo, Italy, 2002), 137–61.

[5] For the percentages cited herein, see Bresc, "Pêche et commerce du corail," 47.

[6] Ibid., 48.

[7] It is of interest that at the first quarter of the fourteenth century there were twenty-five Jews working on corals in Marseille. A list of these coral laborers—all considered very poor—is given in Juliette Sibon, "Les Juifs de Marseille au XIVe siècle," vol. 2 (PhD diss., Université Paris X Nanterre, 2006), 699. There is much more information about work and

These craftsmen were expected to produce "labored, polished and perfo-
rated corals" (no. 252) or, as another document states, "sound, labored"
corals (no. 196). For the adjective *perforated* they used local terms like
infiliati or *picati* (nos. 191, 221). The weight of these round, lentil-sized
products varied from one-third of a gram in Marseille in 1286 to a little
more than two grams in Trapani in 1459. They would be sold by weight,
not by unit.[8]

None of these coralerii can be described as an artist. The documenta-
tion from Trapani and Marseille does not show that any of them were
involved in any other capacity than as craftsmen. No church candelabra,
no sculptures of the Madonna, and no crucifixes (all of which had just
started being produced) are mentioned in connection with Jewish crafts-
men.[9] These coralerii appear to have been engaged exclusively in the pro-
duction of a single Christian devotional object—the "paternoster," a
prayer counter that enabled the devout to control the number of "Paters,"
and later also the "Ave Marias," they recited during prayer. These rosaries
were introduced into Catholic practice comparatively late in Christian
history—according to a persistent legend, by St. Dominic (c. 1130–1221)
himself.[10] Inexpensive rosaries were created by stringing corals on a
thread. More luxurious ones consisted of a combination of corals and
pearls.

As rosaries of all kinds became very popular in the fourteenth century,
some Jews realized the commercial possibilities they offered. From a doc-
ument dated February 20, 1427 (no. 63), we learn about a Jewish part-
nership specializing in the commerce of rosaries. This enterprise was
headed by two Jews living in Trapani who were associated with a fellow
Jew in Marseille. On that date, the three sold an unspecified quantity of
rosaries of lower quality, "coral paternosters of common form and shape,
the way they usually are," to yet another Jew, Israel de Perfia. Evidence
about other ambitious entrepreneurs surfaced in later years: in 1448, for
example, a notarial contract mentions a deal in which three pounds of
"paternosters of coral" were negotiated (no. 125), while the amount of
twenty-six pounds is quoted in an agreement drawn up a year later (no.
131). Close to the end of the year 1447, to quote a third example, a Jew
of Trapani, Machlufus de Actono, then in a business relationship with an
Italian merchant from Pisa named Simon de Perto, sold an unspecified

trade of corals in her work; see, for example, 692, 815, 855, 860, 872, and 879. See also
Lavergne, "La pêche et le commerce de corail," 205–6, 210–11.

 [8] See Bresc, "Pêche et commerce du corail," 46 ; and Bresc, "De sang et d'or," 219.

 [9] Bresc, "De sang et d'or."

 [10] See John D. Miller, *Beads and Prayers: The Rosary in History and Devotion* (London,
2001); and Rainer Scherschel, *Der Rosenkranz—das Jesusgebet des Westens* (Freiburg, Ger-
many, 1979).

quantity of rosaries to his counterpart. A notarized document specifies, "The aforementioned Simon acknowledged having received this quantity of perforated paternosters" (nos. 122–24).

There is no way to discover from these documents whether any reservations were raised by either Christian or Jewish religious authorities about the involvement of Jews in the manufacture or trading of paternosters. The 370 Sicilian contracts and agreements are purely technical in nature. One would have to consult rabbinic documents to learn whether there were objections to this practice among Jews. Such documents do not exist for the island.

Bookbinding was yet another profession that enabled medieval Jews to contribute, indirectly, to the religious practices of their neighbors. Unlike the situation we have just seen for Sicily and its coral rosaries, bookbinding need not be discussed only with the help of evidence found in notaries' registers: it can also be studied—in part, at least—by visiting libraries and museums in which a number of the bindings still exist. In this instance, most of the available information comes from both the Germanic lands and from the Iberian Peninsula. The achievements of German Jewish bookbinders were of a remarkably high standard, and their story forms a significant chapter in the history of European art. It is of interest that early evidence from Germany does not prepare us for the spectacular upsurge in Jewish bookbinding that occurred in the fifteenth century. The frequently mentioned Sefer Hasidim of about 1200 CE often refers to books and their bindings, yet three of its exempla convey rather discouraging information about Jewish craftsmanship: it takes for granted that Christian bookbinders, and clerics in particular, were much more proficient binders than the contemporary Jews.[11] Exemplum number 682 presents a clergyman "who was much more expert in binding books than Jews." However, a righteous Jew would only employ his services when nondevotional pieces were concerned. Another exemplum (no. 681) deals with the dilemma a Jew is facing: a priest is willing to teach him the art of bookbinding, but wants him to start working on Christian books. The Jew is clearly uncomfortable but he still wishes to learn the craft. The solution may be surmised from a third instance, in which a religious Jew rejects an offer from a clergyman to assist in putting together the quires of the Hebrew law of Moses (no. 680). Clearly, these three exempla testify to the fact that at the beginning of the thir-

[11] See Colette Sirat, *La conception du livre chez les piétistes Ashkenazes au Moyen Âge* (Paris, 1996). In referring to the *Sefer Hasidim* I use the Wistinetzki edition, as I have throughout this book.

teenth century everybody took it for granted that Jews had much to learn from the Christians.

The ensuing history of the art of bookbinding among German Jews is poorly documented and does not prepare us at all for their extraordinary successes in the fifteenth century. However, some Jewish artists (or artisans) did practice in the generations separating the thirteenth century from the fifteenth. This can be gathered from an entry in the tax register of the community of Erfurt from the very last years of the fourteenth century. In the year 1398 one of its members named Gumprecht was listed as a "scribe" (*Schreiber*) while a year later he was designated as a *buchbynder*. Other bookbinders must have existed by then in other cities.[12]

Gumprecht of Erfurt may have already belonged to the "school of Jewish binding" in which the art of incised leather on book covers had been well perfected. Members of this school only existed in the Germanic lands, and their unique art was known as the "Jewish leather cut" (*jüdischer Lederschnitt*).[13] Profusely decorated bindings were created in the fourteenth and fifteenth centuries (not only by Jews) using sharp knives to work on the leather. A survey led by Ursula and Kurt Schubert of Vienna unearthed some twenty such works of art that can be attributed with certainty to Jewish bookbinders.[14] They are kept today in libraries and museums in Munich, Darmstadt, Vienna, Prague, Wroclaw (Breslau), and Paris. The decorations very much resemble those found in the Gothic illuminated manuscripts of the period. Medallions showing geometrical combinations appear side by side with others that depict horses, lions, panthers, elephants, deer, unicorns, and, of course, dragons. Dogs pursuing hares and portraits of humans are also found in this artistic inventory; in one case there is even a naked man. Heraldic emblems and grotesque animals also figure. The fingerprints of Jewish artists can be easily identified because of the Hebrew inscriptions found on some or the Hebrew letters found on others. Thus a cover from the fifteenth century, now kept in Vienna (Austrian National Library, Cod. Hebr. 919), has a German proverb cut in Hebrew letters that reads *hütikh von der kazen di born leken un hinten krazen*, which means, "beware the cats that lick in the front and scratch behind." The Jewish origin of an inscription on a Hebrew Pentateuch, kept today in the Bavarian State Library in Munich (Cod. Heb. 212) and reading, "The Pentateuch of the Council of Nurem-

[12] See Arthur Süssman (ed.), "Das Erfurter Judenbuch (1357–1407)," *Mitteilungen des Gesamtarchivs der deutschen Juden* 5 (1914–15): 1–126, esp. 79, 83–84, 85.

[13] The discussion of "leather-cut" binding is based on Ursula Schubert and Kurt Schubert, *Jüdische Buchkunst*, 2 vols. (Graz, Austria, 1983–92), and on Max Joseph Husung, "Über den sogenannten 'jüdischen Lederschnitt,'" *Soncino-Blätter* 1 (1925–26): 29–43.

[14] See Schubert and Schubert, *Jüdische Buchkunst*, 1:189–208.

berg, incised by Meir Yaffe, the artisan," is of astounding beauty. In 1927, Max Joseph Husung called attention to a note in the Nuremberg municipal register stating that Mayerlein Jude von Ulm had been hired by the city's governing council for a period of four months to bind a certain number of books. The craftsman was to start on July 4, 1468, and be finished by November 11 of the same year.[15] The above mentioned codex (Heb. 212), kept in Munich, may have been one of these books. In all probability it was placed among Nuremberg's legal books in order to enable Jews to take an oath on "the five books of Moses."

Several other Hebrew books were bound with "leather-cut" covers of this type. This was the case with the famous Darmstadt Haggadah (Hessiche Landes- und Hochschulbibliothek, Codex Orientalis 8) from the second quarter of the fifteenth century, and with a prayer book kept in the Bayerische Staatsbibliothek in Munich (Cod. Heb. 86). Meir Yaffe, the scribe, copied the first Cincinnati Haggadah (Hebrew Union College, Ms. 444), was also possibly its illuminator, and may have created its original cover (lost today).[16] Of much interest is the fact that some Latin books are protected by covers that must have been removed from Hebrew codices. Thus a Vienna Codex now in the Austrian National Library (Hebr. 919), with a German-Hebrew inscription, covers a twelfth-century Latin work, although the cover was produced some three hundred years later. The cover of a Latin pharmaceutical treatise held today in private hands in Paris was also removed from an unknown Hebrew book. On the other hand, the cover of a Hebrew Haggadah in the British Library (Ms. Add. 14762) presents problems, since it has Christian iconography on it: a depiction of St. George stabbing the dragon and of the Archangel Michael struggling with the devil. It is possible that if the artist was a Jew he simply copied these iconographic elements from a model onto the cover, which had been commissioned by a Christian patron.[17]

Only two of these "leather-cut" artists are known by name today. One is Isaac, son of Zaccariah, whose identity can be ascertained from a badly mutilated cover.[18] The other is the already mentioned Meir Yaffe of Ulm,

[15] See Max Joseph Husung, "Ein jüdischer Lederschnittkünstler," *Soncino-Blätter* 1 (1925–26): 197–98.

[16] On scholarly disagreements about the range of productivity of Maire Yaffe, see Franz Landsberger, "The Cincinnati Haggadah and Its Decorator," *Hebrew Union College Annual* 15 (1940): 529–58; and, more recently, Ursula Ephraim Katzenstein, "Meir Jaffe and Bookbinding Research," *Studies in Bibliography and Booklore* 14 (1982): 17–28. Ernst Róth of Frankfurt suggests that the convert Wolfgang, whose name before his baptism during the Trento ritual murder process (see chapter 6, n. 8) was Israel ben Meir, the son of Meir of Ulm. Unfortunately, no documents sustain this possibility. See Ernst Róth, "Der Buchmaler vom Trienter Judenprozess," *Israelitisches Wochenblatt für die Schweiz* 66 (1966): 27–29.

[17] Schubert and Schubert, *Jüdische Buchkunst*, 1:205–8.

[18] See Bruno Italiener, "Isak B. Secharjah, ein jüdischer Lederschnittkünstler des 15.

who, as we have just seen, created at least four other works for the municipality of Nuremberg (besides the Cod. Heb. 212). Of these four works, one (as just noted) covers a pharmaceutical treatise kept today in Paris, while the other three were to cover books of Christian devotion. One of the three is a Bible of the Poor, printed in German and today kept in the Bamberg State Library (Msc. bibl. 148). The other two each cover a part of an important fourteenth-century theological summa. Today these are kept separately, one at the Staatliche Bibliothek (Schlossbibliothek) in Ansbach (Inc. 610) and the other in the British Library in London (IC37.028). This Summa is the *Pantheologia* by Rainerius Giordani de Pisisis, also known as *Summa Universae Theologiae*.[19] Rainerius (d. 1348), a Dominican priest, composed the comprehensive theological encyclopedia, arranged alphabetically for the use of the clergy. Meir Yaffe probably could not read the quires that he was putting together, but he must have had, even out of curiosity, some idea about the kind of work in which he was investing his efforts.

Bookbinders were also active in the Iberian Peninsula, and it is still possible to see some samples of their work there today, although the items are not as beautifully ornate as German bindings. The most spectacular of these Spanish survivors, the cover of the Aberdeen Bible (University of Aberdeen, University Library, Ms. 23) is, as scholarship has established, not really of Iberian provenance. True, it was copied by a Spanish Jewish scribe, Isaac Valensi, for another Sephardi patron, Joseph ben Jacob Albalia less than two years after the expulsion of 1492. But the cover that protects 388 vellum leaves today is not the original binding. Rather, it was produced later, from parts of the box in which the codex was kept.[20] However, as if to make up for the relatively poor-quality materials found in the Iberian museums, the peninsula's archives contain a considerable number of documents about the activities of Jewish Iberian bookbinders. Scholars of the caliber of José María Mandurell y Marimon and Josep Hernando i Delgado assembled (sometimes duplicating each other) a considerable body of archival information that allows us to follow the paths taken by Spanish Jewish artisans and artists. The career of one of these artisan-artists, Salomon Barbut, can be traced for half a century, from the year 1349 when he was taking his very first steps as a silversmith and bookbinder, until the year 1399.

Jahrhunderts," in Alexander Marx and Hermann Meyer (eds.), *Festschrift für Aron Freiman zum 60. Geburtstage* (Berlin, 1935), 159–60.

[19] Schubert and Schubert, *Jüdische Buchkunst*, 189–90. The *Pantheologia* was printed first in Nuremberg in 1473. It has 916 folios.

[20] See Cecil Roth, *The Aberdeen Codex of the Hebrew Bible* (Edinburgh, 1958).

Two apprenticeship contracts (I refer in the following only to the documents published by Hernando i Delgado[21]) show the steps that a youngster—and his parents—had to take when planning to enter the profession. In the first contract a bookbinder (*ligator librorum*) named Strugus Salveti promises to teach a youth named Aron Arzil, a coreligionist, the art of *ligandi libros*. A fee of forty-five shillings is agreed upon, to be paid to the master in three installments: one-third at the very beginning, another third at the end of the first month, and a last installment two months later (Hernando i Delgado, doc. no. 61). This contract was signed on November 27, 1386. Some three years later the same master accepted as an acolyte the young Niscim Struch Mahir. This time the instructor asked for a slightly higher sum of fifty shillings (no. 67). Unfortunately, the document is torn just where the duration of the contract is specified. Only the word "Years," plural, can be deciphered.

For the earliest document showing a *ligator libres* (in the Catalan language) at work we have to return to the Majorcan agreement of February 22, 1335, which was discussed in chapter 6. Bonin Maymo, the scribe and the illuminator, was probably no stranger to the art of bookbinding. There is no doubt he was assisted by his associate Abraham Tati, who specialized in working with silk. Two of the three Hebrew books he undertook to produce were also to be bound by the couple. "We undertake to bind the aforementioned books and protect them with boards and nails and double locks and all other necessities," declared the artisan-artists, adding, "moreover we are bound to cover them with red covers of cloth as is fitting."[22] This Majorcan contract is the only one concluded between Jews. In all the other agreements in our possession, Jews were engaged by Christians—either individuals or, mostly, institutions. Thus, the daybook of Aragon's royal treasury reveals that in September 1412 Salomo Calinas (Salinas), a Jew of Saragossa, was paid the sum of sixteen shillings to bind five books, using leather to cover three of them, and parchment for the binding of the other two. More expensive materials are mentioned in a contract agreed upon on October 15, 1361, according to which the partners Salomon Barbut and Isaacus Momet were to make

[21] See José María Mandurell y Marimon, "Encuadernadores y Libreros Barceloneses Judíos y Conversos (1322–1458)," *Sefarad* 21 (1961): 300-338; 22 (1962): 345–72; 23 (1963): 74–103; José María Mandurell y Marimon, "La contratación laboral judaica y conversa en Barcelona (1349–1416). Documentos para su estudio," *Sefarad* 16 (1956): 33–71, 369–98; and see especially the more systematic Josep Hernando i Delgado, "Escrivans, illuminadors, lligadors, argenters i el llibre a Barcelona, segle XIV: Documents dels protocols notarials," *Miscellània de textos medievals* 7 (1994): 189–258.

[22] See Jocelyn N. Hillgarth and Bezalel Narkiss, "A List of Hebrew Books and a Contract to Illuminate Manuscripts (1335) from Majorca," *Revue des études juives* 120 (1961): 297–320, esp. 305–6.

silver plates and silver locks to protect an illuminated manuscript created by Arnaldus de la Pena, a non-Jewish artist. The patron who ordered the work was a nobleman named Bonantus de Colle (no. 38). Some ten years earlier a more ambitious project was undertaken by the same Salomon Barbut. The contract, signed on May 16, 1351, envisaged cover plates of silver decorated with gold. The silversmith was to be provided with the precious materials, and required to promise to return whatever silver and gold that was not used. This project was ordered by Bernardus de Lercio, a canon of the Catalan city of Vic (nos. 12–13).

Not all craftsmen were entrusted with such ornate and luxurious projects as was Barbut. Some were preparing no more than blank-page registers for the use of public authorities. In 1372 for example a *ligator* by the name of Bongudas Mahir sold to the municipality of Cervera four blank registers that were to be used as tax registers "in order to write in them the [tax] declarations ("manifests") of the [inhabitants of] said city" (no. 52). Ten years earlier Meir Salamonis had provided the jurist Bernardus de Ultzinellis with three similar registers. The jurist was a treasurer (*thesaurarius*) of the central government of Aragon, and the registers were to be used "for the sake of your work at the treasury office" (nos. 41–42). The same craftsman was still supplying the treasury with registers in the 1380s. According to the Catalan Hebraist José María Millas Vallicrosa, several of these registers can still be seen in the archives of the Crown of Aragon in Barcelona.[23]

Another relic of the Jewish contribution to the production of government records is the Book of Privileges from Majorca, though unfortunately it is in a badly mutilated state. A certain Vidal Abraham was asked in 1341 to paint in the register colored indicators for a long series of paragraphs as well as hundreds of initial letters (*capletres*) of a different size and quality. The Majorcan authorities paid forty pounds for the work: about thirteen and a half for the decorations of Vidal Abraham and the rest (two-thirds of the total) for the scribe's work and the binding of the book.[24] A third piece of evidence comes from Murcia, on the border of Granada, the last Moslem principality on Iberian soil. A Jew named Yucaf Abenaex had agreed to bind three codices at the request of the municipality of Murcia. These were the book of regulation and new ordinances of the city; a collection of charters issued by King Don Alfonso V "The Magnanimous"; and, finally, the customs of Seville. On August 2, 1435, Joseph asked for his salary of 150 maravedis. This Jew had by then

[23] José María Millas Vallicrosa, "Los judíos Barcelonenses y las artes del libro," *Sefarad* 16 (1956): 129–36.

[24] See Jocelyn N. Hillgarth, *Readers and Books in Majorca 1229–1550*, vol. 2 (Paris, 1991), 249–50.

maintained an almost ten-year business relationship with city hall, supplying them (as a *botecario*, a specialized shopkeeper) with paper and wax for sealing documents. He would still be active in 1471. As early as February 1427 he bound the ordinances of the city of Toledo for the council. The mayordomo paid twenty four maravedis for this work.[25]

Alongside the civic authorities Jewish bookbinders also dealt with ecclesiastics and their devotional books. The magnificent plates that Salomon Barbut produced on the orders of the canon of Vic in 1351 were to cover a copy of the Gospels (*textus evangeliorum*; no. 13). A colleague of his, Isaac David Jaba, agreed to work on several liturgical works belonging to the church of Santa Maria de Cubelles which needed binding. The contract signed on August 12, 1359, mentions a missal, a breviary, and an epistolary. The rector of the church promised Isaac David a fee of thirty-three shillings (no. 29). In February of that year Mahir Salomo another Jewish ligator librorum from Barcelona, produced a fabulous copy of the most popular *Golden Legend* (*Legenda Aurea*) by Jacopo da Voragine for a rich merchant from the same city. Listed in the document by its Spanish title *Flos Sanctorum*, this encyclopedic dictionary of Christian saints was sold for the considerable sum of forty-nine pounds (no. 24). Another copy of the *Flos sanctorum* was handed over to Salomon Barbut for binding on November 15, 1358, by a canon of Valencia. For an unknown reason, Salomon had the book in his possession three months later, and at that time he sold it to a Barcelona merchant (no. 23). On April 5, 1359, Michael Astruc, another Jewish binder, sold a breviary according to the rule (*regula*) of the bishopric of Barcelona (*Breviarium juxta morem seu officium Barchinone*), which for some reason was in his possession, to a priest named Guillelmus Figera (no. 26). A much extended Latin dictionary of biblical terminology known as the *Catholicon* was entrusted into the hands of the Jewish craftsman Bonjuha Mahir on May 13, 1384. Written some hundred years earlier (completed in March 1286) by a Dominican, Johannes de Balbis of Genua, the *Catholicon* was intended to help the devout to understand the Bible in the "correct" way—that is, the Christian way. The Jewish bookbinder was promised forty solidi for his labor. The undertaking was commissioned by Ferrarius de Condamina, a citizen of Barcelona, who intended to fulfill the wishes of his late father and donate this hefty volume (it has 741 two-column pages in the first Mainz edition of 1460!) to the cathedral of the city (no. 59).

[25] See Luis Rubio García, *Los Judíos de Murcia en la Baja Edad Media (1350–1500): Collección documental*, vol. 1 (Murcia, Spain, 1995), 376, doc. no. 524. For Joseph's business with the city council, see Luis Rubio García, *Los Judíos de Murcia en la Edad Media* (Murcia, Spain, 1997), 30–41, and esp. 31, 108. In June 1427, notes Rubio García, another Jew—Ycaque Borgi, labeled a *librerio*—bound no fewer than nine codices of royal ordinances. His salary was 123 maravedi (p. 31).

These Jewish-Christian collaborations were not at all to the liking of Pedro de Luna, better known as Pope Benedict XIII (1394–1417), the last pope of Avignon. Of Spanish origin, he ranks high on the scale of Jew-baiters. Shortly after his problematic election to the Holy See on May 11, 1415, he enacted very hostile legislation against the Jews in which the bookbinding business was mentioned in particular.[26] Any Jew who would dare to bind Christian books in which the names of Christ or Saint Mary were mentioned would be subject to Christian excommunication; he would be thus deprived from all contacts with Christians. This legislation was endorsed on the same day by King Ferdinand I of Aragon (1412–16), a great admirer of the pope. Four years later, on July 23, 1415, King Alfonso IV "The Magnanimous" (1399–1436) mitigated the injunction somewhat, saying that Christians who entrusted books like missals or breviaries to Jews would incur only a monetary fine.[27]

Once again, a distinction between the strength of the bark versus the bite can be evoked. The Jewish contribution to Christian liturgical art outlived Pope Benedict XIII. To cite just one example, in Sicily as late as March 1471 the Jewish silversmith Fariono Provinzano created a reliquary in the form of an ark (*tabernaculum*) to hold the relics of St. Pellegrinus. The silver was partly decorated with gold. A similar project was also undertaken in Calabria in 1451.[28]

Other evidence shows that Jewish artists drove even deeper roots into the realm of Christian ceremonials. The first reference might admittedly be out of place in the present discussion. It is the story of a magnificent altarpiece, a retable, that is kept today in the cathedral of Tarazona in Catalonia.[29] *Retable* is a term that comes from the Latin *retro tabulum*—

[26] See Shlomo Simonsohn, *The Apostolic See and the Jews*, vol. 2 (Toronto, 1988–91), 593–602 and doc. no. 538.

[27] Millas Vallicrosa, "Los judíos Barcelonenses y las arts del libro," 131.

[28] See Angela Scandaliato, *Judaica minora sicula: indagini sugli ebrei di Sicilia nel Medioevo* (Florence, Italy, 2006), 154. For Calabria, see Cesare Colafemmina, *Per la storia degli ebrei in Calabria, Saggi e documenti* (Messina, Italy, 1996), 27n36.

[29] A beautiful publication of this retable is in the *Diputación General de Aragon*; see María Teresa Ainaga Andres (ed.), *El retablo de Juan de Leví y su restauración: Capilla de los Pérez Calvillo Catedral de Tarazona* (Saragossa, Spain, 1990). See Kees van der Ploeg, "How Liturgical Is a Medieval Altarpiece?" in Victor M. Schmidt (ed.), *Italian Panel Painting of the Duecento and Trecento* (New Haven, CT, 2002), 103–21. See also Geneviève Bresc-Bautier, *Artistes, patriciens et confréries: Production et consommation de l'œuvre d'art à Palerme et en Sicile occidentale (1348–1460)* (Rome, 1979); and see especially Judith Berg Sobre, *Behind the Altar Table: The Development of Painted Retables in Spain, 1350–1500* (Columbia, MO, 1989). Léon-Honoré Labande's classic *Les primitifes francais. Paintres et verriers de la Provence Occidentale* (Marseille, 1932) is dedicated principally to the study of retables and their painters; Labande lists twenty-eight that still exist in the region

that is, "behind the (altar's) table"—and in most cases consists of a frame of decorated panels placed at the back of the altar. They are generally profusely illustrated. The Tarazona piece, which is as tall as a man, was ordered by the bishop of the diocese, Cardinal Fernando Perez Cavillo, shortly before March 1403 (see fig. 30). A great number of archival documents in our possession show the care taken by the cardinal and by his cousin, the bishop of the diocese of Vic, as to the size of the paintings, their content, and the materials to be used by the artists. The documents also reveal the names of the artists, Guillem and Johan de Levi, certainly relatives and perhaps even brothers, who painted the greater part of the retable.[30] Johan almost certainly painted the third part.[31] Even though they had the name Levi the brothers were not Jewish; not one of the many documents relating to their activity ever describes them as "Judei." Guillem, on one occasion took an oath "on the Cross, the four Saint Gospels of our Lord Jesus Christ . . . touched by me corporally" and not on the five books of Moses, as a Jew would.[32] At most, the name Levi may allude to their immediate Jewish origin or to that of their family. Such a pious undertaking as building and painting a retable, argues the Spanish scholar José María Sanz Artibucilla, could only have been assumed by Christians. Jews would not have been able to follow the patrons' instructions with regard to the episodes in Christian sacred history that were to be painted.[33]

However, other indications allow us to disagree with this last statement. A story, perhaps a legend, from England of the reign of Henry III (1207–72) and his heir Edward I (1237–1307) mentions a Jewish painter in London entrusted with a task similar to that of the Levi artists in Tarragona. Prince Edward, so the story goes, who was worried about the possible results of a military campaign against the Welsh, had "the Glorious Mother of God" appear to him in a dream. She ordered him to introduce into a chapel of the Church of All Hallows, near the Tower of

(see 141–214), and nine that are considered to hail from Provence. Information about dozens of similar contracts with painters signed in Tarascon-en-Provence can be found in Claude Roux, "Les peintres et leurs œuvres à Tarascon à la fin du Moyen Âge au travers des vies de Barthélémy Ricard et Jean Audin," *Provence Historique* 58 (2008): 181–213. The contracts are reproduced in the appendix, 210–13.

[30] See José María Sanz Artibucilla, "Guillen y Juan de Levi, pintores de Retablos," *Sefarad* 4 (1944): 73–98; and María Teresa Ainaga Andres, "Datos documentales sobre los pintores Guillen de Levi y Juan de Levi, 1378–1410," *Turaiso* 14 (1998): 71–105.

[31] Sanz Artibucilla, "Guillen y Juan de Levi," 87–91.

[32] Ibid., 84.

[33] Ibid., 79: "Los pintores de retablos para iglesias necesariamente habían ser cristianos para conocer, sentir e interpretar los asuntos religiosos que tenían ejecutar." Indeed, there is no Jew in the list of retable painters presented in Berg Sobré, *Behind the Altar Table*, 338–40.

FIGURE 30. A drawing of a reconstructed altar table (retable) of the cathedral of Taraz-
ona Spain. It was painted around the year 1400 by the brothers de Levi. Today in situ.
 Drawing by Architect Natali Lashko (in private collection).

London, a two-faced image, showing both her face and that of the savior.
The artist who was entrusted with the task, we are told, was the Jew
Marlibrun—that is, Me'ir le Brun—"the most skillful painter in the
whole world."[34] While it is difficult to separate truth from fiction in this
story, two facts can certainly be noted. First, Sir Thomas More (1478–
1535) reports that in his time women in London still venerated this
image in the chapel, which was then known as "the smiling image." Sec-
ond, the names Me'ir, Le Brun, and Juda (the wife of Me'ir, pronounced
probably "Juta") were quite common among northern European Jews of
the High Middle Ages.
 What was veiled by legend in the English hagiographical tale from the
second half of the thirteenth century became unquestionable reality in
Iberia some hundred years later. There Jews did in fact paint scenes from
Christian sacred history in churches. Sanz Artibucilla himself knew the

[34] See Alfred Rubens, "Early Anglo Jewish Artists," *Transactions of the Jewish Historical
Society of England* 14 (1935–39; 1940): 91–129, esp. 93–95.

name of the painter Abraham de Salinas of Saragossa (Zaragoza) but he must not have been aware that this Jew's activity as a *pintor* also included working on altarpieces (*retablos*). It was only recently that Asunción Blasco-Martínez brought to light two documents noticed previously by the French scholar Béatrice Leroy, one dated April 25, 1393 and the other May 27 of the same year, both relating to Abraham's involvement in decorating churches. The first of the two concerned the painting of an altarpiece in the cathedral (La Seo) of Saragossa, while the second, agreed upon just a month later, recorded an identical arrangement with the township of Puebla de Albetron, south of Saragossa. This second contract includes a short set of instructions for the Jewish painter issued by Bernart d'Alfajerin, cleric of the cathedral, which are of great interest. The retablo was to be ten palms wide and ten palms tall and "The story of the annunciation of Saint Mary should be depicted in six episodes. This work should have, in sum, everything that the story of the annunciation does require." As for technicalities, Abraham is instructed thus: "You will have to paint with good and fine gold and with colors of a quality similar to the ones you have used in the two retables you painted in the church of Saint Philip, namely the one of Saint Mathew and the one of Saint John the Evangelist" The cleric thus knew about previous undertakings that were accomplished by the Jewish painter.[35]

A briefer description of what had to be shown on the other retable is found in the first contract. Here Abraham was expected to tell "the story of Saint Mary." No further specifications are mentioned. Anton Marcen, the sacristan of the cathedral, did not go into detail except to state that its dimensions should be the same as the retable of Peter and Paul, which already existed in the cathedral. Still, this second assignment must have been a slightly more ambitious undertaking than the first since the painter was paid four hundred shillings for it, while the provincial township of Puebla de Albetron did not offer him more than three hundred for his work there. The fact that Abraham was only given brief instructions in

[35] Asunción Blasco Martínez, "Pintores y Orfebres judíos en Zaragoza (siglo XIV)," *Aragon en la Edad Media* 8 (1989): 113–31, esp. 129–31, doc. nos. 4 and 5. The second contract was translated into French by Béatrice Leroy in *Les Juifs dans l'Espagne Chrétienne avant 1492* (Paris, 1993), 58–59, as well as in her *Les Juifs du Bassin de l'Èbre au Moyen Âge* (Biarritz, France, 1987), 81. The original language of the text translated above reads, "el qual vos obredes de la storia de la Anunciacion de Sancta Maria, et aya en aquell syes stories, conteniente en fin aquella obra que a la storia de la Anunciacion se requiere" (Blasco Martínez, 130). These altarpieces were certainly not the only ones Abraham created. Vivian B. Mann, who discovered two other retables painted by Abraham de Salinas (in the parochial church of La Puebla de Alborton) is right in suggesting that further research will, in all probability, reveal even more information about this artist's activity. See Vivian B. Mann, "Jews and Altarpieces in Spain," in Vivian B. Mann (ed.), *Uneasy Communion: Jews, Christians and the Altarpieces of Medieval Spain*" (New York, 2010), 76–129, esp. 86–92.

both contracts is due to his previous expertise in such work; his familiarity with Christian hagiography was taken for granted. It appears that no one in the Jewish community was surprised when the two agreements were signed. Indeed, Abraham's Jewish friends, who may also have been his associates, were present and helped to conclude the agreements. One of them, Junes Avenfora, stood surety with the church of Puebla while another, Abraham Passagon, served as one of the witnesses. Bonafos Aventue and Yzdrach (Isaac) Avenbrucco, two other Jews, were part of the agreement with the Cathedral of Saragossa.

Equanimity seems to have prevailed in two similar situations where Jewish silversmiths—Salomom Barbut and Judah Almoli—undertook to produce objects that Christians cherished and revered for their sanctity. In 1399, Salomon Barbut undertook the production of a reliquary for the Augustinians of Barcelona. The monks showed him a model that he was to emulate. The planned reliquary was to weigh at least ten *marchas* of Barcelona, and the silver was to be adorned with gold. Salomon invested his own money in the enterprise but received an advance payment of ten pounds, about 10 percent of the estimated cost of this magnificent piece.[36] Salomon, who was by then obviously a well-to-do and highly appreciated artisan, does not appear to have played any particular role in the political or social life of his community, preferring to display his talents in his workshop. In contrast, the profile of Judah Almoli was quite different. A silversmith like his father, he was a member of a rather well established family in Saragossa who played a leading role in the life of the local Jewish community. He too was no stranger to the public arena. Still, on February 14, 1385, he agreed to build a standing cross for the church of Alcañas. Pedro Castillan, vicar general of the city, was ready to invest the considerable sum of 540 shillings in this spectacular project.[37]

[36] The text was published by Miguel González Sugrañés in *Contribució a la historia dels antichs gremis dels arts y oficis de la ciutat de Barcelona*, vol. 1 (Barcelona, 1915–18), 188n2. This is the last we hear from Salomon Barbut. The first document of the of May, 1, 1349 is mentioned by José Puiggari in his "Noticia de algunos artistas catalanes ineditos de la edad media y del renacimiento (parte secunda)," *Memorias de la Academia de buenas letras de Barcelona* 3 (1880): 272–73. An undertaking similar to the one by Barbut in 1399 has been noted in Cesare Colafemmina, *Per la storia degli ebrei in Calabria*, (Messina, 1996) 27–28: A Jewish master by the name of Monus, inhabitant of Sinopoli, agreed about the year 1451 to build a reliquary for the monastery of San Filareto. Several other Jews stood as surety in the affair. A litigation followed, as it was claimed the Jew used part of the two pounds of silver given to him in another undertaking. For the document itself, see Ernesto Pontieri (ed.), *Fonti Aragonesi*, vol. 2 (Napoli, 1961), 70–71.

[37] See Blasco Martínez, "Pintores y orfebres judíos," 121–24, esp. 129.

The artists and artisans whose activities have been recorded in these
pages, would not necessarily have been considered to be transgressors by
all the interpreters of rabbinical jurisprudence during this period. The
Jewish religious law, the Halakha—as in any other legal system—decrees
what is permitted and clarifies what is prohibited.[38] One should consume,
for example, only the meat of certain animals, slaughtered according to
the rules elaborated by the rabbis (*kasher*), and should abstain from that
which is not allowed (*assur* or *taref*). However, the Halakha would toler-
ate situations where benefit (*Hana'ah* in rabbinic semantics) could be de-
rived from otherwise nonpermitted products. To be sure, a law-abiding
Jew cannot consume nonkosher meat himself, but he is permitted to de-
rive benefit from it. This reasoning explains the fact that Jewish butchers
in Navarra during the 1360s and '70s regularly supplied nonkosher
products to their neighbors while offering at the same time their coreli-
gionists kosher meat. These butchers recorded (for the purpose of taxa-
tion) their activities in their daybooks.[39] We understand, for example,
that out of the sixty-five entries recorded from February 2, 1363, to the
end of that year, fourteen taref operations took place (amounting to 21
percent of that period's gain). In one week in September the butcher Yom
Tov Asayag slaughtered three goats and an ox for Jewish consumption
and one taref bull. On October 7, his records show two kasher goats and
two others that were ritually improper. The same week his colleague Isaac
ben Nataf recorded no less than seven taref operations. Obviously these
"improper" slaughterings did not occur because of mistakes, nor did they
result from the discovery of blemishes in the animals. Rather, they formed
part of the butchers' regular involvement with the neighboring society.
Asayag and Nataf saw nothing wrong with deriving benefit from their
work for Christian clients. It is not impossible that this concept of
Hana'ah also guided bookbinders, silversmiths, and the painters of reta-
blos and enabled them to pursue their business with the ecclesiastical in-
stitutions with little compunction.

Unbelievable as it may seem, some medieval Talmudists may have tol-
erated the building of crosses and the shaping of reliquaries even if they

[38] On the Halakha (Jewish law) in general, see Efraim E. Urbach, *The Halakhah, Its
Sources and Development* (Tel Aviv, 1986; in Hebrew).

[39] These documents were published three times: first in Yom Tov Assis and Ramon Mag-
dalena, *The Jews of Navarre in the Middle Ages*, 2 vols. (Jerusalem, 1990); second, in Yom
Tov Assis, Ramon Magdalena, and Coloma Lleal Galceran, *Navarra Hebraica*, 2 vols. (Bar-
celona, 2003); and third, in José Luis Lacave, *Los judíos del reino de Navarra: Documentos
hebreos 1297–1486*, Navarra Judaica 7 (Pamplona, 1998). The citations herein are from
this last publication, 184–270 (doc. nos. 33–34, esp. entries 90–91, 93 in doc. no. 34).

considered them to be blatant objects of idolatry. The German Hasidim at
the beginning of the thirteenth century would surely have been upset and
angry about such assignments, but in Spain the rabbis may well have re-
lied on an old law of the second century, a Mishnah of the tract Avodah
Zarah (1.8) stating that the faithful are allowed to produce decorations
for the idolatry, as long as they do it for remuneration and not because
they believe in it. This doctrine is pronounced on the authority of the
"Tana," Eliezer ben Hyrcanos "The Great" of the second century, one of
the founders of the rabbinical tradition: "None may make ornaments for
an idol, necklaces or earrings or finger rings, while Rabbi Eliezer says: If
for payment it is permitted." Not all manuscripts contain this surprising
teaching, as the twelfth-century students in northern France immediately
noticed. Some manuscripts simply omit it all together. These sharp Tal-
mudists (known as the Tosaphists) must have doubted its authenticity on
the grounds that the later sages, the Amora'im, who followed the great
Eliezer, did not refer to it at all, in contradiction to their usual habit of
discussing, commenting on, and analyzing statements of much lesser con-
sequence. Did these Amora'im of the forth and fifth centuries already
doubt the authenticity of this provocative teaching? Hesitation among
scholars prevails even today. Although the late Ephraim E. Urbach, one of
the leading Talmudic scholars at the Hebrew University, did not see any
reason to discard it, his follower, David Rosenthal, has omitted the prob-
lematic text from his recent "definitive" two-volume edition of this tract,
Mishnah Abodah Zara—A Critical Edition with Introduction (Jerusa-
lem, 1980). This notwithstanding, what counts in our present discussion
is the fact that some of the manuscripts of the Mishnaic tract Avodah
Zarah that were copied in medieval Spain did include this problematic
statement. It is not unreasonable therefore to imagine that in Iberia some
rabbis considered Eliezer ben Hyrcanos's teaching authentic and thus
strengthening the notion of Hana'ah. The fact that the silversmiths and
painters who worked in the churches and cathedrals demonstrated so
much confidence and self-assurance may somehow have been related to
the teaching of this problematic Mishnah. This allowed Jews to move
freely in the marketplace. If any of these artists and artisans or their spiri-
tual leaders happened to have knowledge of the book of religious polem-
ics written in the twelfth century by Jacob ben Reu'ven, *The Wars of the
Lord*, they could also have relied on this and argued, "Our creator, may
He be praised, never forbade the production of statues and pictures; He
only forbade them with respect to worship and service."[40]

[40] Yehuda Rosenthal (ed.), *Sefer Milhemot ha Shem* (Jerusalem, 1963; in Hebrew); the
quote given herein is from the English translation by Kalman P. Bland, *The Artless Jew*
(Princeton, NJ, 2000), 139.

CONCLUSIONS

When planning to study the role of the marketplace in the exchange of cultural values in the Middle Ages and the effects of external contribution on what we consider to be Jewish art, I did not envisage any revisionist perspectives. Scholars recognized the Gothic input into medieval Hebrew manuscripts and other liturgical objects long ago and it has become common currency among all observers. I did not doubt this when I began the project, and I have found no reason to change my mind as I reached the concluding stages. Instead, most of my efforts have gone in to attempting to discover the avenues through which external influences entered into the Jewish domain. Archival documents dealing with financial operations in the marketplace promised to yield information about pledges and pawns of all sorts, including sacred vessels and other objects of Christian devotion as well as objects of princely paraphernalia that were entrusted to the hands of Jews. Thus, in my working hypothesis I joined previous scholars who maintained that the business environment facilitated the Jewish appreciation of Christian art and artifacts. As described in part 3 of this book there were more direct means for the transmission of values, including those of economic character, where craftsmen were remunerated for providing their skills to the "other." However, the movement of pledges back and forth also exercised a great amount of influence, indirect as it may have been. Fortunately this movement lent itself with relative ease to my observation.

Students of the Jewish experience in the Middle Ages do not have enough episodic data to work with, since for the Hebrew intellectuals of the time the study of contemporary events and the reporting of them was not a high priority. As a consequence, present-day historians in their quest for information written by Jews must rely on rabbinic jurisprudence and other writings of the spiritual leaders of the Jewish communities. The rabbis, acting as judges and official interpreters of Jewish jurisprudence, had to confront the conflicts of daily life experienced by their followers and to offer solutions and instructions. Luckily they sometimes

recorded the essentials of the problems they were asked to solve (including complications that arose in the universe of pawnbroking), providing names, dates, localities, and other facts that are cherished today by historians. Ḥaym Soloveitchick taught us all in his Hebrew book *The Use of Responsum as Historical Source: A Methodological Introduction* (Jerusalem, 1990). Even though the rabbis' aim was not to satisfy the curiosity of future generations but to establish legal precedents, the precious information included in their writings, if treated skillfully, may be of great value to students of the past. More than that, at times the rabbis were ready not only to modify doctrines and customs established by their predecessors but also to explain the circumstances that led them to take a new course. In this study we have seen them struggling with the question of whether Jews could accept as collateral objects held to be sacred by Christians. The rabbis, amazingly, were far from being unhappy that Christians were engaged in the decoration of Jewish liturgical objects. Still, it is not always easy to get a clear idea of how much pressure they had to endure from members of the business community before making their unprecedented decisions.

Documents written in Latin or in the vernacular, not by Jews but about them and for them, offer immense support to students of this medieval minority. The data included in these "non-Jewish" documents, whether in administrative records or in reports emanating from the work of judicial institutions, considerably make up for what is missing in the Hebrew sources. To the present study, documents dealing with the transfer of precious objects turned out to be of fundamental importance. Needless to say, the numerous objects of visual art that have survived the centuries are of equal importance in providing immediate contact with the realities that this Jewish and Christian documentation treated.

Medieval Jews, at least the majority of them, lived in quarters and streets that were considered to be "theirs." In large urban centers they represented 5 percent and even 10 percent of the inhabitants. In many other smaller centers numbers and proportions were lower. Recent scholarship has discovered the sites of many of these medieval "Jewries" in the urban landscapes. In certain instances specialists have even been able to follow the layout of the "Jewish street" house by house. Living in segregated neighborhoods did not isolate them from developments that occurred outside their quarters. In the market they occupied a prominent place, much larger than the modest size their settlements would suggest. And as they were required to deal with all classes of society they extended dozens, if not hundreds, of loans on a daily basis. Some of their premises could hardly contain the immense numbers of pawns they were offered. This book therefore necessarily follows in much more detail the one-way movement of the exchange that took place, since Jews were almost al-

ways on the receiving end. And yet the last chapter of the book deals exclusively with Jews' contribution to the culture of the societies that hosted them.

This investigation has rendered some exciting results. To find the crowns of the Duchy of Savoy, and no less than that of Edward III of England, in the hands of Jews is an unexpected discovery. It was also exhilarating to discover, in an apartment in Switzerland, frescoes of secular content surrounded by more than two dozen coats of arms of German aristocratic families. In Zurich these frescoes embellished the walls of the dwelling of one of the most learned rabbis of Europe. One would hardly expect medieval Jews to serve the rival religion by painting altar tables (retables) in cathedrals or by building at their request reliquaries or (much less so) a standing silver crucifix, but such things happened in Spain and to a certain degree even in Germany. It was no surprise that Christian artisans did not shy away from decorating Jewish objects for devotional purposes. When exceptional situations like the movement of the artisans' services back and forth are observed, instances of peaceful exchange and probably even friendly coexistence, even if ephemeral, do emerge.

Such "moments of grace" did not occur only among members of the artistic community. While a mass of documentation records the hostility and violence that marked Christian-Jewish relationships during these centuries, instances of tolerance surface in the documents as well, if only occasionally. Two documents, one from Valencia and the other from Sicily, show such compassionate moments. In Valencia on March 4, 1339, King Pedro III of Aragon ordered the jurist Guillem Maxwell to inquire whether there was any truth to the allegation that the Jew Samuel Benvenist of Barcelona had allowed the nobleman Jorda d'Illa to celebrate the Mass in his house. True or false, such open-mindedness was not considered impossible for people in the capital of Catalonia. In Sicily in October 1484, the Jews of the small community of Castrogiovanni were fined thirty ounces of gold, the price of a pardon for a series of unspecified transgressions they had allegedly committed. Yet one instance of a positive exchange has been recorded: during the celebration of the circumcision of the son of a certain Sori Ziccari, Christians were not only present in the ceremonial but one of them was honored to become the godfather (*compaternitas* in the Latin text possibly compares to the Jewish term *sandak*) of the newborn infant. Again, whether it really happened or not is immaterial in my opinion. What counts is that in Valencia it was considered possible that such a friendly relationship could exist.[1]

[1] The Sicilian case is reported in Shlomo Simonsohn, *The Jews in Sicily*, vol. 7, *1478–1489* (Leiden, Netherlands, 2005), doc. nos. 4763–64. The Valencian document was published in Gemma Escriba, *The Jews in the Crown of Aragon: Regesta of the Cartas Reales*

In the future these rich archives, as well as others, are sure to reveal more information about cordial Jewish relationships between Jews and Christians in past centuries. Today many of my fellow Jewish or Christian colleagues would readily demonstrate such respect and tolerance to the religiosity of the other. But we congratulate ourselves for living in enlightened societies and not any more in the Middle Ages, do we not?

in the Archivio de la Corona de Aragon, Part II: 1328–1493, Sources for the History of the Jews in Spain 5 (Jerusalem, 1995), 884, doc. no. 883.

Appendix

JEWISH TRADITIONS AND CEREMONIES: HOW ORIGINAL?

In recent years, students of Jewish history have engaged in a pronounced effort to widen the profession's horizons and include domains of creativity from the past that had not occupied a prominent place in their scholarly agenda.[1] Aware of this new trend, New York University held a small but highly important conference in November 1988 titled What Can Jewish History Learn from Jewish Art?[2] In the first part of his keynote presentation, Joseph Guttmann of the Hebrew Union College, offered some elements that related directly to the problem, insisting in particular on the close relationship between Jewish artistic creativity and that of the surrounding society. He pointed out, for example, that in the thirteenth century the Pesah Haggadah, a book of household liturgy that accompanies the feast of Passover, became an illuminated work of art at the same time as similarly ornate liturgical books appeared in many non-Jewish homes. Also indicative is the fact that the "giant" German mahzorim (prayer books for the high holy days) are patterned, both in shape and format, on the enormous contemporary Christian breviaries. There even exists a document in which a mahzor is labeled "a Jewish breviary" (*Breviarium judaicum*). We can add that Colette Sirat of Paris (who did not participate in the conference) also drew attention to the close similarities between the formats of Hebrew books and those in Latin by comparing a minuscule Latin Bible produced in thirteenth-century France and a small He-

[1] See, for example, the studies published in David Biale (ed.), *Cultures of the Jews: A New History* (New York, 2002).

[2] Joseph Gutmann, Pamela Sheingorn, Herbert R. Broderick, and David Berger, "What Can Jewish History Learn from Jewish Art?" This manuscript from 1989 has not been published; David Berger kindly sent me a copy.

162

brew Bible written on exceptionally thin parchment dating from around the same time. Both are kept in the Bibliothèque Nationale in Paris.[3] Sirat and Gutmann also commented on the resemblance between the "Gothic" shape of Hebrew letters and the Latin script of the time. The similarity is so striking that from a distance it would be difficult to distinguish between the two scripts. Gutmann noted, "Were I not to know that the page of a manuscript is in Hebrew I would have considered it a Christian one," and Sirat posited, as quoted earlier, that "The traditional Hebrew text took the mantle after the Latin book."[4]

It could be argued that in the second part of his address, and perhaps even in the first, Gutmann's heart was not really with books or Jewish objects of art. Instead he centered his presentation around the problem of Jews borrowing, from the environment elements pertaining to the realms of liturgy and religious ceremonials. He claimed for example that the Jewish practice of memorializing martyrs had its roots in the Christian ritual of All Souls Day while the Kaddish, the prayer for the dead, must have been related to the Requiem Mass of the Christian church. He drew special attention to a crucial element in Jewish wedding ceremonials: the employment of the *huppah*, the portable canopy under which the couple stands, is a custom that does not have medieval origins at all but is an early modern Jewish invention "probably adopted (by the Jews) from Catholicism, where it had already served in nuptial ceremonies in the early ages." According to Gutmann, the smashing of a glass, a high point in all Jewish weddings, goes back to pre-Christian times; Germanic superstitions led people to believe that the explosive effect would smash the power of demons.

Gutmann's address to the New York conference was not the first occasion on which he had ventured beyond the usual borders of his discipline. Similar references to the origins of non-Jewish practices and ceremonials can be found in his study titled "Christian Influences on Jewish Customs," published some five years previous to the conference.[5] He was not

[3] Colette Sirat, "Le livre hébreu: rencontre de la tradition juive et de l'esthétique française," in Gilbert Dahan, Gerard Nahan, and Elie Nicholas (eds.), *Rashi et la culture juive en France du Nord au Moyen Âge* (Paris, 1997), 243–57.

[4] Colette Sirat, "En vision globale: les Juifs médiévaux et les livres latins," in Pierre Lardet (ed.), *La tradition vive: Mélanges d'histoire des textes en l'honneur de Louis Holtz*, Bibliologia 20 (Turnhout, Belgium, 2003), 15–23; Joseph Gutmann, *Hebrew Manuscript Painting* (New York, 1978), 77–78.

[5] Joseph Gutmann, "Christian Influences on Jewish Customs," in Leon Klenicki and Gabe Huck (eds.), *Spirituality and Prayer: Jewish and Christian Understandings* (New York, 1983), 128–38. See also Joseph Guttman, "Jewish Medieval Marriage Customs in Art: Creativity and Adaption," in David C. Kraemer (ed.), *The Jewish Family: Metaphor and Memory* (New York, 1989), 47–62.

the first to pursue this line of study: credit is due to the pioneering writings of a Viennese rabbi of the nineteenth century, Moritz Güdemann. In volume 1 of Güdemann's *Geschichte des Erziehungswesens und der Kultur der abendländischen Juden* (History of Education and Culture of the Western Jews), published in 1880, he assembled a considerable number of beliefs and superstitions shared by Jews and Christians alike during the Middle Ages, mostly in the Germanic lands. Demonology, magic, and folk medicine are just three of the many elements he singled out. In making his observations, Rabbi Güdemann depended on data he had found in the writings of the Brothers Grimm, the famous folklorists and philologists.

Particular consideration should be given here to the work of Ytzhak (Fritz) Baer, founder of the School of History at the Hebrew University of Jerusalem. At the beginning of his career and for many years, he made it a cornerstone of his studies to demonstrate the intimate relationship between Jews and the larger society. Just browsing through the first volume of his two-volume *Studies in the History of the Jewish People* (Jerusalem, 1985), one cannot help but be struck by this historian's versatility, as the following examples (all in volume 2 of his studies) show. Baer stressed that one would have to be blind not to see the impact of the twelfth-century non-Jewish "commune" on the structures of Jewish self-government (*Kahal*) and their almost identical organizational arrangements (pp. 31, 87–100). Similarly, in the twelfth century the German Jewish Pietists (Hasidim) were not only the exact contemporaries of the early Franciscans but were actually influenced by their preaching as well as by their doctrines (pp. 211, 223–24). And when Eliezer of Worms, the major pietist of his time, wrote fine and delicate paragraphs about the social equality prevailing in the primeval agricultural world, his inspiration can be traced to early Christian adaptations of stoic ideals (pp. 225–32). As well, elements of social criticism that were expressed by Spanish Jews in the last decades of the thirteenth century and form part of the major kabbalist treatise *The Book of Splendor* (the *Zohar*) can be discovered in the doctrines of an illustrious contemporary, the Franciscan Joachim of Fiore (pp. 306–49). Baer even pointed to a particular Joachimite treatise that might have inspired a Jewish critic when he described certain unsavory phenomena that existed in his own community (pp. 309–10). Hebrew historiography of the Middle Ages has provided Baer with more examples. The anonymous author of the Yossipon, the Jewish chronicle written in the tenth century, was familiar with political ideas that were circulating in the court of Emperor Otto III at the end of that century (pp. 101–27). Five hundred years later the historian Salomon ibn

Verga, in his *Shevet Yehudah* ("The Rod [or the Tribe] of Judah") simply translated into Hebrew a long paragraph from the then popular novelist Antonio de Guevara (d. 1545; seepp. 417–44). It is also remarkable that the Hebrew Chronicles of the First Crusade, written some fifty years after the events, employ terminology, and indeed whole paragraphs, that are found in the writings of contemporary Christian chroniclers (pp. 147–61).[6]

Although Baer was admired by everybody for his scholarship, his discoveries and his search for external influences on Jewish life were not applauded by influential scholars of the Jerusalem University like Gershom Scholem and Ephraim E. Urbach. They maintained that "Judaism was and remained a self-contained entity and its transmutations throughout history were first and foremost to be attributed to internal developments" and "Christianity as a formative and influential force" was to be ignored "when assessing developments within Judaism."[7] Nevertheless, Baer's teachings did not remain a voice crying in the wilderness. One of his disciples, the jurist Ze'ev W. Falk, followed the same path in his book *Jewish Matrimonial Law in the Middle Ages* (London, 1966). Falk gave a very detailed account not only of similarities in the nuptial ceremonials and their jurisprudence (principally the history of the marriage contract) but also compared the procedures that took place when the dissolution of a union was called for.[8]

Contemporary scholars take it for granted that they must look at the larger society in discussing certain topics in Jewish history. Evidence of this is the excellent collection of articles assembled by David Biale and published under the title *Cultures of the Jews: A New History* (New York, 2002). Of particular interest in Biale's volume is the long and well-documented contribution of Ivan G, Marcus, "Jewish Christian Symbiosis: The Culture of early Ashkenaz" (pp. 449–516), were he looked not only at external input and borrowing but tried to figure out how Jews absorbed these contributions; colored them, so to speak, with

[6] See also Ytzhak Baer, *Die Juden im christlichen Spanien*, vol. 1, *Aragonien und Navarra* (Berlin, 1929), 1044–80, dealing with parallels in Latin documents and their influence on the wording and content of Hebrew deeds.

[7] The quotations are from the extensive study of Oded Irshai, "Ephraim E. Urbach and the Study of Judeo-Christian Dialogue in the Late Antiquity—Some Preliminary Observations," in Matthew A. Kraus (ed.), *How Should Rabbinical Literature Be Read in the Modern World?* (Piscataway, NJ, 2006), 167–97, esp. 174–75. For Gerschom Scholem's attitude, see Peter Schäfer, *Mirror of His Beauty: Feminine Images of God from the Bible to the Early Kabbalah* (Princeton, NJ, 2002), 268–69. Highly important is the study of Amnon Raz-Krakotzkin, "Without Regard for External Consideration—The Question of Christianity in Scholem and Baer's Writings," *Jewish Studies* 38 (1998): 73–96 (in Hebrew).

[8] See also Ze'ev Falk, "Jewish Law and Medieval Canon Law," in Bernard S. Jackson (ed.), *Jewish Law in Legal History and Modern World* (Leiden, Netherlands, 1980).

their particular paints; integrated them, and made them part of their own heritage.

Israel Jacob Yuval, a Jerusalem medievalist, has also discussed religious ceremonials and modes of divine worship in a Christian-Jewish framework. Most of his reflections can be found in his book *Two Nations in Your Womb: Perception of Jews and Christians* (Tel Aviv, 2001; English translation Berkeley, 2006). Yuval maintains that several Passover ceremonials must be understood in the context of a dialogue between Jews and Christians, which was already taking place in late antiquity and continued in the High Middle Ages. Thus the Major Shabbat (Hebrew: *Shabbat ha-Gadol*) that opens the week of the Passover is a twelfth-century innovation that emulates the Sabbatum Sanctum, a Christian custom dating back to the Council of Nicaea in 325 CE (Yuval, pp. 209–29). Another Passover ritual, eating a piece of unleavened bread (matzoh) at the end of the meal, also shows the influence of the Christian practice: known as the Afikoman (from the Greek *aphi komenos*, "that which is to come"), this ritual has its origins in late antiquity being the equivalent of the Christian Communion wafer (pp. 239–48). Finally, the daily prayer Alenu le-Shabe'ah (It is our duty to praise the Master of the world) does not escape Yuval's scrutiny either. Its parallel—not its origins, this time—lies in the Te Deum of the Christian church (pp. 115–119, 198–204). Yuval's writings contain more such statements.[9]

Be that as it may, these discoveries come as no surprise to students of societies past or present. Indeed, the movement of values from one civilization to another is a very common phenomenon. It would be practically impossible to identify a society that is hermetically sealed and lives in its own self-sufficient universe. Giambathista Vico (d. 1774) probably would have added a statement of this fact to the list of axioms in his *New Science* and given it the number 115. What renders the Jews' experience of particular interest is their long history, coupled with the great variety of host societies in which they have found themselves over the course of time.

[9] See also Israel Jacob Yuval, "The Language and Symbols of Hebrew Chronicles of the Crusades," in Yom Tov Assis, Michael Toch, and Geremi Kohen (eds.), *Facing the Cross: The Persecution of 1096 in History and Historiography* (Jerusalem, 2000), 112–15 (in Hebrew). An eye-opener is Israel Ta-Shama, "The Origin and Place of *Aleinu le-Shabbeah* in the Daily Prayer Book: *Seder ha-Maamadot* and Its Relation to the Conclusion of the Daily Service," in *The Frank Talmage Memorial Volume*, vol. 1, Hebrew section (Haifa, Israel, 1993), 85–98.

Select Bibliography

Abrahams, Harold J. "A Thirteenth-century Portuguese work on Manuscript Illumination." *Ambix: The Journal of the Society for the History of Alchemy and Chemistry* 26 (1979): 93–99.

Ainaga Andres, María Teresa. "Datos documentales sobre los pintores Guillen de Levi y Juan de Levi, 1378–1410." *Turaiso* 14 (1998): 71–105.

Ainaga Andres, María Teresa (ed.). *El Retablo de Juan de Leví y su restauración: Capilla de los Pérez Calvillo. Catedral de Tarazona.* Saragossa, Spain, 1990.

Alexander, Jonathan J. G. *Medieval Illuminations and Their Methods.* New Haven, CT, 1992.

Ameisenowa, Zofia. "Animal-headed Gods, Evangelists, Saints and Righteous Men." *Journal of the Warburg and Courtauld Institutes* 12 (1949): 21–45.

Antonioli Martelli, Valeria, and Luisa Mortara Ottolenghi. *Manoscritti Biblici ebraici decorate provenienti da biblioteche italiane pubbliche e private.* Milan, 1960.

Avrin, Leila. *Hebrew Micrography.* Jerusalem, 1981.

Avrin, Leila. "A Note on Micrography: A Jewish Art Form." *Journal of Jewish Art* 6 (1979): 112–14.

Beit Arié, Malachi. "Joel ben Simon's Manuscripts: A Codicologer's View." In *The Making of the Medieval Hebrew Book: Studies in Paleography and Codicology.* Jerusalem, 1993, 93–108.

Berger, David (ed.). *What Can Jewish History Learn from Jewish Art?* Occasional Papers in Jewish History and Thought 3. New York, 1989.

Bland, Kalman P. *The Artless Jew: Medieval and Modern Affirmations and Denials of the Visual.* Princeton, NJ, 2000.

Bland, Kalman P. "Defining, Enjoying and Regulating the Visual." In Lawrence Fine (ed.), *Judaism in Practice: From the Middle Ages through the Early Modern Period.* Princeton, NJ, 2001, 281–97.

Blasco Martínez, Asunción. "Pintores y Orfebres judíos en Zaragoza (siglo XIV)." *Aragon en la Edad Media* 8 (1989): 113–31.

Blondheim, D. S. "An Old Portuguese Work on Manuscript Illumination." *Jewish Quarterly Review*, n.s., 19 (1928): 97–125.

Blumenkranz, Bernhard. "Les manuscrits enluminés (en France)." In Bernhard
Blumenkranz (ed.), *Art et archéologie des Juifs en France*. Paris, 1980,
159–86.

Blumenkranz, Bernhard. "La représentation de Synagoga dans les bibles morali-
sées françaises du XIII^e au XV^e siècle." *Proceedings of the Israel Academy of
Sciences and Humanities* 5, no. 2 (1970): 70–91.

Böhmer, Roland. "Bogenschütze, Bauerntanz und Falkenjagd: Zur Ikonographie
der Wandmalereien im Haus 'Zum Brunnenhof in Zürich." In Eckart Conrad
Lutz, Johanna Thali, and René Wetzel (eds.), *Literatur und Wandmalerei I.
Erscheinungsformen höfischer Kultur und ihre Träger im Mittelalter,
Freiburger Colloquium 1998*. Tübingen, Germany, 2002, 329–64.

Bradley, John W. *A Dictionary of Miniaturists, Illuminators, Calligraphers and
Copyists* (3 vols., 1887–89). Vol. 2. Reprint, New York, 1958.

Bresc-Bautier, Geneviève. *Artistes, patriciens et confréries: Production et con-
sommation de l'œuvre d'art à Palerme et en Sicile occidentale (1348–1460)*.
Rome, 1979.

Castaño, Javier, Renate Engels, and Alfred Haverkamp (eds.). *Europas Juden im
Mittelalter*. Stuttgart, 2004.

Cluse, Christoph (ed.). The Jews of Europe in the Middle Ages (Tenth to
Fifteenth Centuries). Turnhout, Belgium, 2004.

Cohen, Evelyn M. "The Artists of the Kaufmann Mishneh Torah." In
Proceedings of the Ninth World Congress of Jewish Studies, Division D, vol.
2. Jerusalem, 1986, 25–30.

Cohen, Evelyn M. "The Decoration of Medieval Hebrew Manuscripts." In
Leonard Singer Gold (ed.), *A Sign and a Witness: 2000 Years of Hebrew
Books and Illuminated Manuscripts*. New York, 1988, 46–64.

Cohen, Evelyn M. "The Kaufmann Mishneh Torah Illuminations." In Eva Apor
(ed.), *David Kaufmann Memorial Volume*. Budapest, 2002, 97–104.

Cohen, Evelyn M. "A Woman's Hebrew Prayer Book and the Art of Mariano del
Buono." In Katrin Kogman-Appel and Mati Meyer (eds.), *Between Judaism
and Christianity: Art Historical Essays in Honor of Elisheva (Elisabeth)
Revel-Neher*. Leiden, Netherlands, 2009, 371–78.

Friedenberg, Daniel M. *Medieval Jewish Seals from Europe*. Detroit, 1987.

Friedman, Mira. "The Falcon and the Hunt: Symbolic Love Imagery in
Medieval and Renaissance Art." In Moshe Lazar and Norris J. Lacy (eds.),
Poetics of Love in the Middle Ages: Texts and Contexts. Fairfax, VA, 1989,
157–75.

Frojmovic, Eva. "Early Ashkenazic Prayer Books and Their Christian
Illustrations." In Piet van Boxel and Sabine Arndt (eds.), *Crossing Borders:
Hebrew Manuscripts as Meeting-place of Cultures*. Oxford, 2009, 45–56.

Frojmovic, Eva. "Jewish Scribes and Christian Illuminators: Interstitial
Encounters and Cultural Negotiations." In Katrin Kogman-Appel and Mati
Meyer (eds.), *Between Judaism and Christianity: Art Historical Essays in*

Honor of Elisheva (Elisabeth) Revel-Neher. (Leiden, Netherlands, 2009, 281–305.

Garel, Michel. "The Provenance of the Manuscript." In Jeremy Schonfield (ed.), *The North French Hebrew Miscellany (British Library Add. Ms. 11639).* 2 vols. London, 2003, 2:27–39.

Garzelli, Annarosa (ed.). *Miniatura fiorentina del Rinascimento: un primo censimento, 1440–1525.* 2 vols. Florence, Italy, 1984.

Gasparri, Françoise. "Un contrat de copiste à Orange au XVe siècle." *Scriptorium* 28 (1974): 1285–86.

González Sugrañés, Miguel. *Contribució a la historia dels antichs gremis dels arts y oficis de la ciutat de Barcelona.* 2 vols. Barcelona, 1915–18.

Gutmann, Joseph. *Hebrew Manuscript Painting.* New York, 1978.

Gutmann, Joseph. "Masorah Figurata: The Origins and Development of a Jewish Art Form." In *Sacred Images: Studies in Jewish Art from Antiquity to the Middle Ages.* Northampton, England, 1989, article 15.

Gutmann, Joseph. "Thirteen Manuscripts in Search of an Author: Joel ben Simeon, Fifteenth Century Scribe Artist." *Studies in Bibliography and Booklore* 9 (1970): 76–95.

Hernando i Delgado, Josep. "Escrivans, illuminadors, lligadors, argenters i el libre a Barcelona, segle XIV: Documents dels protocols notarials." *Miscellània de textos medievales* 7 (1994): 189–258.

Hillgarth, Jocelyn N., and Bezalel Narkiss. "A List of Hebrew Books and a Contract to Illuminate Manuscripts (1335) from Majorca." *Revue des études juives* 120 (1961): 297–320.

Hillgarth, Jocelyn N. *Readers and Books in Majorca, 1229–1550.* Vol. 2. Paris, 1991.

Horowitz, Elliott. "Giotto in Avignon, Adler in London, Panofsky in Princeton: On the Odyssey of an Illustrated Hebrew Manuscript from Italy and on Its Meaning." *Journal of Jewish Art* 19–20 (1993–94): 99–109.

Horowitz, Elliott [Elimelech]. "About an Illuminated Manuscript of the Mishneh Torah." *Kiryat Sefer* 61 (1986–87): 583–86 (in Hebrew).

Husung, Max Joseph. "Ein jüdischer Lederschnittkünstler." *Soncino-Blätter* 1 (1927): 197–98.

Husung, Max Joseph. "Über den sogenannten 'jüdischen Lederschnitt.'" *Soncino-Blätter* 1 (1925–26): 29–43.

Idel, Moshe. "Panim: On Facial Re-presentations in Jewish Thought: Some Correlational Instances." In Nurit Yaari (ed.), *On Interpretation in the Arts: Interdisciplinary Studies in Honor of Moshe Lazar.* Tel Aviv, 2000, 21–56.

Italiener, Bruno. "Isak B. Secharjah, ein jüdischer Lederschnittkünstler des 15. Jahrhunderts." In Alexander Marx and Hermann Meyer (eds.), *Festschrift für Aron Freiman zum 60. Geburtstage.* Berlin, 1935, 159–60.

Jordan, William Chester. "A Jewish Atelier for Illuminated Manuscripts in Amiens?" *Wiener Jahrbuch für Kunstgeschichte* 37 (1984): 155–56.

Jordan, William Chester. "Women and Credit in the Middle Ages: Problems and Directions." *Journal of European Economic History* 17 (1988): 33–62.

Kanarfogel, Ephraim. "Varieties of Belief in Medieval Ashkenaz: The Case of Anthropomorphism." In Matt Goldish and Daniel Frank (eds.), *Rabbinic Culture and Its Critics*. Detroit, MI, 2007, 117–59.

Katzenstein, Ursula Ephraim. "Mair Jaffe and Bookbinding Research." *Studies in Bibliography and Booklore* 14 (1982): 17–28.

Kelleher, Patrick J. *The Holy Crown of Hungary*. Rome, 1951.

Kessler, Herbert L. *The Frescoes of the Dura Synagogue and Christian Art*. Washington, DC, 1990.

Klagsbald, Victor A. *A l'ombre de Dieu: dix essais sur la symbolique dans l'art juif*. Louvain, Belgium, 1997.

Klemm, Elisabeth. *Die illuminierten Handschriften des 13. Jahrhunderts deutscher Herkunft in der Bayerischen Staatsbibliothek: Textband*. Wiesbaden, Germany, 1998.

Kogman-Appel, Katrin. "Coping with Christian Pictorial Sources: What Did Jewish Miniaturists Not Paint?" *Speculum* 75 (2000): 816–58.

Kogman-Appel, Katrin. *Illustrated Haggadoth from Medieval Spain: Biblical Imagery and the Passover Holiday*. University Park, PA, 2006.

Kogman-Appel, Katrin. "Jewish Art and Non-Jewish Culture: The Dynamics of Artistic Borrowing in Medieval Hebrew Manuscript Illumination." *Jewish History* 15 (2001): 187–234.

Kogman-Appel, Katrin. *Jewish Books between Islam and Christianity: The Decoration of Hebrew Bibles in Spain*. Leiden, Netherlands, 2004.

Kogman-Appel, Katrin. "Sephardic Ideas in Ashkenaz—Visualizing the Temple in Medieval Regensburg." *Jahrbuch des Simon-Dubnow Instituts* 8 (2009): 246–77.

Kohn, Roger. "Fortune et genres de vie des Juifs de Dijon à la fin du XVe siècle." *Annales de Bourgogne* 44 (1982): 171–92.

Kosmar, Ellen. "Master Honoré: A Reconstruction of the Documents." *Gesta: International Center for Medieval Art* 124 (1975): 63–68.

Kotlar, David. *Art and Religion*. Jerusalem, 1971 (in Hebrew).

Labande, Léon-Honoré. *Les primitifs français. Paintres et verriers de la Provence Occidentale*. Marseille, 1932.

Landsberger, Franz. "The Cincinnati Haggadah and Its Decorator." *Hebrew Union College Annual* 15 (1940): 529–58.

Lazar, Hava. "Instructions to the Illuminator of the Schocken Haggadah." *Kirjat Sefer* 53 (1978): 373–75 (in Hebrew).

Maier, Johann. "Bilder im *Sefer Chasidim*." In Michael Graetz (ed.), *Ein Leben für die jüdische Kunst: Gedenkband für Hannelore Künzl*. Heidelberg, 2003, 7–14.

Mandurell y Marimon, José María. "La contratación laboral judaica y conversa

en Barcelona (1349–1416): Documentos para su estudio." *Sefarad* 16 (1956): 33–71, 369–98.

Mandurell y Marimon, José María. "Encuadernadores y Libreros Barceloneses Judíos y Conversos (1322–1458)." *Sefarad* 21 (1961): 300–38; 22 (1962): 345–72; and 23 (1963): 74–103.

Mann, Vivian B. "Between Worship and Wall: The Place of Art in Liturgical Spaces." In Ruth Langer and Steven Fine (eds.), *Liturgy in the Life of the Synagogue: Studies in the History of Jewish Prayer.* Winona Lake, IN, 2005, 109–19.

Mann, Vivian B. *Jewish Texts on the Visual Arts.* Cambridge, 2000.

Martindale, Andrew. *The Rise of the Artist in the Middle Ages and Early Renaissance.* New York, 1972.

Mellinkoff, Ruth. *Antisemitic Hate Signs in Hebrew Illuminated Manuscripts from Medieval Germany.* Jerusalem, 1999.

Mellinkoff, Ruth. *The Horned Moses in Medieval Art and Thought.* Berkeley, 1970.

Mellinkoff, Ruth. "More about Horned Moses." *Jewish Art* 11–12 (1987): 184–98.

Merz, Walther, and Friedrich Hegi. *Die Wappenrolle von Zürich: ein heraldisches Denkmal des vierzehnten Jahrhunderts.* Zurich, 1930.

Metzger, Thérèse. *Die Bibel von Meschulam und Joseph Qalonymos: Ms. 1106 der Universitätsbibliothek Breslau (Wrocław).* Würzburg, Germany, 1994.

Metzger, Thérèse. "The Iconography of the Hebrew Psalter from the Thirteenth to the Fifteenth Century." In Clare Moore (ed.), *The Visual Dimension: Aspects of Jewish Art Published in Memory of Isaiah Shachar (1935–1977).* Boulder, CO, 1993, 47–81.

Metzger, Thérèse, and Mendel Metzger. "Les enluminures du Ms. 11639 de la British Library, un manuscrit hébreu du nord de la France (fin du XIIIe siècle–premier quart du XIVe siècle)." *Wiener Jahrbuch für Kunstgeschichte* 38 (1985): 59–113.

Metzger, Thérèse, and Mendel Metzger. *Jewish Life in the Middle Ages.* Fribourg, Switzerland, 1982).

Metzger, Thérèse, and Mendel Metzger. "Meir ben Baruch de Rothenbourg et la question des images chez les Juifs au Moyen Âge." *Aschkenas* 4 (1994): 33–82.

Millar, Eric. *The Parisian Miniaturist Honoré.* London, 1959.

Millas Vallicrosa, José María. "Los judíos Barcelonenses y las artes del libro." *Sefarad* 16 (1956): 129–36.

Mortara Ottolenghi, Luisa. "Scribes, Patrons and Artists of Italian Illuminated Manuscripts in Hebrew." *Journal of Jewish Art* 19–20 (1993–94): 86–98.

Müller, Karlheinz. *Die Würzburger Judengemeinde im Mittelalter von den Anfangen um 1100 bis zum Tod Julius Echters (1617).* Würzburg, Germany, 2004.

Müller, Paul Johannes. *Jüdische Miniaturen aus sechs Jahrhunderten.* Wiesbaden, 1998.

Narkiss, Bezalel. "An Illuminated Ms. of Maimonides' Code in the JNUL (with 8 Facsimiles)." *Kiryat Sefer* 43 (1967–68): 285–300.

Narkiss, Bezalel. *Illuminations from Hebrew Bibles of Leningrad.* Jerusalem, 1990.

Narkiss, Bezalel. "On the Zoocephalic Phenomenon in Medieval Ashkenazi Manuscripts." In *Norms and Variations in Art: Essays in Honour of Moshe Barash.* Jerusalem, 1983, 49–62.

Narkiss, Bezalel. "A Tripartite Illuminated Mahzor from a South German School of Hebrew Illuminated Manuscripts around 1300." In *Proceedings of the Fourth World Congress of Jewish Studies.* 2 vols. Jerusalem, 1968, 2:125–33.

Narkiss, Bezalel."The Seal of Solomon the Scribe: The Illustrations of the Leblanc Pentateuch of 1340." In Katrin Kogman-Appel and Mati Meyer (eds.), *Between Judaism and Christianity: Art Historical Essays in Honor of Elisheva (Elisabeth) Revel-Neher.* Leiden, Netherlands, 2009, 319–49.

Narkiss, Mordechai. "Origins of the Spice Box." *Journal of Jewish Art* 8 (1981): 28–41.

Perani, Mauro, and Saverio Campanini. *I frammenti ebraici di Modena e di Correggio.* Florence, Italy, 1999.

Pietrusinski, Jerzy. *King John of Luxembourg (1296–1346) and the Art of His Era.* Prague, 1998.

Revel-Neher, Elisheva. "Seeing the Voice: Configuring the Non-figurable in Early Medieval Jewish Art." In Bracha Yaniv (ed.), *Timorah: Articles in Jewish Art.* Ramat Gan, Israel, 2006, 7–22 (in Hebrew).

Richler, Benjamin. "Regulations between a Lender and Borrower Attributed to Zacharias Puglese." In Abraham David (ed.), *From the Collections of the Institute of Microfilmed Hebrew Manuscripts.* Jerusalem, 1995, 102.

Richler, Binyamin. *Hebrew Manuscripts: A Treasured Legacy.* Cleveland, OH, 1990.

Rostovzeff, Michael I., A. R. Bellinger, and F. E. Brown (eds.). *The Excavations at Dura-Europos: Final Report.* Vol. 4.1.1. New Haven, CT, 1943.

Roth, Cecil. *The Aberdeen Codex of the Hebrew Bible.* Edinburgh, 1958.

Roth, Cecil. "Pledging a Book in Medieval England." In *Studies in Books and Booklore.* London, 1972, 36–41.

Rouse, Richard H., and Mary A. Rouse. *Illiterati et uxorati: Manuscripts and Their Makers. Commercial Books Producers in Medieval Paris 1200–1500.* 2 vols. Turnhout, Belgium, 2000.

Roux, Claude. "Les peintres et leurs œuvres à Tarascon à la fin du Moyen Âge au travers des vies de Barthélémy Ricard et Jean Audin." *Provence Historique* 58 (2008): 181–213.

Saltman, Ellen S. "The 'Forbidden Image' in Jewish Art." *Journal of Jewish Art* 8 (1981): 42–53.

Sanz Artibucilla, José María. "Guillen y Juan de Levi, pintores de Retablos." *Sefarad* 4 (1944): 73–98.

Schäfer, Peter. *Mirror of His Beauty: Feminine Images of God from the Bible to the Early Kabbalah.* Princeton, NJ, 2002.

Schonfield, Jeremy (ed.). *The North French Hebrew Miscellany (British Library Add. Ms. 11639).* 2 vols. London, 2003.

Shapiro, Meyer. "Introduction." In Moshe Spitzer and Max Jaffé (eds.), *The Bird's Head Haggada of the Bezalel National Art Museum in Jerusalem.* Jerusalem, 1967, 15–19.

Schneider, Jürg E., and Jürg Hanser. *Wandmalerei im Alten Zürich.* Zurich, 1986.

Schubert, Ursula. *Jüdische Buchkunst.* 2 vols. Graz, Austria, 1983–92.

Sed-Rajna, Gabrielle. "Ateliers de manuscrits hébreux dans l'Occident médiéval." In Xavier Barral i Altet (ed.), *Artistes, artisans et production artistique au Moyen Âge.* Vol. 1, *Les hommes.* Paris, 1986, 339–52.

Sed-Rajna, Gabrielle. "The History of a Hebrew Codex: A Hebrew Codex as History, Maimonides' Mishneh Torah at the Library of the Hungarian Academy of Sciences." In Joseph Dan and Klaus Herrmann (eds.), *Studies in Jewish Manuscripts.* Texts and Studies in Medieval and Early Modern Judaism 14. Tübingen, Germany, 1999, 199–219.

Sed-Rajna, Gabrielle. "The Illustrations of the Kaufmann Mishneh Torah." *Journal of Jewish Art* 6 (1979): 64–77.

Sed-Rajna, Gabrielle. *Le Mahzor enluminé: les voies de formation d'un programme iconographique.* Leiden, Netherlands, 1983.

Sed-Rajna, Gabrielle. *Les Manuscrits hébreux enluminés des bibliothèques de France.* Leuven, Belgium, 1994.

Shalev-Eyni, Sarit. "The Antecedants of the Padua Bible and Its Parallels in Spain," *Arte medievale*, n.s., 4 (2005): 83–94.

Shalev-Eyni, Sarit. "Illuminierte hebräische Handschriften aus dem Bodensee-Raum." *Kunst + Architektur in der Schweiz* 51 (2003): 29–37.

Shalev-Eyni, Sarit. "Obvious and Ambiguous in Hebrew Illuminated Manuscripts from France and Germany." *Materia giudaica* 7 (2002): 249–71.

Shalev-Eyni, Sarit. "The Tripartite Mahzor." PhD diss., Hebrew University of Jerusalem, 2001 (in Hebrew).

Sibon, Juliette. *Les juifs de Marseille au XIVe siècle.* Paris, 2011.

Sirat, Colette. *La conception du livre chez les piétistes Ashkenazes au Moyen Âge.* Paris, 1996.

Sirat, Colette. *Hebrew Manuscripts of the Middle Ages.* Cambridge, 2002.

Sirat, Colette. "*Le livre hébreu: rencontre de la tradition juive et de l'esthétique française.*" In Gilbert Dahan, Gerard Nahan, and Elie Nicholas (eds.), *Rashi et la culture juive en France du Nord au Moyen Âge.* Paris, 1997, 243–57.

Sirat, Colette. "Notes sur la circulation de livres entre Juifs et chrétiens au Moyen Âge." In Donatella Nebbiai-Dalla Guarda and Jean-François Genest

(eds.), *Du copiste au collectionneur: Mélanges d'histoire des textes et des bibliothèques en l'honneur d'André Vernet*. Bibliologia 18. Turnhout, Belgium, 1999, 383–403.

Sirat, Colette. "En vision globale: les Juifs médiévaux et les livres latins." In Pierre Lardet (ed.), *La tradition vive: Mélanges d'histoire des textes en l'honneur de Louis Holtz*. Bibliologia 20. Turnhout, Belgium, 2003, 15–23.

Soloveitchik, Haym. *Pawnbroking: A Study in the Inter-relationship between Halakha, Economic Activity and Communal Self-image*. Jerusalem, 1985 (in Hebrew).

Soloveitchik, Haym. *The Use of Responsum as Historical Source: A Methodological Introduction*. Jerusalem, 1990 (in Hebrew).

Sparti, Aldo. "Gli ebrei siciliani e l'arte de corallo." In Nicolo Bucaria, Michele Luzzati, and Angela Tarantino (eds.), *Ebrei e Sicilia*. Palermo, Italy, 2002, 137–61.

Sparti, Aldo (ed.). *Fonti por la storia del corallo nel Medioevo mediterraneo*. Trapani, Italy, 1986.

Suckale, Robert. "Über den Anteil kristlicher Maler an der Ausmalung hebräischer Handschriften der Gotik in Bayern." In Manfred Treml and Josef Kirmeier (eds.), *Geschichte und Kultur der Juden in Bayern: Aufsätze*. Munich, 1988, 123–34.

Süssman, Arthur (ed.). "Das Erfurter Judenbuch (1357–1407)." *Mitteilungen des Gesamtarchivs der deutschen Juden* 5 (1914–15): 1–126.

Toch, Michael. "Medieval Treasure Troves and Jews." In Iris Shagrir, Ronnie Ellenblum, and Jonathan Riley-Smith (eds.), *In Laudem Hierosolymitani: Studies in Crusades and Medieval Culture in Honour of Bejamin Z. Kedar*. Aldershot, England, 2007, 273–96.

Toch, Michael (ed.). *Wirschaftgeseichte der Mittelalterlichen Juden*. Munich, 2008.

Twining, Edward F. *A History of the Crown Jewels of Europe*. London, 1960.

Urbach, Ephraim E. "Rabbi Menahem Ha Meiri's Theory of Tolerance: Its Origins and Limits." In Immanuel Etkes and Yosef Salmon (eds.), *Studies in the History of the Jewish Society in the Middle Ages and in the Modern Period Presented to Professor Jacob Katz on His Seventy-fifth Birthday*. Jerusalem, 1980, 34–44 (in Hebrew).

Vitzthum von Eckstädt, Georg. *Die Pariser Miniaturmalerei: von der Zeit des hl. Ludwig bis zu Philipp von Valois und ihr Verhältnis zur Malerei in Nordwesteuropa*. Berlin, 1907.

Voelkle, William M., and Susan L'Engle. *Manuscrits Enluminés. Chefs-d'oeuvre de la Pierpont Morgan Library—New York*. New York, 1998.

Waissenberger, Robert (ed.). *The Neidhart Frescoes ca. 1400: The Oldest Secular Mural Paintings in Vienna*. Vienna, 1982.

Weiss, Daniel H. *Art and Crusade in the Age of Saint Louis*. Cambridge, 1998.

Wild, Dölf, and Roland Böhmer. "Die spätmittelalterlichen Wandmalereien im

Hause 'Zum Brunnenhof' in Zürich und ihre jüdischen Auftraggeber." In
Ursula Koch (ed.), *Zürcher Denkmalpflege: Bericht 1995/96*. Zurich, 1997,
15–33.

Zirlin, Yael. "Celui qui se cache derrière l'image: Colophons des enlumineurs
dans les manuscrits hébraïques." *Revue des études juives* 155 (1996): 47–51.

Zirlin, Yael. "The Decorations of the Miscellany, Its Iconography and Style." In
Jeremy Schonfield (ed.), *The North French Hebrew Miscellany (British
Library Add. Ms. 11639)*. 2 vols. London, 2003, 2:75–161.

Zirlin, Yael. "Discovering the Floersheim Haggadah." *Ars Judaica: The Bar Ilan
Journal of Jewish Art* 1 (2005): 91–108.

Zirlin, Yael. "The Early Works of Yoel ben Simon, a Jewish Scribe and Artist."
PhD diss., Hebrew University of Jerusalem, 1995. (in Hebrew).

Zirlin, Yael. "Jael Meets Johannes: A Fifteenth Century Jewish-Christian
Collaboration in Manuscript Illumination." *Viator* 26 (1995): 264–82).

Zirlin, Yael. "The Jewish-Christian Polemic in Pictures: *The North French
Miscellany* (BL. Ms. Add. 11639)." In Bracha Yaniv (ed.), *Timorah: Articles
on Jewish Art*. Ramat Gan, Israel, 2006, 61–72 (in Hebrew).

Zirlin, Yael. "The Schocken Italian Haggadah of c. 1400 and Its Origins."
Jewish Art 12–13 (1986–87): 55–72.

Index

Honoré of Amiens (later Paris), 134–36
Hundred Years War, 53
Husung, Max Joseph, 146

iconoclasm, 77, 82, 96–100, 108–9
Idel, Moshe, 106
illuminated Hebrew manuscripts, 75, 77–
 105; animal-like and zoocephalic fig-
 ures in, 84–93, 100–103; animals and
 flowers in, 103–5; anti-Semitic images
 in, 136–39; Christian artists of, 78, 79–
 80, 84, 90, 93–94, 102–3, 121–40; for
 holy prayer books, 104–5; Jewish art-
 ists of, 113–20; of non-Germanic ori-
 gin, 99–100, 106–7; non-Jewish mis-
 takes in, 126–31; portraiture of patrons
 in, 136, 137f; presentation of faces and
 heads in, 77–84, 93–100, 105–8,
 138–39
influence. See external influences on Jewish
 aesthetics
Innocent III, Pope, 29–30
Institutes of Justinian, 23
Irenaeus of Lyon (Saint), 88
Isaac, son of Zaccariah, 146
Isaac of Dampierre "Ri," 32–33
Isaac of Vienna "'Or Zaru'a," 76–77
Isis, 87n13
Islam, 7–8; figurative art in, 75; iconic mo-
 tifs in, 119

Jacob, son of Benjamin of Montalcino, 123
Jacob, son of Solomon of Perugia, 123
Jacob ben Asher, 99
Jacob ben Moses Molen "Maharil" of
 Mainz, 58, 104
Jacob ben Reu'ven, 157
Jacopo da Voragine, 150
James, Thomas, Bishop of Dole, 125
Jeckelin of Strasbourg, 52–53
Jehan de Grise, 57
Jericho mosaic pavement, 75
Jermann, Alexandra, 62n1
Jerusalem Mishneh Torah, 123, 126
Jewish aesthetics. See external influences
 on Jewish aesthetics
Jewish artists and craftsmen, 4, 113–20,
 160; architectural works of, 73–74;
 bookbinding work of, 144–51; Chris-
 tian liturgical objects made by, 141–44,
 151–57, 160; collaboration with Chris-

tian artists by, 116–19; color prepara-
 tion manual for, 113–14; coral work by,
 141–44; impact of Gothic art on, 119–
 20, 145, 158, 163; instructions pro-
 vided for, 154–55; Jewish law on work
 of, 156–57; mosaic pavements of, 74–
 75; written contracts of, 114–15
Jewish books and manuscripts: external in-
 fluence on, 26–28, 57–58, 162–63; illu-
 mination of, 75, 77–105
"Jewish Christian Symbiosis: The Culture
 of Early Ashkenaz" (Marcus), 165–66
Jewish garments, 19
Jewish iconoclasm, 77, 82, 96–100, 108–9
Jewish leatherwork, 145–47
Jewish Matrimonial Law in the Middle
 Ages (Falk), 165
Jewish Museum of Spain, 64, 65f
Jewish neighborhoods, 53–55, 56f, 159–60
Jewish ritual objects, 1–4, 42–44, 120–21,
 122f, 160
The Jews in Umbria (Toaff), 24–25
Jews of Perpignan in the Thirteenth Cen-
 tury (Emery), 8
"The Jews of Sicily" series (Simonsohn),
 13–14, 18n24
Joachim of Fiore, 164
Joel ben Simon "Feibush Ashkenazi," 107,
 115–18, 120; five sages of Bnei Brak of,
 116, 117f; trademark of, 116
Johan de Levi, 152, 153f
John Rylands Haggadah, 41–42
Joseph ben Moses of Ulm, 78, 79
Joseph ha-Zarfati "the Frenchman," 115
Joseph ibn Caspi, 139n52
Joseph ibn Hayim, 115
Joseph of Saint-Mihiel, 18–20, 36
Judah bar Samuel "Saltman," 84
Justinian, 23

kabbalah, 89–90, 106, 164
Kalonymos ben Kalonymos of Ulm, 79
Kalonymos of Speyer, 56–57
Kanarfogel, Ephraim, 107
Kara, Joseph, 77–79
Katz, Jacob, 31
Kaufmann Haggadah, 41, 64, 66f, 126–29
Klagsbald, Victor, 1
Klosterneuberg Abbey, 34
Kogman-Appel, Katrin, 119, 133
Kohn, Roger, 20

Jews, Christians, and Muslims from the Ancient to the Modern World